D0028915

BRAIN STORM

Unleashing Your Creative Self

Also by Don Hahn

The Alchemy of Animation
Animation Magic
Dancing Corndogs in the Night

BRAIN STORM

Unleashing Your Creative Self

DON HAHN

Disney Editions

New York

Copyright © 2011 Don Hahn
All rights reserved. Published by Disney Editions, an imprint of
Disney Book Group. No part of this book may be reproduced or
transmitted in any form or by any means, electronic or mechanical,
including photocopying, recording, or by any information storage
and retrieval system, without written permission from the publisher.
For information address Disney Editions, 114 Fifth Avenue, New
York, New York 10011-5690.
Printed in the United States of America
First Edition
10 9 8 7 6 5 4 3 2
Book design arlene schleifer goldberg
ISBN 978-1-4231-4036-8
V475-2873-0 12282

SUSTAINABLE
FORESTRY
INITIATIVE

Certified Chain of Custody
Promoting Sustainable Forestry

www.sfiprogram.org
SFI-01054

The SFI label applies to the text stock

For Emilie

Table of Contents

1.

Beginning

First Impressions

It's ten o'clock at night. My parents are in the living room howling at Barney Fife on *The Andy Griffith Show*, and I've secretly smuggled a flashlight into bed. Maybe that doesn't sound like big-city excitement, but at five years old, well, it was a treat. I'd sneak under the covers with a flashlight from the kitchen drawer and pajama bottoms stuffed with green plastic army men. When the lights went out, I'd flip on the flashlight and reenact the allied invasion of Normandy beneath the sheets for what seemed like hours.

When I got bored with that, I'd punch some holes in a piece of tinfoil and put it over the flashlight, securing it with a rubber band from that morning's newspaper. Suddenly my room was a planetarium, full of stars and constellations. The

Big Dipper was way up there next to my toy monster collection, and the North Star burned brightly just above my sock drawer. I once smuggled a giant colander from the kitchen in my pajama bottoms to my bedroom. With a flashlight and that colander, I could re-create the entire Milky Way galaxy on my ceiling. I didn't think my mom suspected a thing, but in retrospect, I'm sure she just shook her head and said, "Your son has the colander in his pants again." Dad probably snorted a proud snort and went back to Andy Griffith.

Sometimes I would prop the flashlight up on my bookshelf and try making silhouettes on the wall. I could do a passable barking dog, a butterfly, and a bust of Lincoln, but the big crowd-pleaser was a lifelike silhouette of Marilyn Monroe smoking a pipe, a feat that I must say was not unimpressive.

It was about this time that I had my first encounter with the movies. My mom and dad would make some popcorn, dress my brother and sister and me in our jammies, and load us into the back of our pink Rambler station wagon, and we'd head off to the Rosecrans Drive-In for a double bill: *One Hundred and One Dalmatians* and one of those Doug McClure movies titled *Journey to Somewhere Underground with Big Rubber Dinosaurs* or the like.

After we'd found our perfect parking place and hung the high-fidelity speaker on my dad's window, we'd eat popcorn and play Twister, waiting for the show to begin. And then it was showtime. All the lights in the drive-in went out, the kids at the big playground underneath the screen ran back to

their cars, and a beacon of light beamed through the darkness from the snack-bar roof onto what appeared to be the biggest white rectangle in the Western Hemisphere. The first image that night was of a quartet of animated snacks delivering a snappy jingle touting the tasty treats available inside.

I was mesmerized. Sure, I had watched television, but the difference between watching Andy Griffith and Barney Fife on a sixteen-inch black-and-white TV screen and watching a dancing hot dog on that huge white rectangle was life-transforming. This was better than my flashlight and colander. Much better. I became glued to the light in the darkness. There I was with my family in a station wagon parked near two hundred other cars on a hot Saturday night. There were other kids with their families, older couples, horny teenagers, and pimply-faced snack-bar attendants all staring at the light in the darkness. (Or was it pimply-faced teenagers and horny snack-bar attendants? Oh, well, you get the idea.)

I'm not an anthropologist, but it seemed to my five-year-old brain that I was experiencing a primal joy as I stared at this light in the darkness. It was probably the same joy cavemen experienced from staring at a campfire in the frigid void of night—except without the giant dancing hot dog part.

Three hours, two features, and seven cans of RC Cola later, I was hooked on movies, and I had to go to the bathroom in a profound way. I was too young to understand the concept of a double bill, and for years I wanted to go back to see that movie again—the one with the dalmatians, dinosaurs,

and the big hot dog. Staring at the big rectangle would be the most amazing fun I would have in the back of a station wagon for years to come.

Foundations

The foundation of creative thinking is formed from three critical elements. First, you need a huge amount of information. Fortunately we are alive in the middle of the biggest information boom since the invention of movable type five hundred years ago. Modern media is everywhere, and the ability to get information on the Internet has put nearly every man, woman, and child in contact not only with the 1,644,009 entries listed when you type in the words *Kim Kardashian*, but also with the greatest thinkers and libraries known to humankind.

Second, you need an untiring interest in your work. Are you obsessed enough with your ideas to play with them into the dead of night—to turn things over in your head and play with the problems of your craft just because that's what you love to do? You need the passion to bring loads and loads of raw material to consciousness for consideration.

And finally, you must have not only the ability, but also the ruthlessness to take out the trash. Nobody can think of only good ideas or write only touching, sensitive prose all the

time. If we've done our creative work effectively, first we've done our homework; next, we've created tons of fodder for thought; and finally, we've weeded through our thoughts, separating the rocks from the gems, always mindful that time changes things and today's rock might be tomorrow's gem.

Sadly, there is no National Bureau of Good Taste, no sole arbiter of good and bad ideas. That choice between the good idea and the bad one is up to you. It's a very personal choice, too—as personal as the friends you keep, the clothes you wear, and the food you choose to eat.

Choosing between the junk and the genius is called your *taste* or your *gut*. It's that still-small voice inside you that whispers in your ear, "This really stinks" or "This ain't bad." You may not be able to articulate completely why an idea is gold or tin—most likely you will feel the distinction. That gut feeling is part of your DNA, combined with your life experiences and the exposure you've had to a world full of ideas. But that gut feeling is a changing organism that grows with you on life's journeys.

Creativity beckons us to jump into the void—to shine a light into the darkness and risk following a new idea. You may find a good idea today that will seem half-baked tomorrow. You may discard an idea that comes back years later to haunt you. You may even create something that society tells you is total folly and then be seen by generations to come as genius.

Let's take a ridiculously broad perspective and consider for a moment where exactly we fit in the universe. The universe is basically a bunch of stars and planets floating around

in a big black void, as previously illustrated on my bedroom ceiling. In that universe there is a galaxy, and in that galaxy a star, and orbiting that star is Earth, and resting on Earth is a highly sensitive, intuitive being prone to horrific acts of violence and unbelievable acts of kindness: *Homo sapiens*—a term that was coined to describe an advanced form of human life, and was derived from the Latin, meaning literally "wise man." A bit self-congratulatory, don't you think?

If viewed from outer space, this colony of about six or seven billion human beings may seem almost like a single cohesive organism. This organism called humanity is obsessed with building, crafting, and organizing the planet. Shaping, forming, interpreting, and studying the mysteries of life. Somewhere in this vast universe on this tiny planet is you. Feel pretty insignificant now, don't you?

What are we doing here? Why are we worried about Kate Gosselin, the housing market, or whether cow flatulence is tied to global warming? Why are we rushing around so much, trying to get ahead, when such galactic forces are at work in the universe? We feel so tiny, almost as if we were one small cell in the body of humanity, doing our job to service the body in our own small way for the betterment of the whole.

Our ancestors didn't seem to care much about the meaning of life when they grunted their way out of the primordial ooze. Their only concern was dealing with basic survival. But as their brains grew and their knuckles stopped dragging on the ground, the fundamentals of survival became second nature to them, and they longed for a sense of meaning and

belonging in their world. It wasn't enough just to build a fire and plow a field; they wanted to know where fire came from and why plants grew. Why had we been put here in the first place, and how could our voices be heard over the vast thunder of the cosmos?

We come not only from cosmic roots, but also from a long human line of ancestors who ate, slept, laughed, cried, worked, and played their way through life just for a chance to pass their genes on to us. It seems funny in a way, because we are so much like our ancestors and we possess so many of their genetic gifts, and yet most of us can't say that we know a whole lot about them.

I know my grandpa was a mail carrier who liked to play cribbage and eat scallions with salt. My grandma worked for the Burpee seed company and made world-class rhubarb pie. My dad's mother was an interpreter during the Great War. She spoke four languages and would travel from her village in Poland to Krakow or Warsaw to interpret for the politicians and businessmen. She came to America with my dad and his cousins, passing through Ellis Island in October 1921, and they all settled in Cleveland and later upstate New York.

I have some old photos of relatives from the nineteenth century. They seem nice enough, even though I don't know much about them. I remember hearing talk about my great-great-grandmother, who lived in Quincy, Illinois, and once served mashed potatoes to a local politician named Abraham Lincoln. My great-grandfather published the German-language newspaper in Clinton, Iowa. I even

remember meeting him when I was a little kid. He lived in a dark upstairs room in a big wooden house on Third Street. There he would sit for hours on end doing what most men of his generation did—smoking cigars and talking about politics. He looked as if he were about five feet tall, and he always wore a suit and tie—the same suit and tie that he wore in the picture I have.

I think about how we compare with his generation. We're taller and healthier now, probably fatter, too, and I almost never wear a tie. We smoke fewer cigars, and I really can't remember the last time I had a good long talk about politics. I think back on all of these strangers that are part of my family—that genetically live on in me—and I feel humbled.

We are alive in the most complex times. We're pretty lucky to be here at all. The fact that any one of us was born is due to a million-in-one chance meeting between an egg and a sperm. The fact that we have survived infant diseases, the Cold War, junior high school dances, Y2K, and *Jersey Shore* is in and of itself reason to celebrate.

The truth is that you probably don't know very much about your own mom and dad, much less the hundreds of ancestors who have lived their lives so that you could be here reading this book today. Their genetic gifts are sitting inside you now. If you look closely you can see bits of Uncle Herman the miner and Aunt Rose the seamstress. Grandpa Rudolph the tobacco farmer and Great-Great-Grandma Elsie the painter. Farther back, there are Chester the horse thief and your medieval Uncle Heinz, who supposedly went on

the Crusades, and Grandma Alice, who practiced witchcraft and made a fine meat pie. These people all lived and loved and laughed and cried, and then they died—but they never died completely. They all passed a tiny portion of themselves on to you. They're all sitting right there in your lap in the form of genetic material—a vast storehouse of human potential inside of us, ready to be discovered.

The same stunning system that bred human beings in a billion different variations—from Stephen Hawking to Tyra Banks, from Warren Buffett to Kobe Bryant—has bred you. Each relative, no matter how distant, has thrown something into your bag of life that contributed to the person you have become. Your oldest relatives were probably a pretty feeble bunch who spent most of their time dealing with life's basic problems, such as "Maybe we can wear this to keep warm" or "Who wants to be the first to try eating that?" Our relatives of the *Homo sapiens* persuasion may not have given us a specific genetic desire to wear animal skins, live in mud huts, and eat nuts, berries, and the occasional squirrel, but they did give us the gift of the survival instinct—the basic primal skill of knowing when to fight or run and knowing that light usually means warmth and survival and darkness means danger and possible demise.

Cave dwellers needed to exercise a certain amount of creative muscle just to survive. They fought to keep their fires burning in the dark and to stay warm until the sunrise illuminated their lives again. They knew the value of light. When you think about it, we really haven't changed much. We've

merely exchanged the berries, loincloths, and mud huts of previous generations for Starbucks, the L.L. Bean catalog, and the Dish Network. But even in our modern lives, we carry with us ancestral gifts, like our love of light and our desire to survive.

Dreamer, Doer

Our earliest predecessors were born with two sets of instructions in their brains. One set said, *Be conservative, save your energy, drink eight glasses of water, and wear a jacket before you go out.* The other set of instructions said, *Go crazy, hurl yourself into life, drink eight glasses of Red Bull, and wear underpants on your head before you go out.* Believe it or not, we need both of those sets of instructions to live well, and while we all seem to get the first set loud and clear, we often pay little attention to the second set.

Yes, it seems that our craniums are occupied by a bickering, odd couple that can't quite live with each other, but can't live alone, either. Call them the dreamer and the doer. Our dreamer brain is visual, spatial, relational, nonverbal, and intuitive and loves to run, play, and watch reruns of *The Twilight Zone.* It thinks in wild fantasies without reference to time or the mortgage crisis precipitated by subprime lending practices. Our doer brain, on the other hand, *is* the mortgage

crisis, and thrives on the structured, linear, logical, verbal, and analytical side of life. It is that pragmatic worker bee in all of us who busily goes about making lists, balancing checkbooks, sorting socks, and constantly trying to bring order into a chaotic world that doesn't naturally like order.

Sometimes it's hard to get the dreamer and doer to work in sync with each other. All too often we spend most of our day do, do, doing and a very small portion of it dreaming. At other times, we get lost in our thoughts and dream dreams only to spend our waking hours doing something entirely different. Getting the dreamer and the doer to work together is one of the first steps toward reawakening the creative spirit.

It's no surprise that the doer in us often takes center stage. First, consider the fact that in normal life, a great portion of our waking hours is devoted to just staying alive and well. Take a typical day and subtract the hours devoted to cooking, eating, cleaning, sleeping, shaving, shining, showering, plucking, waxing, and some of the less mentionable bodily functions. Then subtract the time spent on occupational functions like commuting, meeting, texting, calendar making, lunching, plucking, and waxing. Finally, subtract the time spent shopping, taking the kids to school, picking up the dry cleaning, and dropping the kids off at soccer, ballet, and the doctor. We're left with about thirty-nine seconds each day to be completely swept away in rapturous fantasy. There's not a lot of leisure time left even to think about adding some creative balance to your life.

We lead lives of response: response to emergencies, deadlines, doorbells, and text messages. As a result of this deadening drone of responsibility, we are left with little or no time for the dreamer. Creativity demands big, protected chunks of time set aside just to dream, and big, protected places like studios, labs, and libraries set aside just to dream in. Cultivating the dreamer is not just a once-in-a-while thing, but rather a constant, regular, habitual practice of dreaming for the rest of our lives.

We have no problem saying that we need at least thirty minutes of vigorous physical exercise each day, but I'm not sure our society is ready for thirty minutes of vigorous dreaming every day. However, we can change that.

Lizard Brain

Along with the left and right brain, there's another method of looking at our gray matter—old brain and new brain. Our old caveman brain, or the *amygdala*, sits at the base of the skull on top of the spine in the same way it has for millions of years. It controls our basic instincts to eat, breathe, hoard, attack, run, and mate, instincts that have been around since we were, well . . . lizards. It also has the added attraction of saving us from social conflict. It was important for our old brain to fit in socially with our tribe so we wouldn't be shunned or left to

die. Behaviors that made us clever and lovable were encouraged, as were behaviors that helped us know when to shut up. Surrounding the old brain is the more thoughtful new brain, or *neocortex*. Its function is much more sensitive, feeling, thoughtful, and analytical, not unlike the new Oprah Winfrey cable channel.

So when we talk about creativity, it helps to understand how old and new brains drive our thought process. For example, one of the first rules of brainstorming and creating in a group environment is to suspend judgment. When people get together to create, it has to be in a safe room where expression is encouraged without fear of derision. Your old brain won't let you become a social outcast without at least haunting you with memories of that time you were horribly embarrassed in front of class or spoke out at work and got shut down.

Old brain makes distinctions in the blink of an eye. New brain takes time to access and bring a little reasonable cognitive thought to a situation. Old brain is, "Ready, fire, aim." New brain is, "Ready, aim, fire." When we first meet someone, old brain has an immediate and intuitive reaction. Sometimes we connect with that person instantly as though we were soul mates. Or, we're immediately suspicious that something isn't right. It's our old brain, full of snap decisions that are black and white, life or death, love or hate.

So now put yourself in a social setting like a work retreat. You're having a good time exchanging ideas, writing them down with felt markers on those huge Post-it notepads. Suddenly your boss says to you in a vaguely accusatory tone,

"Don, I overheard you talking in your group and it sounded like you had some ideas for better-quality products here at the Widget company. What were those ideas?"

Lizard brain, being our social survival coach, immediately speaks up in your head: "This is a setup, he's going to shoot you down no matter what you say, deflect the question! Keep your mouth shut, keep it shut!" All lizard brain remembers are the times when parents, teachers, and other bosses humiliated you.

The sad result? A new idea is edited before it is spoken. The boss feels a certain satisfaction and superiority in your embarrassment. Neither person has contributed to a productive creative exchange. But your lizard brain and all the fears that go with it is here to stay, and your job is to figure out a way to ignore it sometimes, and when the coast is clear and you are in a safe room, say what you deeply feel without fear of reproach.

Toad's Brain

If you're like me, you are probably spending several hours a day wondering about the size of your brain. You're probably asking yourself right now, as people frequently do, "Is my brain normal?" Well, here's an interesting thought: the most accomplished neurosurgeon could open your skull right now and

look at your brain and not really be able to distinguish it from the brain of Mozart, Einstein, or Barney Fife. Brains are so similar in the amount of information they can process and the speed with which they can process it that one might hypothesize that we should all be able to perform mental acrobatics at the level of the most successful scholars and artists.

Certain cultures were great breeding grounds of creative thought and action. Just think what it must have been like to be living in the highly creative cultures of ancient Greece, Florence in the Renaissance, or Paris during the nineteenth century.

Those great epochs of creativity grew from times of relative prosperity, when people had ample leisure time to devote to reading, painting, and debate. The personal challenge, then, is to carve out time for your own creative renaissance to take place—time for your dreamer to dream deep, long, satisfying dreams.

My high school friend was named Toad (we never knew his real name or how he got the name Toad, but there are certain things in life that shouldn't be questioned). Toad was a fireplug of a boy. He was about five feet tall and spent the greater part of his high school years emitting vapors and making funny sounds with his hands. Other students had jammed their schedules with chess club, radio club, pep club, Latin club, and drill team and had very little time to devote to dreaming. Toad, on the other hand, had participated in none of these extracurricular activities and could devote large chunks of time to dreaming about:

- The mysteries of inner space.
- The vastness of the cosmos.
- How to line a locker with Vaseline and grass clippings.

The point is that we all have very real limitations on our time and, consequently, limits on the number of things that we can attend to. And it's important to do some cerebral housecleaning by eliminating boring things. Our brain hates being bored, so bypass the boring and look for the energy.

And speaking of healthy things for the brain, let's talk sleep. Our body needs some rest, but it's our brain that really needs time to sort out and process what just happened during our day. Don't cut sleep time short. Chances are that you are either a morning person or a late-night enthusiast. Embrace your inner clock and don't let the world try to change you. If you're a night person, embrace it and understand that you aren't necessarily abnormal. Maybe your brain just works better at night. Try napping, too. Call it meditation, prayer, or just plain napping. The National Institute of Mental Health funded a team of doctors at Harvard University that showed a midday snooze can reverse fatigue faster than a case of Red Bull. Their findings, published in the journal *Nature Neuroscience*, demonstrated that a one-hour nap could boost performance quite substantially. They wrote, "The bottom line is: we should stop feeling guilty about taking that 'power nap' at work." Try adding that to the company mission statement.

Our brains are powerful, natural explorers hunting for ideas in the chaos of life. Even in old age, our brains are still malleable. We can still learn new things. Just look at Frank Lloyd Wright, who, at the age of ninety, was coming to work each day, participating in client meetings, designing buildings, and reading the *New Yorker* cover to cover.

Jacksonville Conquered

It's only natural to want to emulate some of the great minds of the ages. In one way, it's encouraging to think that human beings can rise to the heights of a Bach or a Baryshnikov; on the other hand, it's intimidating to think of the accomplishments of highly creative people.

I hold up certain historical figures as my creative idols: Mozart, Beethoven, Ben Franklin, Thomas Jefferson, Picasso, Groucho Marx, Frank Capra. Their talent and accomplishment intimidate me. How could anyone ever attain what these masters attained? Why even try? But then I started to realize that many of these greats of history lived in a much smaller, simpler world.

The Greeks didn't have much to work with, but they did a lot for creativity in their era. In about 400 BC, they began construction on the Parthenon, and the Greek mathematician Archytas invented the pulley and was credited with building

the first heavier-than-air flying machine, which, it was said, actually flew. Sophocles died around that time. He was a prizewinning wrestler and musician and was even a general in the Athenian army, and he still had time left over to write 123 plays. The population of ancient Greece at that time was around three million people, roughly the size of greater Cleveland. I'm in awe of this small culture that shaped the world, and I expect a lot more from the citizens of Cleveland in the future.

In 43 AD, the Romans, under the direction of their emperor, Claudius, occupied what is now Britain and founded Londinium (now London). The population of the British Isles was an estimated 800,000, about equal to that of Jacksonville, Florida, today. Claudius was a short, balding man not unlike Danny DeVito in appearance. Now, I'm not saying that it wouldn't be a newsworthy day if Danny DeVito invaded Jacksonville, or that Danny DeVito wouldn't make a heck of an emperor, but the comparison does help give human scale to the sometimes mythic events of history.

George Washington, John Adams, Thomas Jefferson, and a group of upstart colonial businessmen gave birth to America in 1776. The population of the colonies was 2,418,000, or about the same as that of Minneapolis-Saint Paul. George was forty-four, John forty, and Ringo was . . . er . . . wait, that's not right. Ah, yes, sorry, and Thomas Jefferson was a young thirty-three years old.

I don't mean to trivialize the accomplishments of these

giants of history, but this perspective helps me realize that while these storied people may have lived in a very different world, they probably still put their pants on one leg at a time.

We have an advantage over our predecessors. We live in an era of relative prosperity. Besides just dreaming of doing things that might affect the entire world, it's now possible, through the advances of the information age, for an individual voice to be *heard* around the world. Dickens didn't have Google, Mozart didn't have GarageBand, Charlie Chaplin didn't have YouTube, Walt Disney had no cell phone, and the Roman army didn't even have GPS. We have incredible technology.

Even though they lived in another world and their technology was crude by today's standards, these historical figures understood two timeless qualities that great innovators always seem to possess: a passion for ideas and a work ethic to carry them out. These are uniquely human qualities. Our modern technology gives us neither. A generation ago, our parents had only a small black-and-white television, no debit cards, and no Facebook, but they put men on the moon through passion and hard work. At the end of the nineteenth century, our parents' grandparents had no airplanes, phones, lights, cars, or Major League Baseball, and yet in a span of forty years, all those things became reality with passion and hard work. History reminds us that it's people, not their tools, that do amazing things. Don't be intimidated by technology.

Nobody's Perfect

I was having breakfast one day at a place called Fast Donut. I patronize Fast Donut because I believe it stands for the best that America has to offer. In Europe, you'd never see places like Fast Croissant or Fast Biscotti. Not only did we invent the doughnut, we're happy to serve it to you fast. I like that.

Anyway, while I was waiting for my doughnut, I couldn't help overhearing the guy behind the counter talking about the screenplay he was working on. Just the day before, I was having breakfast with a friend and all the waiters and waitresses were talking about *their* screenplays—everyone in Los Angeles works on screenplays at night with the dream of making it big. There seems to be some link between screenwriting and places that serve breakfast food. I think they should just combine screenwriting and breakfast so that people like me could come in and hear waiters pitch you stories for new movies while you eat.

> **WAITER:** Hi, my name's Eric, and I'll be your
> server this morning. Today's special is the
> seafood omelet, and you'll be hearing a pitch
> for a premise starring that new guy from
> *Twilight* . . .
> **PRODUCER:** Robert Pattinson?

WAITER: No, Taylor Lautner.

PRODUCER: What's in it?

WAITER: Action, romance, pathos—

PRODUCER: No, what's in the omelet?

WAITER: Peppers, onions, Jack cheese . . .

PRODUCER: I'll have that. And what's the pitch again?

WAITER: It's called *Briefcase* . . . it's a love story, but from a completely different perspective. The film opens with a shot of a young lawyer named Brian Samson, played by—

PRODUCER: Taylor Lautner?

WAITER: Correct. Coffee? *(Producer nods.)* I'll be right back.

The waiter dashes over to another table to fill up coffee cups. I overhear a pitch at the next table—Sandra Bullock as the tortured wife of an NFL player. It's called Personal Foul. *My waiter returns.*

WAITER: Anyway, we think he'd be great.

PRODUCER: Who?

A busboy sails past and plops down a tray of dishes.

BUSBOY *(whispering)*: Taylor Lautner.

PRODUCER: Oh.

WAITER: So . . . it's a story about this young lawyer who gets this job representing this transvestite guy who's accused of murder, and the media tries to make a mockery of the whole thing.

BUSBOY: Those bastards.

It is becoming increasingly apparent that the busboy is cowriting this screenplay.

PRODUCER: Really.

WAITER: The main character is this girl, only she's really a guy, and he's in a jail cell with his lawyer and he's crying.

PRODUCER: Lautner?

BUSBOY: No, the guy . . . who's dressed like a girl.

PRODUCER: Really.

WAITER: Anyway, this transvestite admits to murdering this other transvestite, but he starts crying because, get this, he was in love with the girl he murdered!

BUSBOY: Don't you get it?

PRODUCER: Get what?

WAITER: Two girls in love, only they're guys!

PRODUCER: Well, how does Taylor Lautner feel?

WAITER: About what?

PRODUCER: About what! He's in a jail cell with

a girl who's really a guy that killed a guy who's dressed like a girl! Don't you think he'd have an *opinion* about all this?

WAITER: Well . . . it's a moral dilemma.

PRODUCER: I can see that.

WAITER: So now, Taylor Lautner knows she's guilty, but he still has to defend her, and his dilemma is he's falling in love with her.

PRODUCER: But she's a guy.

BUSBOY (*yelling from across the restaurant*): *He doesn't know that!*

PRODUCER: He doesn't *know* that?

WAITER: He thinks the defendant is the most beautiful and vulnerable girl he's ever met. He thinks she's a girl, but we know she's a guy. So, here's the topper: he goes to court the next day, after a long night of preparation, and he's really struggling with his feelings for her, and now it's the first day of the trial, and she's ushered into the courtroom, only—get this—now she's dressed like a guy!

The busboy has joined the waiter, both with a yer-gonna-love-this-part grin.

WAITER: Now Taylor Lautner thinks, *Holy crap, she's a guy.*

BUSBOY: From then on it writes itself.

I like waiters who write screenplays. I like people who spend their free time writing late into the night on the off chance that their story will make it to the screen. It's hard to be dismissive of the passion and work ethic that these midnight warriors possess.

And who's to say that someday their work won't make one heck of a movie? *E. T.*, *Forrest Gump*, and *Beauty and the Beast* were all bypassed or shelved at different studios. They were all dismissed at one time or another. I'm sure by now that the waiter at Fast Donut has a development deal at DreamWorks. Why not? And Taylor Lautner, if you're reading this, please stay close to your phone.

Artifacts

As hard as you may try, you can't guarantee a positive reaction to your personal brand of creativity. For every successfully produced screenplay, there are thousands of scripts that languish on dusty shelves, never to see the light of day again. We live in a society that values and rewards success. This can lead you to be a very success-driven artist, which in turn can lead you to be constantly disappointed. Creative expressions rarely succeed as big moneymakers, and you can't always measure the value of a creation by the yardstick of financial success.

Van Gogh painted throughout an undistinguished and anonymous lifetime before dying in obscurity. His work went on to be the most celebrated of the post-Impressionists'. Mozart was a musical genius but was buried in a pauper's grave. People hated *Moby Dick* when it was published, and the early episodes of *Seinfeld* garnered some of the most dismal ratings in television history in a year in which the number-one show was *Jake and the Fatman*.

What, then, do Vincent, Wolfgang, Herman, and Jerry have in common? The drive to create, regardless of the outcome. They were driven to paint, compose, write, and tell jokes at any cost. To live lives that were committed to their crafts day in and day out, regardless of the perceived success or failure of their work.

Our capitalist system loves and rewards tangible success. We attain that success by a system based on this equation: ideas + materials + process + quality + marketing = success and money. We judge our success or failure by how good the reviews are and how big the financial rewards are.

We are goal-oriented. We learn to celebrate the completion of a job with pomp and circumstance; the arrival of a product like the iPad is touted with headlines and hyperbole. In all this celebration and marketing, we lose track of the earlier part of the equation: the ideas, materials, and quality that go into the work.

This obsession with the end product sets us up for a nasty, lifelong pattern of seemingly endless periods of boredom, stress, and tension while waiting to celebrate, followed by a

celebration that is far too short, followed by long periods of boredom, stress, and tension, and so on. Not a fun way to spend one's life.

The process itself is where the treasure of creativity is buried. It's the feeling you get when you are immersed in a project with your head down, and all of your one billion brain cells are immersed in trying to forge idea, quality, and process into a new creation on a canvas, or in a laboratory, or in a saucepan.

Think of any creative production as you would a big vacation. When we take a long trip to London, for example, our journey will take us to charming shops, pubs, quaint hotels, restaurants, pubs, landmarks, and pubs, and we'll enjoy all kinds of interesting and memorable things along the way. In fact, we form memories that last a lifetime on trips like this. The literal goal of your trip was to travel to London and return home in two weeks. Yet when we get home we would never say, "Thank god I met my deadline of returning home in two weeks."

When we return home, we realize how completely absorbed we were by our journey. We love to recount the joy, pain, elation, and disappointment we felt along the way. At the end of our trip, we revel in the memories of the journey—not in the deadline for arriving home.

We show the stupid pictures of us in front of everything. We wax sentimental about the charming bobby who clamped our rental car when we parked illegally in front of Harrods. We laugh about the night we locked ourselves in our hotel

room with a bottle of Old Bushmills and a box of Walkers shortbread cookies and watched *Britain's Got Talent*. We cry "awwww" at the picture of the newborn lamb in Yorkshire. The arrival home means very little; the journey means everything. A creative journey is the same.

There is no assurance of success, acknowledgment, fame, fortune, respect, or cash prizes at the end of our creative process. There isn't even any assurance that you'll finish a project. There is nothing in life that guarantees us immortality. Even fame in our own time doesn't guarantee us that. The famous people of a century ago are all but forgotten. The only thing we have is our present moment and the incredibly joyful feeling we experience when we are working at our favorite craft and solving the problems that our project presents to us. Enjoy the journey along your creative highway like a dog with his head out the window of a car—eyes wide open, ears back, nose wet, tongue out—completely absorbed.

When you focus on the journey and not the arrival, then your art becomes more like a treasured artifact of the creative process. A painting, a poem, a sketch, or a piece of music that you've written becomes a record of your life—a souvenir of the creative process, just as much as the photos are an artifact of your unforgettable travels abroad.

Attribution

I visited one of the temples of art of the modern world, the Louvre museum in Paris. There is a portrait there of Lisa del Giocondo, who is not a character from *Jersey Shore* but, rather, the subject of the most iconic painting in the world, the *Mona Lisa*.

The painting is over five hundred years old. When it was stolen in 1911, her bemused face was plastered across newspapers around the world, and more people lined up to see the place where her picture had hung than had ever come to see her before the theft. Over the years, she's had acid poured on her, rocks thrown at her, red paint sprayed on her, and a gift-shop mug hurled at her. She now sits in a massive room protected by bulletproof glass and surrounded by admirers, about six million of them a year. She is the rock star of the art world.

You have to feel sorry for Salvator Rosa, whose paintings hang to the left and right of the *Mona Lisa*. His paintings are really nice, but they have no pedigree, no mystery, and, most importantly, no big story behind them. Two equally beautiful paintings hang side by side in the Louvre. One has a plaque that says "Leonardo da Vinci" and the other's plaque says "Salvator Rosa." One a legend, and the other a nice Italian painting.

Books of quotations are filled with pithy sayings

attributed to celebrities from science, film, and politics. These are quotes from smart people who seem to know what they are doing, and are now offering us the knowledge that they have gained, condensed into just a line or two.

Some people are quoted more than others. Einstein and Picasso fall into this category. Picasso, by the way, hated to be quoted, so you'll notice that I've quoted him about nine hundred times in this book. While his behavior was, by all accounts, appalling and his personal life a disaster, he actually had some interesting things to say about art and creativity.

People love to hear what big, influential, successful artists have to say. Here's a hypothetical quote from a very famous person:

> There will be those who say that it can't be done. Those who would try and stop us, but we must persevere knowing that God is with us.
> —Franklin Delano Roosevelt

These are inspirational words indeed. So inspirational, in fact, that they would be equally good coming from a football coach.

> There will be those who say it can't be done. Those who would try and stop us, but we must persevere knowing that God is with us.
> —Notre Dame football coach
> Knute Rockne

Or a political leader.

> There will be those who say it can't be done.
> Those who would try and stop us, but we must
> persevere knowing that God is with us.
> —Nelson Mandela

But the same words can be chilling if ascribed to a despot.

> There will be those who say it can't be done.
> Those who would try and stop us, but we must
> persevere knowing that God is with us.
> —Adolf Hitler

The words themselves are identical, but your impression of the words is completely changed by the attribution. Roosevelt's quote seems as if it must refer to the war effort. Rockne's is obviously a halftime pep talk to his Fighting Irish. Mandela offers a spiritual hope for all of us, and Hitler's quote seems like the ravings of a misguided madman. Attribution sways our point of view.

A few months ago, a story circulated about a man who bought a collection of original Ansel Adams photographs at a garage sale. One day the photos were up for sale for a few dollars, along with some old skis and a *That's So Raven* lunch box. The next day they were a newfound treasure of the art world, worth hundreds of thousands of dollars. Same pieces of art,

different attribution. A month later, the photos were proven to be wrongly attributed to Adams. They were taken by one of his contemporaries, and their value plunged because of the attribution.

All of this rush to associate a painting with a great artist or a quote with an exceptional person is fine, but try for once to take a step away from the fame or attribution of a piece of art, and instead form your own opinion regarding that art. Be critical. Be introspective. Be honest. According to an article in the *Guardian* newspaper, most people spend fifteen seconds viewing the *Mona Lisa*. It becomes another box to check off of one's list of Things I Saw in Paris.

Just because a painting hangs in a museum doesn't mean you have to like it. Just because a famous person is quoted doesn't mean the quote has relevance to your life. Not all novels by Steinbeck, plays by Tennessee Williams, songs by Paul McCartney, or films by Hitchcock are uniformly brilliant. You may adore some and feel ambivalent toward others. Disregard pedigree and form an opinion based on how you feel about something. Next time, celebrate Salvator Rosa. Find a Picasso that you hate, some Mozart that doesn't work for you, a classic movie that everyone else loves but that you find flawed. Find an obscure artist to embrace, an unknown band whose music you love, and a little-known film that moves you deeply.

The truth and beauty of art is in the eye of the beholder. What you see as truth may be a lie to me. You may see a hero while I see a goat. You may see artistic brilliance while I see nothing.

The attribution of a quote, a painting, or a poem is indeed important. Knowing that a painting is by Jackson Pollock helps us understand him and his place in our culture and makes it more than just some accidental splashes of paint. But the real truth is how a painting speaks to you personally. Does it move you deeply? Does it engage your imagination? Does it challenge your beliefs?

Here's a list of age-old quotes that have no particular attributions. These pithy little sayings are powerful on their own without knowledge of who said them because they each represent a little capsule of human wisdom. These couplets do, however, contradict one another, and so, just when you find a quote to support your point of view, alongside it comes a quote of equal weight that will undercut your point of view entirely.

> Look before you leap.
> He who hesitates is lost.
>
> If at first you don't succeed, try, try again.
> Don't beat your head against a stone
> wall.
>
> Absence makes the heart grow fonder.
> Out of sight, out of mind.
>
> Two heads are better than one.
> Paddle your own canoe.

Haste makes waste.
Time waits for no man.

You're never too old to learn.
You can't teach an old dog new tricks.

It's better to be safe than sorry.
Nothing ventured, nothing gained.

Hitch your wagon to a star.
Don't bite off more than you can chew.

Many hands make light work.
Too many cooks spoil the broth.

Don't judge a book by its cover.
Clothes make the man.

The squeaky wheel gets the grease.
Silence is golden.

Never put off till tomorrow what you can
 do today.
Don't cross the bridge till you come to it.

The Pursuit of Happiness

Write your future.

—Nike, Inc.

Thomas Jefferson rented a room once in Philadelphia and locked himself in with a pot of tea, his violin, some pens, some paper, a bottle of Old Bushmills, and some Walkers shortbread cookies . . . oh, sorry, I got sidetracked there for a minute. In any case, two days later, he emerged with a document declaring the colonies' independence from King George III. Like most Americans, I had read the Declaration of Independence in school and heard bits of it quoted during patriotic demonstrations, but I never really appreciated Jefferson's definition of freedom until recently. He says, "We hold these truths to be self-evident, that all men are created equal, that they are endowed by their Creator with certain unalienable Rights, that among these are Life, Liberty, and the pursuit of Happiness."

To the colonials, this was pretty great stuff (especially if you were a white man, since women and people of color didn't enjoy the same benefits until much, much later). What Jefferson was able to do was to define freedom in a very abstract, rhapsodic way that we could all agree on. The truth probably is that freedom doesn't always mean equality and equality doesn't always foster the spirit of happiness. What I

like about this sentence is the simplicity of its truth: we are all created equal to pursue our own lives, freedom, and happiness. It's America's mission statement.

The pursuit of happiness is an idea that comes from Aristotle. He thought that all human strivings and yearnings could be distilled into one thought: all we want is dark chocolate. Actually, he said that all we want is to achieve happiness, but I frequently confuse the two. There are a million ways to be happy; the pursuit of a creative dream is one of them.

Authenticity

One night the phone in my office rang, and it was one of the younger production managers assigned to the film I was working on asking if he could come up and talk. Let's call him Sven Bjornson, since I don't want to reveal his true identity and I adore the sound of Scandinavian names. "Sure," I said, and in a few minutes Sven walked into my office, closed the door, and sat down.

"I need some advice." He had been doing his job in junior management for a long time, and you could tell that something was starting to nag at him. Sven wanted to do what everyone else in Hollywood wants to do: he wanted to write screenplays. He was taking a class in screenwriting

and had begun writing a screenplay, but he felt stuck and wanted a push in the right direction.

For some reason, I responded with a diving metaphor, the first I had ever used, but it seemed appropriate for the occasion. "Sven," I said, "you can either tiptoe into the shallow end or jump naked into the deep end. It all depends how much you want to swim."

If you are going to pursue your happiness, you must start by deciding what your happiness is. What's inside of you? What story do you have to tell? What truth do you have to share? The most successful writers write because they *have* to. They have an unquenchable, burning desire to write about the world as seen through their own eyes. This whole conversation with Sven really came down to how much Sven really felt he *had* to write.

At issue here was authenticity. Sven's work at a film studio was a detour from his real job, which was this: to wake up every morning and be the best Sven Bjornson that he could be. To do that, first he had to dig deep and find out who he was. He had to honor his personal history and the strengths and limitations that have made him who he is today. He needed the courage to be honest with himself and make big changes in his career path. He had to write as only he could write. He had to be authentic.

If Sven was willing to go home at night and say to himself, "I'm going to work harder than anyone else; I'm going to carve out big chunks of time to write and study films and scripts and commit myself to my passion," then maybe he

would get a break and be able to write a magazine article that might lead to a television movie and then a feature. Otherwise, he'd be a hobbyist for life. Not a bad thing, but an amateur thing. It's the difference between me on my three-speed bike and Lance Armstrong.

Then Sven said something that stopped me. He was talking about his college experience and the fact that every day he used to do something different in drama or art or music, and that when he went to work in management he left all that behind him. He decided years ago to put his dream on a shelf for a while, but he never went back to it. In essence, he was living a lie in denying himself the parts of his life that gave him joy.

Sven was at a crossroads. Most people who come to this intersection won't make a dramatic change. They may take a class or practice a bit, and then see the writing on the wall and pull the plug on their dreams once again. But a few stalwart souls will latch onto the dream like a bear trap and not let go. They will work and seek out experts and study and marry their dream for better or worse, richer or poorer, in sickness and in health, till death do them part. They will work to dig deeply for the truth about their lives. To explore their desire to create without guilt and for no other reason than this: they have to. They can't *not* do it.

If you love your dream, why not marry it? Feel the fire in your gut. Grit your teeth, put your ears back, and scream a primal scream. There is strength in boldness, and let's face it, the alternative—doing nothing—doesn't sound very satisfying.

Pursue happiness. Strip down and dive into the big waves with Sven. The water is deep, cool, and endlessly refreshing, and you've got plenty of strength to swim to shore.

Thinking Outside the Box

I loved being a Cub Scout. I loved the snappy blue uniforms, the sharp blue caps, and the crisp yellow neckerchiefs. I loved even the word *neckerchief*. Life in Cub Scouts meant weekly pack meetings at Mr. and Mrs. Gillan's house. We never went inside the house, but always had our meetings at a picnic table in the garage, alongside the power mower, bikes, and bags of manure. A typical meeting would start with the Pledge of Allegiance and the Cub Scout Promise and then proceed to any number of boy-pleasing crafts.

The Pinewood Derby is an annual rite of spring in the Cub Scouts of America. It started in Manhattan Beach, California, in 1953 when a Cubmaster was looking for an event for the kids too young to compete in the soapbox derby races. All Pinewood Derby racers start with identical boxed kits that include a ten-inch chunk of wood, a set of plastic wheels, and some rudimentary hardware. Each scout then went home and started whittling away, with his mom and dad's help, to build his own personalized, custom racer.

On the day of the race, everyone showed up with his

completed car. Some had beautiful paint jobs and others had flames and that stupid woodpecker-smoking-a-cigar decal. The scouts would line up their racers on a track made of parallel "lanes" of plywood, and they'd race in heats. The fastest cars were the ones that took advantage of gravity with weighted front ends, but whatever the modifications, the cars had to be built using only the contents supplied in the box and in strict compliance with long-standing rules set by the Boy Scouts of America.

Then Toad walked in the door with a big grin on his face, cradling his Pinewood Derby racer in both hands. Toad was the type of kid who felt that whatever rules there were, they didn't apply to him. He had completely hollowed out the body of his race car to look like a Scud missile launcher, and then strapped his brother's eighteen-inch solid-fuel model rocket to the chassis. He painted a big US flag and the words TO HONOR AMERICA on the side of the fuselage. I was pretty sure Toad hadn't looked at the rules.

His car was the hands-down sentimental favorite of the entire troop, but was disqualified on the grounds that it was a dangerous nuisance. Days later, we gave it a test run by lighting it up on the school playground. It took off with unimaginable speed, ricocheted off the bicycle racks, shot across the baseball field, and blew up in a huge ball of flames inside the third-base dugout. The whole trip took about two seconds. The wheels never really touched the ground. Toad was beside himself with joy. I had had my first real experience with someone who thought outside the box.

Not long after that, I graduated to Boy Scouts, where I noticed a change. The uniforms were now green, with a red neckerchief, and the older boys looked much older indeed. One of the older scouts, named Mitch, even shaved and talked about girls. Cub Scouts had been easy because we all did the same crafts and read the same stories. In Boy Scouts, we were free to explore who we were and what we liked. Boy Scouts even offered a variety of merit badges, representing lots of ways a young lad like me could express himself in all his glorious pubescence.

There were the standard sorts of badges for hiking and camping, canoeing and fishing. There were merit badges for personal fitness, personal finance, and salesmanship. They had badges for rural things like forestry, soil conservation, hog production, and sheep farming. There were police-prep badges for things like marksmanship and fingerprinting; badges for those with artistic aspirations, like painting, sculpting, and basket weaving; badges with lofty and altruistic-sounding names like Citizenship in the Home and World Brotherhood. Everyone could express his strength and get a badge as recognition (even Toad, who desperately wanted a merit badge for sleeping-bag flatulence, which we eventually gave him).

Merit badges were a good idea. I wish they handed them out to adults. It'd be a real icebreaker at parties. When you met someone, you could just look down at his green sash and say, "I can't help noticing that you're into hog production."

I wonder what our adult merit badges would look like. Net surfing, freeway commuting, and *Dancing with the Stars*

addiction? Garage hoarding, procrastination, highest calorie consumption in one sitting?

In scouting, even as young men we wore those badges as signs of who we were. The number of badges you wore showed the diversity of your interests and your commitment to learning. I sometimes stop and think about the merit badges I earned so many years ago. What others have I earned—really *earned*—since then? Or have I been so sidetracked with life that I've forgotten to carve out time for my interests? Even worse, will I wake up one day and find that I have no interests at all?

Labels

Warning: cape does not enable user to fly.
—Batman Halloween costume label

A few years back, after watching Kevin Costner in *Dances with Wolves*, I became fascinated with the Native American way of selecting names. It seemed so honest and forthright to have a name like *Runs with the Wind* or *Dancing Bear*. It was much more poetic than the names that the people in my neighborhood had. The closest we came to an interesting name that told you something about the person was our family plumber, whose name was—and I am not making

this up—Warren Faucet. His wife's name was Flo.

I started to take stock of the people around me as if they were Native Americans, wondering what their names would be.

Out on the streets, I've seen *Waits for Parking Space* and *Drives with Turn Signal On*, and my best friend, Toad, who might simply be called *Bold Wing*. I know *Walks with Stroller*, *Little Hug*, and *Jogs with Crapping Dog*.

We humans love labels. We label our clothes and our food and our freeways and our politicians. We put extra labels on hot dogs, cereal, and record albums: 97% Fat-Free; Toy Inside; 10% More.

We label movies with ratings: PG-13, parental guidance recommended. I always find it odd that we'll rate a movie based solely on the amount of language, sex, and violence it contains. Why stop there? It seems to me that we should rate everything about a movie. If I can pick up a can of Spam at the supermarket and read the entire contents, why shouldn't I be able to read the contents of a movie off the movie poster? As with food ingredients, you could list the good and the bad: "Contains strong language, violence, stupid dialogue in the second act, a meaningless love story that seems pasted on; but there is a cool dinner scene where a girl eats a whole lobster with her bare hands."

We love to affix labels to everything, but most of all we love to label ourselves. Starting very early in school, we put ourselves into neat little boxes for classification, not unlike what is done with butterfly collections. He's a teacher, she's an insurance saleswoman, he's a thespian, she's a lesbian, he's

a liberal, she's a conservative. Teacher, salesman, liberal—all pretty generic labels for complex human beings. The labels deceive us, because the saleswoman is also an actress and the teacher is not just a teacher, but also an artist, a singer, and a weekend hockey goalie.

Our tidy, doer brain seems to need to categorize everything. Even random grasses and wildflowers can be neatly sorted into kingdom, phylum, class, order, family, genus, and species. But imagine for a moment whatwould happen if those labels didn't exist. What if words didn't define? Instead of the "Anglo, middle-aged, Catholic rock hound," you would just be . . . you—the individual. In truth, you are an individual in every way. Nobody does it, sees it, wears it, eats it, learns it, or creates it the way you do.

What if the labels were off and it were just you, the spirit? You the pumping heart, the breathing lungs, the aching back? Just you?

What Do You Live For?

Every man dies; not every man really lives.
—William Ross Wallace

Now that the labels are off, who exactly are you? What are you good at? What do you love to do? What is your fatal flaw?

What is your flame, your torch, your favorite condiment? What will be your creative gift to the world? Look carefully. The answer doesn't lie in what your dad or mom wanted you to do, nor in what your partner wants you to do, but in what *you* want to do. And remember, we are not talking about your career or job, but your life. In searching for your own personal gift, don't feel as if you are limited to an occupation.

Here's an example: even though I hate to quantify creative achievement, every March I don my tuxedo, go to the Academy Awards ceremony in Hollywood, and celebrate my hypocrisy. There, amid the cummerbunds and cleavage, I see my old friend from college, Dave. Dave valet-parks cars for a living. He works for the company that parks your car on Oscar night. Dave also happens to be a world-class organ player. Pipe organ. Big, wonderful pipes and pedals with stacks and stacks of keyboards. He is gifted at and passionate about playing the organ. Dave also runs a valet parking service. The point is, Dave *lives* to play the organ, not to park your Lexus. What do *you* live for?

Only you can decide. Do you want to direct a movie? Do you want buns of steel? That small voice inside of you that gravitates toward cooking or poetry, finance or beaver husbandry, is the very thing that makes you unique. Take the limitations away, take the labels off, and pick your passion.

Sometimes it helps to imagine what your view will be like from the end of your life. What will it feel like looking back over the years? What will your proudest accomplishments be? Raising children, creating a business, writing poems? What

will be your biggest regret? Never learning to play piano, not traveling to Rome, never learning to fly-fish, write, or cook a turkey? Now back up from the end of your life to today. It doesn't matter if you are eighty-five or twenty-five—you have one thing on your side: you are alive. With the remainder of your life, you have the complete control you need to move some things from the regret column to the accomplishment column. Pursue your happiness.

When you finally choose your muse, you may struggle with the feeling that your chosen field is insignificant or has little value. We create in a world that tells us that all things are not equal. It's a world that seems to reward success in a big, public way—a world that likes to keep score on achievement. Your house, your car, your education, your clothes, your job—all scream out loud about you and where you fit into the hierarchy of society.

We organize creative achievements in the same type of hierarchy, in which we rank some things as being of more importance than others. But what if creativity had no hierarchy? There is an impulsive desire in all of us to quantify creative achievement—to attach a value to a person's gift. For example, we generally feel that actors and film directors are more creative than salespeople or body-shop owners. We like to rank celebrity chefs as more creative than financial executives.

But on a fundamental level, there is great value and nobility in all creative processes. The *Mona Lisa* has value, and so does the painting of those dogs playing poker. An episode

of *60 Minutes* and an episode of *South Park* both have value. You may prefer one or the other, but you can't presuppose that one has value and one doesn't. Each grows from culture. Each contributes to culture. Each reflects and in a way defines culture.

We all struggle with thoughts that our work may not have lasting value or social relevance. Let's face it: most of what we do probably doesn't have a great deal of social relevance. That knowledge can become an obstacle to feeling satisfied with your own work, but it shouldn't. As much as we may want others to love and validate us, and as much as we want to have a lasting impact on our world, no one has figured out a way to statistically show what impact you will have on the universe. You have to take the leap of faith that your work is indeed important and will affect the world in unknowable ways.

What do we live for, then? We live for the journey. Every act in your life has relevance to that journey, and both the greatest moments of joy and the deepest personal failures will define who we are and where we've traveled.

Creative People

The desire to create is a uniquely human one. Sure, the animals may build the odd nest or dam up the occasional stream. But you never see a cow painting a mural or a chimp writing

a business plan (well, *almost* never). Humans create constantly, but it seems like some people really excel at it. Some create with astounding and prolific brilliance. What is it that we can learn from highly creative people? What do they have in common?

Some of the most brilliantly creative people on the planet live lives full of contradictions. At times, these people are physical and vigorous, and at other times quiet and contemplative. At times they are expansive and playful, and at other times surgically focused and disciplined. Highly creative people have the willingness to spend limitless time on an idea and come up blank. They have the audacity to throw themselves into unknown ventures and risk spectacular failure. They live in a world of boundless imagination and sobering reality.

Creative people show up in every corner of the Myers-Briggs personality profile test. They are both extroverts and introverts, social and solitary, thinking and feeling. They play the roles of both student and teacher. They can be openly masculine or feminine or they can reach across sexual orientation with a kind of psychological androgyny that allows them to feel emotions with a much larger vocabulary.

There is no more enduring icon in culture than the "creative individual." He seems set apart from the rest of us because he was born with creativity. After all, you either have it or you don't.

But the vision of creativity as a gift from God is largely a myth. If we define creativity simply as "imagination directed toward a goal," then we all have it.

People in the arts often claim the creative process as their own, but they don't have a lock on it. Successful artists do exercise a tremendous amount of imagination in the service and to the end of creating their art. But so do novelists, journalists, photographers, shopkeepers, teachers, and the practitioners of a dozen other professions who bring their imaginations into use on a daily basis.

There is also a misconception that creativity is about exercising your imagination in a wholly original way. We learn by observing others and how they lead their lives, and we are not really original creatures. We are bags of DNA handed down through the centuries and molded by years of personal experience and learning.

Creative people bring their personal experiences to their work. When Julie Taymor adapted *The Lion King* for the Broadway stage, her visionary approach to the material created a version of the story that was stunning and unforgettable, but the roots of the production lay in centuries-old traditions like Javanese shadow puppetry and Japanese Bunraku puppetry. She pulled from modern dance and African tribal chants. Julie's creativity and genius was demonstrated by the manner in which she chose to bring all of those elements together and reimagine the story using a new visual palette that was like nothing you'd ever seen before.

To be creative is to be totally and passionately committed to your work—to be in love with your work and yet be able to separate yourself from it enough to hate it. It means to be completely attached to what you are doing and then to

become completely detached, so that you can criticize and edit your own work. It is a life of pain and vulnerability, of elation and ecstasy. To be creative is to live a life of contradiction.

In all of these definitions and examples of creativity, there is one truth worth repeating: there is no reason why this "highly creative person" can't be you. If you are a living, breathing human, one thing that separates you indisputably from the other animals is your ability to exercise your imagination in the service of an original goal. You are by nature creative. Your life is at times physical and vigorous and at other times quiet and contemplative. At times, you may be expansive and playful and at other times surgically focused and disciplined. I'm sure you've spent limitless time on an idea and come up blank, and who doesn't live in a world of boundless imagination tempered by sobering reality?

Glenn Vilppu, my life drawing teacher, had a student once who struggled with drawing so much that he doubted that he would ever be an artist. His drawings were stiff and uncertain. Glenn told him simply this: "You have to wear the beret. You don't believe that you're an artist, so you aren't. You have to believe it."

The key to the student's drawing wasn't in his hand or pencil, it was in his mind. You have to start thinking like an artist—believing you're an artist. Commit your mind, and your drawings will follow. Sometimes I think we're like the scarecrow in *The Wizard of Oz*, and just need a diploma to validate us. We talk about being an artist as though it were something that we would arrive at one distant day with a

grand ceremony. Well, it's not. We don't need to wait. You are an artist (dancer, chef, poet, painter) now. You may be a novice, you may be flawed, you may need to get better than you are, but welcome to the human journey.

When you read about the "highly creative person," it's easy to think of that person as someone else. We jump at the chance to celebrate the creativity of others who were born creative, yet stop short of celebrating the creative spirit that lies within ourselves. Every trait of a highly creative person is a trait that you possess. The challenge is to engage your mind and start thinking of that highly creative person as you.

Access

Our human condition is based on access. Our ancestors survived because they had access to food, water, mates, and shelter. Then they thrived because they had access to the best weapons and horses, or the best books and universities. We are held back or set free by our ability to access things—knowledge, information, political power, dark chocolate. In our pursuit of Aristotle's happiness, what we all need in one way or another is access.

Business is built on access to people, ideas, money, and the marketplace. If I can get access to some clever and interesting people, they will come up with an idea that will allow

me access to money from the bank, which will allow me to manufacture my idea and advertise it in order to try to access the consumer in the marketplace. If at any step along the way I am denied access either to the people, the idea, the money, or the market, I won't be doing so well. Access is everything.

If I want to make a movie, I need access to the best directors and the biggest stars. If I have access to Johnny Depp, then I will probably get access to the money and the distribution of the film. I probably won't have quite the same luck if I have access only to, say, Spencer Pratt, but then again, you never know.

Historically, people get and hold power by controlling access. This worked for Alexander the Great, Napoleon, Attila the Hun, and Bill Gates (not to imply that these four gentlemen have anything else in common). The rich and powerful in history knew that to maintain their edge, they had to control information and deprive their competitors, and in some cases the population, of any access to the world outside the boundaries of their country or empire. The battle to control information is still in the headlines in many parts of the world where access to Google is limited.

In the most extreme cases, people's demands for access to information, power, or truth have resulted in political revolution. The French, American, and Russian revolutions sprang from a desire for access to information.

For centuries, artists, writers, filmmakers, and even comedians have opened people's eyes to oppression and given the audience access to new ways of thought.

When Picasso painted his requiem for the bombed and burned Basque town of Guernica, he was opening our eyes to the horrors of war. When Dickens wrote *A Christmas Carol*, he educated the growing Victorian middle class in England on how to behave during the holidays. Upton Sinclair's *The Jungle*, Robert Altman's *M*A*S*H*, James Cameron's *Avatar*, or the comedy of Jon Stewart's *The Daily Show* have all brought social issues to the public in sometimes shocking but always accessible ways. The creative community has always been at the forefront of the demand for access.

Access has another, more personal effect on life. We are in the midst of an unusual time in history, when information is more readily available than ever before. There was a time only recently when the types of books, media, and art that were available to you depended upon where you lived. If you lived in the Los Angeles suburb of Bellflower, you had less access to information than if you lived in Paris or New York. If you lived in a rural area, you had less access than in the city.

In the Middle Ages, there was virtually no access to information unless you lived among the inner circle of aristocracy or the church. Then the advent of the printing press and movable type spawned an information boom. Even one generation ago, if you were economically underprivileged, disabled, or a single parent raising a child at home, it would have taken a Herculean effort to access any meaningful quantity of information beyond what was available in the local library. Now, people who live in the most remote sections of the planet can have access, with the aid of the

Web, to nearly every book, article, painting, and photograph known to mankind.

The foundation of higher creativity is learning, and learning comes from information. We have access to information, and so we have access to the building blocks of creativity. The only remaining obstacles are personal ones. We need to find the time—*make* the time—to learn. Whether your field is painting, finance, cooking, dance, music, whatever, the barriers to access are being removed, and the opportunity to learn, and hence to create, has never been better.

Words

Images are probably the most primitive primary mode of communication. The Chinese, Korean, and later Japanese script languages grew from graphic images. As our need to communicate complex ideas grew, words—both written and spoken—became fundamental to communication. We take them for granted, but we humans alone have developed written and spoken language, which is a huge step up from the communication skills possessed by any other primate.

Words are a very interesting commodity. They are pure symbolism. The letters d-o-o-r put together make us think of that wooden plank on hinges that we walk through to get to someplace else. Assemble the letters m-i-l-k, and we can't

help thinking of a glass full of, well . . . milk. Other words carry emotional power. The word *liberty*, for example, symbolizes a grand and abstract condition of humanity in a fairly simple seven letters. *Love* is a highly symbolic word, too, as is the word *family*. They are words that are charged with meaning.

Some activities can't be described with just one word, and so we've invented alternatives. For example, one can be drunken, soused, blitzed, smashed, pickled, pissed (in British English), besotted, crapulent, crapulous, or inebriated. And one can vomit, barf, disgorge, heave, puke, retch, spew, throw up, call Ralph, yell "Wyatt Earp," call Charles Barkley, blow chunks, Technicolor yawn, and talk to God on the big white phone. Other human activities are so basic that they can be described only in one perfect and all-inclusive word. For example: *polka*.

Words fall easily into patterns, and we like that. For example, here are some words that fit comfortably together in groupings:

- Words denoting rest: safe, home, friend, dad, beer, eat, bed, nap
- Words denoting unrest: crazy, lunatic, insane, nuts, wacko, mad, odd
- Words denoting undress: panties, pj's, undies, T-shirts, briefs, boxers
- Words of affection: kiss, hug, squeeze, cuddle, embrace

- Big-concept words: life, light, love, devotion, loyalty
- Spiritual words: God, faith, spirit, angel, soul, hymn, holy
- Confrontation words: fight, yell, hit, slug, shout, push
- Words denoting trust: promise, guarantee, assure, ensure, safe
- Words denoting mistrust: fraud, fake, phony, bogus, slimeball, sleazebag
- Shopping words: bargain, shop, sale, item, buy, tag, price
- Words denoting appeal: beg, plead, cajole, implore, pray

As with a painter using colors and values in a painting for visual effect, the way in which a writer puts words together into sentences will make us feel comfortable or uncomfortable depending on the assembly. A sentence with groups of words on the same topic, for example, is rarely shocking. Here's a sentence about shopping that contains no surprises: "When I shop for a bargain, I always look for a sale item to buy and always check the price tag."

Well, then, that certainly was a perfectly useful combination of words, without much tension. You can make a sentence a little more interesting by using words from opposing topics. Here's an example using words about rest and unrest: "It sounds crazy, but I always feel oddly safe at home drinking beer with my wacko dad."

It makes sense and communicates the idea completely, with a little tension and poetry. In order to create unease with words, let's combine some words, still from the lists above, but in a random and unexpected way that mixes words from many groups to unsettling and unexpected effect: "I felt crazy sitting home in my boxers yelling a hymn at God, begging him to guarantee me life."

Each word pulls us in a different direction. The combination of words is unexpected, and so it makes you listen and try to understand. There is an uncomfortable tension in this juxtaposition of words. Here are some more provocative thoughts using words that contradict one another and inspire us to think: "I yelled at the insane angel that was my dad. His life was a mad fraud, a holy home for beer and bogus devotion."

The English language is a living, breathing organism— a flea market of words from every era. "Wiki-language" would be a more appropriate way to describe it, with everyone contributing to a constantly changing warehouse of words.

Latin-derived words like *candle*, *belt*, and *wall* mingle with Anglo-Saxon words like *earth*, *food*, *sleep*, and *sing*. The Latin-derived words *fork*, *spade*, and *rose* seem quite at home with the Norse-derived words *anger*, *awkward*, *cake*, and *egg*. In 1066, the Normans invaded England, and brought with them the linguistic influence that led to the coinage of such English words as *crown*, *castle*, *court*, *parliament*, *army*, *mansion*, *gown*, *beauty*, *banquet*, *art*, *poet*, *romance*, *chess*, *colour*, *duke*, *servant*, *peasant*, *traitor*, and *governor*.

As the universities of Oxford and Cambridge were

established, new Latin-influenced words appeared: *history, library, solar, recipe, and genius.* From the world of exploration and trade came words including *carnival, macaroni,* and *violin* (Italian-derived); *harem, jar, magazine, and sherbet* (Arabic-derived); *coffee, yogurt,* and *kiosk* (Turkish-derived); and *tomato, potato,* and *tobacco* (Spanish-derived).

And finally, we have added thousands of modern words and expressions of our own: *gas mask, miniskirt, dim sum, cappuccino, weirdo, Web site, ringtone, spyware,* and *gastric bypass.*

Shakespeare must have loved putting words together. He was like a phrase machine. If one guy was able to be that innovative with language in the sixteenth century, then why can't *we* be more innovative? Here are a few examples of what Shakespeare gave us:

all that glitters is not gold (*The Merchant of Venice*)

bated breath (*The Merchant of Venice*)

dead as a doornail (*2 Henry VI*)

eaten me out of house and home (*2 Henry VI*)

good riddance (*Troilus and Cressida*)

in a pickle (*The Tempest*)

in my mind's eye (*Hamlet*)

laughingstock (*The Merry Wives of Windsor*)

neither rhyme nor reason (*As You Like It*)

one fell swoop (*Macbeth*)

play fast and loose (*King John*)

pomp and circumstance (*Othello*)

wear my heart upon my sleeve (*Othello*)

what's done is done (*Macbeth*)

what the dickens (*The Merry Wives of Windsor*)

wild goose chase (*Romeo and Juliet*)

the world's my oyster (*2 Henry VI*)

You start to get the idea from Shakespeare that words are more than just a necessary conduit for communication. They become a medium for expressing complex emotions. Like oil paint and clay, they can be molded and manipulated to express concepts that supersede the literal meanings of the words.

The symbolic quality of words extends to the names we have chosen for the elements of our world. A name is an incredibly powerful label that can conjure up deep feel-

ings. We're not so willing to give our children silly names. We prefer popular and noble names like Matthew, Jake, Emma, and Olivia to Stumpy, Toad, and Moon Unit.

And who wouldn't want to be friends with the Goodman family, the Dearborns, or the Brainard family? Yet we're not so sure about Steve and Cindy Hitler, or the Judas family.

When developers name their housing tracts, they draw on images that evoke comfort and peace. It's easy to name a housing development. First, pick a word from the left side of the following list, then combine it with any word from the right side of the list to create a name for your new neighborhood:

North	Brook
South	Hills
East	Peak
West	Ranch
Fox	Tree
Saddleback	Ridge
Oak	Park
Sunset	Pines

Wouldn't you be happy living in North Hills, Foxbrook, or Saddleback Peak? I'd love to shop at the Oakpark Mall. And for extra credit, just add the word Estates after your new name. It makes anything sound classier: Saddleback Peak Estates. These words conjure up home and hearth much more than Motley, Goobertown, or Lickskillet (yes, these are all real town names).

You can also use the same handy method for selecting the name of your new technology company. Combine a word on the left with any suffix on the right:

Data	com
Pix	net
Micro	link
Digi	soft
Fibre	logic
Trans	scape

Each time, you come up with a perfectly useful name like Datanet, Microlink, Digicom, Fibrescape, or Transnet—all symbols of a smartly aggressive technologies company.

You can play high-testosterone Hollywood producer with a three-column process that not only names your new summer action movie, but also helps you pick a male star for marquee value. Combine a word from the first column with any word from the second column and any star from the third:

Brave	*Peace*	Daniel Day-Lewis
Days of	*Hope*	Denzel Washington
Lethal	*Power*	Leonardo DiCaprio
Absolute	*Impact*	Robert Downey Jr.
Wild	*Strangers*	Will Smith
Future	*Darkness*	Matt Damon
Tough	*Thunder*	Jackie Chan

Heck, I'd pay good money to see Robert Downey Jr. in *Wild Strangers* or Denzel in *Brave Hope*. I'd love to see Will Smith in anything: *Tough Peace, Lethal Impact, Days of Darkness*.

Workplace jargon can evoke deep feelings of comfort and familiarity and a sense that we belong to an exclusive tribe—a shorthand style of communicating within a given profession. Trade jargon also helps us feel like we're part of a tribe. It serves to identify and separate the insiders from the outsiders. The equine industry (horse breeders) has geldings, studs, yearlings, foals, Arabians, grays, and sires. The film industry uses jargon like best boy, gaffer, clapper loader, inkydink, pork chop, Foley, and vizdev.

There are occupations that for some reason never developed their own jargon and so adopted the jargon of another trade. Bankers stole their jargon from plumbers: cash flow, dried-up capital, fluid economy, take a bath, down the drain, float a loan, flood the market, launder money, liquid assets, siphon funds, get soaked, and freeze assets.

Stand-up comedy borrows its jargon from the language of fighting: he was a riot, she's a scream, you crack me up, I got a kick out of him, I bombed. There is slapstick, a gag, a punch line, and, finally, such fatal phrases as "I was dyin' out there," "You were slayin' 'em," "You killed 'em," and "You knocked 'em dead."

Then there is the world of business and management, whose jargon has become so boring (task-oriented, cross-utilization analysis, synergistic multisourcing, vertical interface, seasonal downsizing) that most people prefer to discuss

business in jargon stolen from baseball: I want to *pitch* you a *screwball* idea of mine. If we expect our customers to *play ball* with us, we need to *step up to the plate* with some *big-league* ideas. I'm not *keeping score* here, but lately our *heavy hitters* have been *striking out* with our customers. We always seem to *field* their requests like a bunch of *rookies,* and we certainly took our *eyes off the ball* again this year when we had a chance *at bat.* It's my goal to make *major-league fans* out of our customers. I realize that parts of my new business plan will be *home runs* and parts won't even make it to *first base,* but as long as 'we can continue to *spitball* new ideas, then I think we'll be able to *play hardball* with the competition and *score big* with our customers. I'd like to *touch base* with you on my new *game plan* for our product *lineup.* I hope you don't *balk* at it because I think it's a real *game changer.*

Words are highly symbolic and emotionally charged vehicles with which humans communicate, and they can be both a powerful tool or a horrible hindrance if we don't master their power. Just ask BP CEO Tony Hayward, who, at the height of the Gulf oil leak disaster, said these unfortunate words: "I want my life back."

2.

Passion

Write while the heat is in you. The writer who postpones the recording of his thoughts uses an iron which has cooled to inflame the minds of his audience.

—Henry David Thoreau

Nature's Creative Mechanism

When I was in kindergarten, my personal brand of creativity centered around gluing colorful macaroni to my dad's cigar boxes. When I started growing older I learned that I could create using tools. First I learned about poster paints, paste, and blunt-nose scissors. I learned that you could make

paste from flour and water and make a snowflake by cutting notches in a piece of folded paper. Then one day I started learning how seeds sprout, how birds lay eggs, and how bees pollinate—nature's creativity.

For me, life changed at the age of 13 when I took note of my dental hygienist, Miss Welch, wearing lipstick and showing considerable décolletage as she X-rayed my bicuspids. No more macaroni and cigar boxes for me! I had discovered nature's creative drive, and I visited the dentist more frequently than any other kid just to get a renewed glimpse of Miss Welch.

Now, I feel eminently qualified, being a cartoon producer and all, to comment on most aspects of human sexuality in an authoritative way. For example, I can tell you with some certainty that nature's creative process can be easily divided into five parts.

Step 1. The Spark (also the glint, the gleam, or that frisky feeling)

Step 2. Conception (you figure it out)

Step 3. Gestation (months of anticipation and nest building)

Step 4. Birth (painful but exciting)

Step 5. Twenty Years of Grief (raising the baby, also painful but exciting)

The same process works for the lesser animals, except that there it involves considerably more bobbing of heads and showing of plumage, and animals forgo the twenty-years-of-grief

part, opting instead to kick their young out of the nest, or in some cases to eat them. This creation thing also works well for plants: find a fertile patch of soil, plant a seed, water, tend, and voilà—rhubarb.

Astonishing Results

As I mentioned, when I was thirteen, things started changing big time. I became acutely aware that I was not a kid anymore. I couldn't have cared less about paste and blunt-nose scissors. My voice became lower by the minute, and although I didn't sprout a full beard by lunch like some kids, I did have to shave every third or fourth day! It was about that time that I started to notice the three basic siren calls of a teenage boy's life: cars, girls, and insanely loud music. (The kind with lots of deep, deep bass—more bass than Jerry Bruckheimer at a Fifty Cent concert. The kind of bass that doesn't exist in nature, except possibly in volcanic activity or planetary implosions.)

I answered my first siren call by buying a 1967 Ford Galaxie 500. I didn't know what the "500" meant, but it sounded big, like the Indianapolis 500. It sounded loud and dangerous. It sounded like men. Nothing is linked more directly to a man's identity than his car. It is a two-thousand-pound, shiny, quivering steel symbol of everything he stands for. I don't think girls have the same feelings about their

cars. They seem to think of them as a form of—get this—transportation.

For a man, a car is a gas-burning Pegasus, anxiously champing at the bit to fly us away to Olympian boulevards yet unexplored. Since our lizard brains are easily distracted by chrome, men seem to attach themselves to major appliances in a way that women would never dream of. It starts in puberty when we men will, as the Scriptures exhort us to, "leave our mothers and cleave to our cars, boats, and flat-screen televisions."

A few years ago, I went out looking for a flat-screen TV. I had lived quite happily with a nineteen-inch television set for years but felt the pressure that all American males feel when the other guys at the office replace their television sets. Most everyone else had at least a thirty-two-inch screen at home, and one of my best friends had just purchased a mind-numbing fifty-inch 1080 LCD model. Wow, fifty inches! My impressionable middle-aged head wandered into a glassy-eyed rhapsodic state as I suddenly flashed back to my seminal big-screen experience at the Rosecrans Drive-In Theater. I shook it off and left immediately for the appliance store.

Mine was the kind of electronics superstore that was populated by smiling squadrons of commission-seeking salesmen in blue polo shirts. In the television department there must have been a hundred television sets large and small, all tuned to an LA Lakers basketball game. It was an amazing sight. There were a hundred Kobe Bryants shooting from the top of the key. The commercials featured a hundred cans of

Bud Light being brandished by a hundred incredibly thirsty-but-handsome men. On a fifty-inch set, Kobe was huge. His head was the size of a bison's, and the surround-sound system had the biggest subwoofer I had ever seen. It would have liquefied my spine had I stood any closer. These big-screen models ooze testosterone, and I was sprouting a full beard just by standing there.

A salesman wandered up and asked if I would like to try one out. "Sure," I said confidently, sounding as though I had just been asked to test-drive a Bugatti. There were no controls on the screen itself, just a sleek black rectangle. I was handed a remote control that could certainly do anything a man wanted to do from a sofa. I flipped from image to image, past cooking, home remodeling, and news. I finally came to rest on some sort of infomercial as the salesman began telling me about some of the television's other features. But his spiel ground to a halt as we both noticed what the infomercial was about. There on the screen was what appeared to be an enlightened woman who was selling audio CDs about how to have a better sex life at home. She was fielding tough, unbiased questions from a tough, unbiased host who had been hired to ask her stumpers like, "What exactly is it that men are looking for in bed?" The lady always seemed to have the answers to his questions, and, in a well-prepared, spontaneous response, she would articulate with great enthusiasm and in vivid, G-rated detail the particulars of what men wanted in bed. And I had thought *I* had an interesting job.

After each answer, the tough, unbiased host would sit on

the edge of his seat, furrow his brow, and reply, "Interesting." Damned right it is! If there is one thing that can attract the attention of a group of people in an electronics store, it's an infomercial on human sexuality. The lizard brain in us can't resist.

Infomercials are like car crashes to me—they're horrible, but I can't look away. And by the look of it, neither could the studio audience, who seemed to sit on the edges of their seats, all with that paid-to-look-fascinated expression.

Now, all I really wanted to do that morning was buy a television, so I did my best to tune out the infomercial and listen intently to the salesman as he gathered his thoughts and resumed telling me about all the features of this television set. In doing so, he began to crank up the volume to demonstrate the stereo speakers. But the volume switch must have been stuck, and the sound slowly swelled louder and louder. Car alarms went off in the parking lot, and just as the volume reached an unbearable level, the lady on the infomercial said, ". . . and sometimes all the man wants to do is caress her buttocks." Everyone in the store turned and looked at us. It's not every day you hear the word *buttocks* spoken so loudly that it would drown out the roar of a Blue Angels flyby.

The salesman's cell phone rang, and he went to answer it. I was left standing alone in front of what now seemed like the biggest and loudest television set in the Northern Hemisphere. I moved to turn down the volume, but the salesman had taken the remote control with him. The other people in the store looked on with disgust as I stood there alone,

three feet from the screen, where the host began questioning a couple who had used these CDs, "and with astonishing results." (I don't know about you, but I rarely associate astonishing results in the bedroom with a CD unless it involves a few Marvin Gaye songs.)

By now, a small crowd had gathered, wondering who I was and why I was not watching the Lakers like everyone else. Aside from the discomfort inherent in the situation, this was of course one of those mornings on which I hadn't felt like showering, and had just run out the door wearing ripped shorts, filthy old tennis shoes, bad hair, and a T-shirt emblazoned with FREE HIGH FIVES!

The salesman returned and I asked him, through politely clenched teeth, if he could change channels and turn down the volume a little bit. I decided that nineteen inches was big enough for my televiewing needs and excused myself from the showroom, trying to avoid eye contact with anyone.

I noticed something that day. Everyone in my electronics store seemed interested in the dynamics of the sexes. And since the demographics of my electronics store are statistically aligned with the demographics of the entire planet, I can only surmise that all people are interested in sex. The relationship between man and woman and the reproductive act itself represents our species' creative and rejuvenating mechanism, and that's why we're so interested.

Death and reproduction are nature's change agents, and on a very reptilian level, our desire to reproduce is perhaps the most fundamental expression of our desire to create.

Expressions

Growing from a child to an adult makes for big changes in life. Once upon a time, we would play hard from morning till night, and our brains grew rapidly with each connection, each stimulation. As children we were willing to sing, dance, and sneak into bed with a colander in our pants, but now, as adults, day by day, little by little, we start to edit ourselves. We fear embarrassment in the presence of our peers. We try to decide how we fit into socially acceptable jobs or situations. We want to be adults, and so our play turns slowly to work. We forsake toys and teddy bears for basics like food, shelter, and a venti nonfat latte.

But even the lowest animals seek these basic things (except for the venti latte). Remember again that we are separated from the rest of the animal kingdom not because of our opposable thumbs and hairless bodies. We are different not only because we eat sitting down or because we have a predisposition to enter the Publishers Clearing House Sweepstakes. We are different because we create. We create beyond the fundamentals of food, clothing, and shelter and into the soaring and spiritually enriching arenas of music, fashion, art, and architecture. We create because we have to. It's what we do. Every day, our senses bombard us with a spectrum of impressions. These impressions imprint powerfully on our souls. We can keep these impressions inside, where they build

up and clog our drains, or we can spill them out in wonderful, flowing expressions of how we interpret life.

We are meant to express the way we feel about life. It's like breathing: inhale the experiences of life, exhale how you feel about them. We are at our best when we can turn our impressions into expressions. The equation goes like this: impression without expression equals depression.

The truth is that if we suppress our inner editor, we can express ourselves in natural and uninhibited ways. Our human creative pattern flows naturally and in much the same way as nature's creative process flows: from spark to conception to gestation to birth. The natural process of creation happens constantly. All around us, trees and animals and mountain ranges spring up from the chaotic soil. Creation is not just some distant prehistoric event that God accomplished in seven days. We are in the midst of creation now. It's a ubiquitous constant that surrounds us every day of our lives.

We are wired from birth to be creative, just as the world around us is inherently creative. But sometimes, as our thoughts become more sophisticated, we try to intellectualize the creative process—a process that, in childhood, we used to know instinctively.

Look again at what's been written about the creative process. The textbook description of the creative process is often patterned on nature:

Step 1. The Idea (same as the Spark)

Step 2. Immersion (similar to Conception, but not as much fun)

Step 3. Incubation (Gestation without the morning sickness)

Step 4. The "Eureka" Moment (the Birth)

Step 5. Verification (the Twenty-Years-of-Grief part)

Great path of action, but it's important not to take these steps too seriously. We create a million times a day without thinking about it, and we frequently create in ways that don't fall into a five-step process. Maybe creation should have more steps to the process. Being imaginative and creating is a very personal, nonlinear process. In other words, it doesn't happen in a straight line, and no two people do it alike. Below is yet another set of steps involved in the creative process. I include them to say that it's okay to travel down these numerous side roads during your creative journey. See if any of these sound familiar to you:

Step 1. Anticipation—hunting

Step 2. Preparation—gathering

Step 3. Hesitation—the fear

Step 4. Frustration—dead ends, roadblocks, and potholes

Step 5. Constipation—full of information and anxiety but no breakthrough

Step 6. Improvisation—try all the possibilities

Step 7. Procrastination—avoidance

Step 8. Immersion—time to think, time to absorb
Step 9. Inspiration—the birth of a solution . . .
 eureka, creativity!
Step 10. Perspiration—the hard work of discovery

Anticipation

Leap, and the net will appear.
—John Burroughs

From some mysterious place comes a germ of an idea. It may come in the guise of a goal ("I want to write an opera" or "I want to make a curry") or it may come in the form of a question ("What would happen if I dropped this piece of rubber on the stove top?"). It may even begin with the siren call of possibility. A blank piece of paper, a dinner plate, or an empty parcel of land can call us to action simply because they represent boundless possibility and are waiting receptacles for the products of our imagination.

There is a moment of commitment in the creative process. Pretend you're a skydiver. The defining moment in writing, cooking, architecture, or dance is when you decide to leave the safety of inaction and leap into the void. The courage and willingness to jump into that void and feel the rush of the wind in the hopes that you will be able to spread your

wings and fly . . . that is the touchstone of the creative process. We've got an idea, and we are flush with anticipation. Our minds race with the possibilities.

We leap.

Preparation

> Prepare at the highest level.
> Practice at the highest level.
> Play at the highest level.
> —Pete Carroll, former USC football coach

For Pete Carroll, these three lines are an inseparable truth. If you want to win games, and win constantly, you have to prepare and practice at the level at which you expect to perform. What works in football works in painting, writing, and filmmaking. Can you commit at the outset to approaching your preparation and practice with the same zeal that you plan to show on game day? Can you study great painters, and then bring that information to the field when you mix paint and examine color relationships? If you can do those things, when you approach the canvas or the blank piece of paper to create a final work, you will be filled with strong, confident purpose. You will be able to play, paint, or write at the highest level because you have built your creative life on a strong foundation.

Preparation assumes an intellectual openness to all possibilities, regardless of how far-fetched or contradictory they may seem to your present knowledge and belief. It also assumes an emotional and physical readiness: a taking stock of yourself to know where your strengths and vulnerabilities lie. To prepare is to be like a sponge ready to absorb.

Our emotions are fed by endless sources. Part of your preparation for a creative journey is seeking out those sources and opening yourself to their gifts of inspiration. Picasso said, "The artist is a receptacle for emotions that come from all over the place: from the sky, from the earth, from a scrap of paper, from a passing shape, from a spider's web. That is why we must not discriminate between things. Where things are concerned, there are no class distinctions. We must pick out what is good for us where we can find it— except from our own works. I have a horror of copying myself, but when I am shown a portfolio of old drawings, for instance, I have no qualms about taking anything I want from them."

We prepare by reading books and watching films; we prepare by studying manuscripts and visiting galleries. And there is another kind of preparation that Picasso alludes to. We prepare by being open to influences of all kinds. In that way, a spider's web or a scrap of paper can be just as inspirational as a Degas drawing or a quote from Voltaire. We prepare not only by studying within the bounds of our craft, but also by searching across disciplines for a broad base of inspiration. It's a sort of creative cross-pollination. In a lecture at Harvard,

Leonard Bernstein used the evolution of spoken language to help clarify the evolution of modern musical harmonies. Marcel Proust used the memories of food and the senses of taste and smell to inspire vivid literary pictures of his youth. Frank Lloyd Wright used inspiration from Mayan art to make his textile block building designs.

I like the football team that prepares for the season with ballet classes. I like the painter who listens to Miles Davis before she paints. I like the architect who hang glides in order to understand space. Music inspires dance. Dance inspires sculpture. Sculpture inspires architecture. Architecture inspires business. Business inspires mathematics. Mathematics inspires science. Science inspires theology. Theology inspires singing. Singing inspires poetry. Poetry inspires painting, and on and on and on.

Hesitation

Hesitation is a very strong and dominant human reaction. It probably stems from the days when we wore animal pelts, carried clubs, and had to decide in a split second what to do when suddenly faced with an angry bear the size of a bus. Hesitation was a method of survival that gave us a brief moment when we could choose to fight the bear and risk death or run from the bear and risk death. This fight-or-flight

reaction—this moment of hesitation when we decide whether to stay and attack or run away—is still working well in modern times and comes in handy when facing an assailant such as a vicious dog, a burglar, or a mime.

The fight-or-flight response also comes in handy when facing the creative process. It helps us make an intuitive assessment of our work. Is an idea worth running towards, or should we just walk away? Do we really want to live with this idea for weeks to come? Can we devote the time to preparing and practicing at the highest level possible so that this idea will work?

The other part of the fight-or-flight response comes when we freeze up. When presented with a threat, many animals just freeze in their tracks as a defensive maneuver. Humans can do this, too. It is a useful physical response when we're faced with an explosion or an earthquake, but if we freeze too long, it can be a deadly response.

It's natural that we freeze when we are at a crossroads in our life. By saying yes to one choice in our lives, we are by default saying no to many others. We may decide to return to school and follow a course of study, but at the same time we are saying no to a steady income. We may move away from the comfort of our homes, only to say good-bye to the relationships and comforts to which we have grown accustomed.

We call it fight or flight, but in reality we should call it fight, flight, or freeze. All three reactions are valid responses that keep us alive during times of crisis, but in our creative

lives the freeze response, if left to go on too long, turns into stagnation. You can't steer a ship that is not in motion. Freeze, yes, but only long enough to know what your next move will be.

Constipation

Sometimes during the creative process we take in loads and loads of information and inspiration and seem ready to explode, but nothing happens. The idea that all of this preparation may yield nothing can be incredibly frustrating, not to mention uncomfortable. Creativity is a process of sometimes long periods of incubation. The ideas don't always flow smoothly, and at times even preparation and practice won't spur a creative breakthrough. Recognizing this sort of creative logjam is important. Your head probably won't explode if an idea doesn't emerge, but it's crucial to have the faith that one day a breakthrough will most certainly come. It's so easy to give up at this stage and abandon your project, but it's important to dominate your ideas, rather than let your ideas dominate you. You need to hang in there and keep trying.

There was a scene in *The Lion King* that wasn't working very well. It was a scene in which adult Simba returns secretly to Pride Rock with Nala, Pumbaa, and Timon. The scene starts with Simba asking his buddies to create a diversion. In

an early version, Timon and Pumbaa do a vaudevillian soft-shoe routine and banter with each other:

> **TIMON:** Hey, Pumbaa, it looks like you've put on a
> few pounds.
> **PUMBAA:** Yep, boy, I ate like a pig.
> **TIMON:** Why, you look like you could feed a family
> of four.

> *Etcetera.*

The scene brought forth smiles but not laughs, and we needed a big laugh at that point in the movie. It was the last chance for some shtick before we launched into the very dramatic third act.

So late one night, the directors, writers, and I held some pizzas hostage in our tomblike story room, trying to find a better gag. About an hour later, we had consumed enough pizza to feed the entire population of Saddleback Peak Estates. We had done nothing particularly creative with our time, save for the little happy face we had made with pineapples and olives on the last remaining slice. We were all incredibly constipated (and here I speak metaphorically, even though we had each consumed a metric ton of cheese). We stared blankly at the last happy slice of pizza and hoped it would speak to us. We couldn't come up with a good idea.

"What if Timon has a cowboy hat on and Pumbaa's on a barbecue?"

Silence. We stared at the pizza, but it offered no wisdom.

"What if there's this big banquet table and . . . naw . . . oh, how about a backyard barbecue, and Timon could wear a big chef's hat and an apron that says KISS THE COOK."

More silence.

Then, in a moment of divine intervention, the pizza finally spoke. It shouted, "Hey, how about a luau?" We started to laugh a crazy, what-a-stupid-idea laugh when the directors stopped and said, "Hey, how about a luau?"

We realized we could do a luau with Pumbaa as the suckling pig and Timon as the hula-dancing pitchman. We cobbled together some lyrics for a hula, then grabbed an empty five-gallon water bottle for a drum and an animator who had a ukulele in his room (more common than you would think) to try out the song.

> *If you're hungry for a hunk of fat and juicy meat*
> *Eat my buddy Pumbaa here, because he is a treat.*
> *Come on and dine on this tasty swine.*
> *All you gotta do is get in line.*
> *Are you achin'*
> *For some bacon?*
> *He's a big pig, you can be a big pig, too. Hey!*

It wasn't Shakespeare, but it made us laugh. The next week, we recorded Nathan Lane singing the song. He also recorded the lines that led into the song, which went something like this:

TIMON: How we gonna distract these guys?

SIMBA: Live bait.

TIMON: Great idea! *(there is a beat of realization)*
 Hey!

SIMBA: Come on, Timon, you guys have to create
 a diversion.

TIMON: What do you want me to do, wear a skirt
 and do the hula?

About five takes later, Nathan got bored with the last line and blurted out, "What do you want me to do, dress in drag and do the hula?" Luckily, the tape was still running, and we knew we had a scene.

Timon would say this line and we'd cut ahead in time to him wearing a grass skirt and singing about his delicious buddy Pumbaa. We wanted to use the melody from an old Hawaiian war chant. The music attorney had warned us that it would cost a lot since another music publisher owned it. This was going to need to be one big gut-buster for it to be worth the cost. But we still wanted to try it at the next audience test screening.

When the night of the preview came, we gathered in the lobby of a nearby theater and watched as the audience filed in. Our fate was in their hands. It must have been what it feels like to be a defendant and watch the jury take their seats, except that the legal system discourages popcorn and nachos in the jury box. We had refined the movie in many spots, added laughs, and cut our fat, but the question of the evening was, will the luau gag work?

The lights went down and we took our seats in the back of the auditorium. The movie played really well, and as we approached the scene of the luau gag, my stomach was in knots. Were we nuts? What was so funny about a meerkat in a grass skirt? When it came time for the scene, I closed my eyes and wrapped my hand around the cup holder in my seat as though I were on a catapult about to be launched at the screen at high speed if the gag didn't work. Timon said his "dress in drag" line, and the ensuing laughter drowned out most of the lyrics to the hula song. We had our big laugh and I could unpeel my fingers from the cup holder, all because of some cold pizza, desperation, constipation, and, eventually, inspiration.

Improvisation

Improvisation is something we normally associate with jazz musicians. Musicians take a line of melody, spin it around, and make it their own. Great cooks improvise, great writers improvise, dancers, lawyers, actors, magicians, and painters all improvise.

Picasso said, "A picture is not thought out and settled beforehand. While it is being done it changes as one's thoughts change. And when it is finished, it still goes on changing, according to the state of mind of whoever is looking at it. A picture lives a life like a living creature, undergoing the changes imposed on

us by our life from day to day. This is natural enough, as the picture lives only through the man who is looking at it."

So next time you set out to paint a landscape featuring a bunch of trees, and you follow the mobility of your thoughts and end up painting a portrait of the Thunder from Down Under dancers, realize that improvisation is at play.

Improvisation shouldn't be completely foreign to us. We improvise constantly in our everyday lives. We'll start out to do some errands, and halfway there our thoughts will change and we'll decide to stop for coffee. When we get back into the car, we'll remember we must buy stamps and stop at the pet store to look at the puppies. We wouldn't think twice about the freedom to change our plans when we go out to buy groceries, so why shouldn't we welcome the same freedom when we create? You'll still arrive at the grocery store, and even if you don't, it probably means that it wasn't important to go there in the first place.

All projects change in the course of their journeys. It's best to start with a plan and then expect accidents along the way—accidents that allow you to revise the plan, or to "plus" the plan and make it far better than when the journey began. Creativity demands that we be spontaneous enough to follow the merit of a better idea. Planning for spontaneity and improvisation can be tricky. It's hard to budget for and schedule a creative process that allows ideas to surface at any time, even late in the game, yet that's exactly what businesses need for innovation. The entire team, from top to bottom, needs to improvise together.

This may seem chancy and accidental. It may even seem lazy or irresponsible, but these "accidents" are the stuff of innovation. These improvisations allow us to explore new areas of our work. They encourage us to stop repeating ourselves and to reach out and explore new ideas. The way we deal with accidents reveals much more about us than does the way we deal with plans.

There was a day on *The Lion King* when Hans Zimmer had done a stirring arrangement of "The Circle of Life" in preparation for a singer to come in and record the vocals, but something seemed missing. We knew that to establish the African setting, we wanted a more indigenous sound from the first note of the film. Hans invited African singer Lebo M to the studio to try some experiments on tape. Lebo had been working as a valet-parking attendant, and Hans had used him to sing on an African-themed score a year earlier. At the time, Hans worked in an improvised space that he had carved out of the back of a nondescript industrial building on Santa Monica Boulevard.

The studio didn't even have a glass partition separating the recording booth from the area where the talent stood at the microphone. The room was stacked with boxes of tapes, and there were old guitars, a piano, and a table laden with Chinese food in the corner. It was in that backroom studio that Lebo put down his egg roll, stepped up to the microphone, and began recording. He experimented a few times to find something unique—a sort of tribal cry—and then, on the next take, out of nowhere, came the now-famous cry in the wilderness that begins *The Lion King*. It was improvised

quickly, crudely, and with little preparation, but it worked. It captured the mood of an entire film.

Singer Carmen Twilly came to the studio that night to sing the vocal track on "Circle of Life." By late that evening the crew had finished up all the moo shu shrimp, bang bang chicken, and kung pao pork, and Carmen had finished recording an extraordinary version of the whole song. At the time, Carmen's performance was meant to be used as temporary vocals that would eventually be discarded and replaced. For months, we listened to other singers, looking for a permanent vocalist for "The Circle of Life," but in the end we could never improve on Carmen's emotional delivery, recorded that night in a backroom studio on Santa Monica Boulevard. The setting was improvised—part recording studio, part storeroom, part Chinese bistro—but the work was electrifying.

The Physics of Procrastination

The scariest moment is just before you start.
—Stephen King

The hardest part of creating is sitting down to do the work. Procrastination (derived from the Latin *pro* or *forward* and *crastinus*, of tomorrow) is that impulsive, distracted, delaying mechanism that puts things off. It is a form of self-sabotage

that has less to do with poor time management and more to do with our coping mechanism for dealing with the fear-laden prospect of undertaking our work. Stephen King knows about scary, so if he thinks that starting to write is scary, I think we should listen to him.

I personally have a black belt in procrastination. It manifests itself with the strong and erroneous sense that my work is "under control" and that I'll sit down at the last minute and breeze through it. It's a total fantasy, but somehow I always fall for it.

Newton's laws of motion can be applied to human creative endeavor: an object at rest will stay at rest until acted on by some external force. There is nothing more "at rest" than an idea.

In my case, every ounce of my procrastination comes from one place: fear. I'm afraid of bankruptcy, both financial and intellectual. I'm afraid of being ridiculous, so I think I'll wait until I can figure "it" out and then I'll start.

Another part of Newtonian physics is that an object in motion tends to stay in motion until acted upon. My every-day life is full of thousands of objects in motion. This makes it even easier to procrastinate because, well, I'm a victim of physics. I love to travel, shop, eat out, watch TV, and consume low-fiber meals, all of which are lifelong habits with years of physical momentum behind them. They are big, fast-moving objects that are part of the kinetic fabric of my life, in stark contrast to the small and sadly stationary dream that can always wait until tomorrow.

Novelist Steven Pressfield says in his amazing book *The*

War of Art that most of us have two lives: the life we live, and the unlived life within us. Between the two stands what he terms *resistance*. It's that toxic, unrelenting force that pushes back when we try to assert ourselves. It's the same force that pushes back our dreams and makes it easy to give up, shut up, and go about our normal unremarkable existence.

If we believe that we have a destiny in life, our job is to find that calling and overcome the resistance. The opposing forces will scream at us, "You can't, you shouldn't, you're a fool and possibly insane." The opposition is unrelenting and unquenchable. Fall prey to it, and we lapse into mediocrity. We can't wait for opportunity to be given to us, or for the time to be right. The time is never right. Just go after it like a true warrior.

Immersion

Richard Williams is one of the most creative people I know. He carved out his career animating television commercials in London for twenty years while simultaneously working through the night on an animated film called *The Thief*. The commercials weren't his creative outlet, although they were full of ingenuity and brilliance. Dick wanted to make a film, and for twenty years *The Thief* consumed him.

Dick worked on his film in a most interesting way. Little

sequences would emerge, based on a character or a part of a story. He'd see a movie and become inspired, run home, and animate. The film progressed in this mosaic fashion.

The other thing Dick did was teach. In the prime of his career, he went to the cinema and saw Disney's *Jungle Book*, and upon leaving the theater said three words that every middle-aged man dreads even thinking about: "I know nothing." (There are lots of three-word phrases that middle-aged men dread—*lose some weight, trash night tonight*—but this one has to do with an all-encompassing fear: the confirmation of the fact that all your life you've been an impostor.)

Dick didn't collapse with this realization. He continued, with a relentless drive to learn. He found all of the surviving animators who had worked with Walt Disney or at Warner Bros. during the golden age of animation. He'd fly them to London on his dime for classes. When they wouldn't come, he'd send them sequences of *The Thief* to work on. Then, when they turned in their artwork, he'd study it and play it for himself and his close-knit team of animators.

I worked with Dick for two years on *Who Framed Roger Rabbit*. After spending a few weeks with him in the studio, it shocked me that this legend of animation seemed to do very little work. He'd come in in the morning and we'd talk a while. Then he'd take a call. Then, when faced with a deadline for designing a character, say Jessica Rabbit, instead of sitting at a desk and pulling out a pencil, he'd leave the studio. About an hour later, he would come back from the bookstore with loads of magazines and books under his arm and proceed

to pull out a pair of scissors and cut them up. Each clipping became an idea. That girl's hair, this one's eyes, that actress's body, or her dress. Dozens of clippings were made, and Dick would tape them to big white cards. I would offer to help, but he'd always say, "No, no, it's this thing I do, and I really have to do it."

I thought he was nuts. Why are we paying this director to cut out pictures and tape them to a board? But as eccentric as Dick was, he was smart. Really smart. He knew about immersion. He went on for weeks with this clipping-and-pasting routine. When he wasn't clipping, he was taking home cartoons and watching them until the early hours of the morning. When he wasn't watching cartoons, he was going out for coffee with Roy Naisbitt.

Roy was a master designer and special-effects artist who made his career working on Stanley Kubrick's *2001: A Space Odyssey*. But Roy and Dick didn't talk about movies when they went out. They'd order eggs on toast with coffee, and they'd talk about politics, the studio, the food, and Dick's favorite cornet player, Bix Beiderbecke. After the bill was paid, and just before they got up, Dick would invariably say, "Oh, I had this idea for a shot." They'd sit down again and, with borrowed pen and a napkin, Dick would sketch a few postage-stamp-size drawings.

Every Sunday Dick would roll out of bed, grab his cornet, and take a cab to Grosvenor Square where he played with an unlikely group of musician friends called Dick's Six. On Sundays, the Grosvenor House had a buffet brunch, which

seemed to feature only items that could be made with mayonnaise in bulk. There were peas and mayonnaise, carrots and mayonnaise, corn, cheese, and beets with mayonnaise. In the middle of the buffet, there would be a hot beef dish, some chicken, some fish, some lettuce, and then, in big crocks at the end of the buffet, more mayonnaise.

The Sunday brunch lured mainly tourists and hotel guests who had come to eat their fill at the buffet, drink free champagne, and listen to Dick and his band play jazz. And what glorious jazz it was. As far as I could tell, it was the only place on the planet where you could watch an animator play the cornet and consume a kilo of mayonnaise all for one low price. Once in a while, Dick would invite me to play drums for a set. It was heaven.

The point I finally understood after dealing with Dick's free-spirited ways and the manic "Where's Dick?" calls from the studio was that this was his process, and that it was every bit as valid a process as any artist's. The clippings, the eggs on toast, the cornet, and the mayonnaise were all somehow linked. It was Dick's way of preparing and it was preparation at its highest level. He drank up a big bucket of inspiration from every imaginable source, and then, often in the middle of the night, he would hover over his drawing table, where the drawings would leap like fire out of the ends of his fingers and onto the paper. His weeks of immersion, of idea gathering, would culminate in heaping torrents of nonstop work. The deadline arrived. The work got finished at an alarming rate of speed. It was all brilliant.

Inspiration

The moment of inspiration is magical: the moment when all of the input and research and frustration combine to create a spark, a breakthrough, a solution—the eureka moment.

This spark of inspiration can come quietly in the dead of night to a writer hunched over his keyboard. Or it can come like a skyrocket when an idea emerges from a collaborating group. Both are valid. Both are inexplicable gifts. I have a million ideas that waltz through my head on a daily basis but I dismiss most of them, simply because the ideas come from me. They can't be that good. Good ideas only come to Stephen Hawking or Simon Cowell—not to me. Read carefully what Ralph Waldo Emerson said about trusting your own inspirations and, more important, the consequences of ignoring them:

> A man should learn to detect and watch that gleam of light which flashes across his mind from within . . . yet he dismisses without notice his thought, because it is his. In every work of genius we recognize our own rejected thoughts; they come back to us with a certain alienated majesty. Great works of art have no more affecting lesson for us than this. They teach us to abide by our spontaneous impression with more good-humored inflexibility than most,

when the whole cry of voices is on the other side. Else tomorrow a stranger will say with masterly good sense precisely what we have thought and felt all the time, and we shall be forced to take with shame our own opinion from another.

Perspiration

One of the elements that unify the lives of extremely creative people is their capacity for hard work. Satisfaction lies in the effort, not in the attainment. Full effort is full victory.

—Gandhi

People who are seriously creating seem driven by some unseen force. They are absorbed in their work and will put in almost any number of hours to reach a breakthrough.

Hard work doesn't guarantee that anything will happen; it simply gives you better odds. Imagine if someone said that you would have a life-changing success but that first you would have to endure a hundred failures. Wouldn't you want to get to work and get those hundred failures out of the way? In other words: fail fast, fail often.

We most often think of hard work as being physical,

like throwing a pot or spending long hours on your feet in front of an easel. Dancers, actors, cooks, and musicians bring a physical element to their work. A painting, after all, is a sort of record of the painter's gestures. In a good restaurant, you can feel a chef's kinetic energy coming from the kitchen, and a violinist doesn't sit frozen during a performance. They are fluid and alive, endowing a meal or a piece of music with tremendous physical motion and emotion.

But other forms of creation are decidedly not physical. There are writers who labor in quiet isolation for years at a time. When we read their books, we can feel the energy that they've put on the page and we don't really think about their monastic work process.

The proceeds of our work aren't always immediately apparent. Robert Louis Stevenson said, "Don't judge each day by the harvest you reap, but by the seeds you plant."

To me the most challenging thing about my work is knowing when to move on. In the film business, there are release dates that force us to be finished. But I've never ever felt like any of the films I've worked on was actually finished. The feeling is more akin to abandonment. There was so much more we could have done on *Beauty and the Beast* to make it better. We could have worked harder at each drawing—there were some really bad drawings in the film. And we could have added more details like shadows and visual touches that would have added richness to the film. But you know what? We ran out of time, and in the end no one cared. The audience didn't see what we saw, and they embraced the film in every way.

What if we don't have a release date? When is our work over? When is a project finished? When do you walk away from a painting or a novel? Baseball great Yogi Berra said, "It ain't over till it's over," but I disagree. To me, it isn't over when it's over. Work continues. I have been working on some of my paintings for literally twenty years and they still don't seem done to me.

I have paintings that I consider outright failures. I abandon them. No one starts out to make a bad painting, but I've done more than my share of them. Sometimes they just look contrived, or I don't like the color relationships that are evolving on the canvas. Some paintings suck so bad that they'll end up in the trash or I'll Frisbee them over the back fence into the canyon below. Others will sit around for years, not bad enough to toss, not good enough to show. Occasionally I'll pick up an abandoned painting and take another stab at it, but more often than not, I will just dab away on it and crash it into the ground.

If I can bury my ego long enough, I look at these crashed paintings and try to do a postmortem of what went wrong. The failure is only as good as the learning that accompanies it. An honest postmortem on a failed piece is probably some of the most valuable work we can do as artists. The most valuable times at Disney are the postmortem meetings we have after a film is completed. We look at places where we could have done better and try to apply those learnings to the next film.

It ain't over when it's over. It takes hard work to give birth to a new idea, and even more work to turn that idea into a

tangible thing like a film or a painting. And then just when you think it's over, it takes more work and tenacity to stare at your creation, good or bad, and try to learn from it and move forward.

The Art of Reinvention

Now we have some sense of the creative process at play in our lives. This frustration-laden process is useful if we are faced with the task of inventing a solution to a problem. What happens, though, if we have reached some level of success and then watched our success fade, or even evaporate? How can we face the daunting task of reinventing ourselves, with reviving ideas that were once vibrant but have now grown stale? When confronted with these riddles of life, I forgo the advice of the great psychologists of our era and look instead to the food-service industry for the answer.

In the 1970s, dining out at a fancy restaurant meant the Monday-night steak special at the Sizzler steak house across the street from Bellflower High School. There, you could get the complete top-sirloin steak dinner, which included baked potatoes and their famous Texas toast (a piece of garlic bread the size of one of those cushions you take to the football game). This became a family tradition with us; once in a while, however, we were able to talk our dad into taking us

for international cuisine, which usually consisted of the five-for-a-dollar chimichanga night at Casa de Pepe.

I was jealous of my older brother and sister who, on their dates, started to go to more chic, grown-up places with names like Red Lobster, The Rusty Pelican, or The Cork and Cleaver. It was there, amid the macramé plant holders, Captain & Tennille Muzak, and menu filled with exotic things like mahimahi and artichokes, that you could find every man's dream entrée, the surf and turf: "a generous cut of prime rib served with fresh New England lobster tail, drawn butter, and a Texas-style baked potato [the size of a small child] smothered in butter and sour cream." And as if that weren't enough saturated fat, you could have a decadent dessert item with a name that sounded as if it came from a fundamentalist pulpit-pounding sermon on sin: devil's food cake, Death by Chocolate, Satan's fudge pie, Chocolate Madness, and lady fingers soaked in rum.

Then, a few years ago, something changed. Eating out got boring, the restaurant business sagged as people became more health-conscious, and the industry had to reinvent itself or be doomed to a lifetime of serving liver and onions to blue-haired ladies. Creativity hit the restaurant business in a big way. Out with the surf and turf, the garlic mushroom caps, the deep-fried cheese sticks, and the Texas-style anything. In with the shellfish-and-tiger-prawn paella with shrimp-tomato couscous, the wild boar bratwurst with horseradish cream and apple-walnut chutney, the crab falafel salad with saffron pita and red-pepper tahini with salsify chips, and the

sizzling Jamaican chicken sausage on a bed of baby chicory with shiitake-mushroom polenta. For a while I wasn't sure that I wanted to eat a baby chicory or, for that matter, anything with a name like shiitake. But what these adventuresome chefs were bringing their hungry patrons was food not just as sustenance, but as experience and entertainment, too.

It's easy to get seduced by this wonderful world of culinary hyperbole, where even a glass of water becomes "eau minerale served chilled with a citrus wedge in a Welsh crystal cylinder." The restaurant industry's blend of international ingredients, colorful adjectives, and showmanship has not only brought a lot of fun back to the experience of eating out, but has also crept into other industries, with interesting results:

- *Politics:* John Doe, candidate for senate, gentle-minded public servant with a dash of humility, seasoned with experience; no ordinary Texas-style politician [here, I guess, "Texas-style" is a negative].
- *Music:* His flavors of Brazilian samba are mixed with influences from flamenco on a bed of American jazz.
- *Cars:* Rich Corinthian leather [I prefer cow leather, but hey, I hear rich Corinthians are very soft and supple], with four Tiger Paw steel-belted radials and a sizzling-hot power train.
- *Insurance:* The comfort of reliable coverage with the

assurance of a family-run business based on pride, personal service, and integrity.
- *Movies:* A sizzling blend of white-knuckle action, high-drama thrill ride, and an age-old love story that will warm your heart while making your stomach churn.

Life is reinvention. The restaurant industry reinvented itself. The flip side is the music industry, which took so long to reinvent itself that somebody had to reinvent it for them, namely Napster and eventually Steve Jobs and iTunes. And so it is inevitable that you, too, will have to reinvent yourself many times during your life. It takes courage to admit that you may be becoming as obsolete as the macramé plant holders at the Rusty Pelican.

I love the words of French philosopher Henri Bergson, who won the Nobel Prize for his work and who achieved cult status during his lifetime, in the early part of the twentieth century. His work centered on what he called process philosophy, which emphasized change, novelty, and the art of becoming. This was contrary to much Western thought, which was based on a sense of uniformity and permanence. Bergson argued that the nature of life is deeply inspired by our immediate experience and our intuition. Intelligence, to Bergson, was not about book learning, but was, rather, intuitive, sensory, creative, and free.

Bergson said, "To exist is to change, to change is to mature, and to mature is to go on creating oneself endlessly." Change

as a process is painful, but it's a constant part of the human journey. Some will reinvent themselves willingly as a self-aware exercise, and some will be forced kicking and screaming into reinvention by the changing economy or the loss of a job. There may be a divorce or a death in your life. What then? Mourning? Yes. Time to reevaluate? Yes. Reinvention? Yes. Stagnation? Never.

Big Things, Little Things

Enjoy the little things, for one day you may look back and realize they were the big things.
—Robert Brault

Days are filled with uncountable acts of creativity. For example, this morning I did a painting on my iPad; by noon I had an idea for a new story; and by nightfall I had put a fine wax finish on my car and came up with a new recipe for tangy lamb shank (try saying that five times quickly). All of these acts of creativity brought joy to me and my family, and so I will continue painting and waxing my car for years to come. But will any of these creations change the world as we know it? Well, with the possible exception of my tangy lamb shank recipe . . . no.

You may look at creativity in this world on two levels. The micro level of daily creations would include things like my

fine car-wax job and my tangy lamb shank recipe. The macro level of creativity would include a creation that, as Steve Jobs once said, "puts a dent in the universe": Martin Luther's Reformation, Picasso's paintings, Jane Goodall's environmental activism. These macro works and macro artists are embraced by society for their visionary qualities. They change us, inspire us, and give us a new perspective on ourselves.

The micro level of creativity has to do with very personal satisfactions and joys. The macro level suggests innovations that become part of the culture, with the potential to change the way we perceive things or the way in which we live. It's important to understand that both macro and micro acts of creation have validity.

The small painting you do for your mom can have a more profound effect on her life than some dusty masterpiece hanging in a museum. Culture needs the macro masterstrokes of creativity in order to evolve. Things like the invention of the microchip, the motion-picture camera, and the refrigerator brought about global revolutions in the quality of life.

The human race has embraced many great artistic masterworks and celebrated stunning scientific discoveries, but it needs more than that. We thrive on the thousands of small, meaningful, and intensely personal innovations that the people close to us produce every day. The hand-knit sweater, the specially baked pie, the love letter. These micro works may not revolutionize the human race; they do, however, make important and lasting connections in our lives—personal connections to people close to us, via their creative gifts.

The breathtaking cultural changes brought on by acts of macrocreativity and the intimate personal connections brought on by acts of microcreativity are both crucially important to the quality of our lives.

Time

> Clocks slay time . . . time is dead as long as it is being clicked off by little wheels; only when the clock stops does time come to life.
>
> —William Faulkner

I can remember my dad telling me when he turned ninety years old that time was moving fast for him. His years were flying by, or at least so he said. And now that I'm growing older, I'm starting to get nervous. My years are flying by faster.

Some chalk this phenomenon up to perspective. When you are four years old, a year is fully twenty-five percent of your entire life. When you are ninety, a year is just 1.1 percent of your life. Imagine the endless journey a kid takes during one of the early years of her life. Trips to the store with Mom seem to take a monumentally long time.

There are great traditions that mark our lives as we pass through the yearly rituals associated with summer, the winter

holidays, the school semester, and so on. Soon we are like my dad—ninety years old with time roaring past. It seemed to him as if life were being played out on an endlessly repeated loop, and the years became indistinguishable one from another.

But I think we have more control over our perceptions of time than we know. When we are four, everything is new. There is little or no routine to our lives, and every day represents a challenge for our brain. As we settle into a job, a relationship, a house, a pattern of living, we stop experiencing the world as a new thing and we start seeing experiences as repetition.

We can work to control time, but it needs the same kind of really fresh and new daily input that we had when we were four. Try this for just one day: don't use a computer or a cell phone, take a different route to work, eat a food that you have never eaten, introduce yourself to someone at work that you don't know, take a nap in the afternoon, and try running as fast as you possibly can for five seconds.

This all sounds nutty, I know, but we will remember every moment of this day because we have had to think. No autopilot—we have to think about our drive and our food and the people we meet. I guarantee that it will be a day that you remember, and it will indeed slow down your perception of time.

Travel is another way to get me into that four-year-old space. It has many things in common with our "just one day" experiment, with the added bonus of being immersed in another language. Not only are the surroundings, food, and

people different, but now you can't understand them. When you've been gone from the routine of home and the endlessly repeated cycle of normal life, a sudden week in a foreign country seems like a month, and every day is loaded with experiences that will become memories.

Time is not a solid, immovable object. I like people like Edward VIII of England. The king ordered that all the clocks on the estate of Sandringham be set half an hour ahead of Greenwich mean time so that when it was noon in London, it would be 12:30 p.m. at Sandringham. He did this to make more time to hunt during daylight hours. The practice was only observed at the royal residences of Sandringham, Windsor, and Balmoral. It might have seemed foolish and eccentric to some, but it seemed very practical to Edward, who saw time as arbitrary and something to control.

Modern timekeeping divides our day into twenty-four hours. It wasn't always that way. The Romans used water clocks to tell time, but they used different scales of measurement for different times of year. At Rome's latitude, the third hour from sunrise (hora tertia) started at what would have been about 9 a.m. according to modern timekeeping, and lasted only forty-four minutes in the dead of winter. In summer, the third hour of the day started at the rough equivalent of 7 a.m., and lasted a whole seventy-five minutes.

When Ben Franklin was the American ambassador to France, he came up with a nutty idea that he published as an anonymous letter suggesting that Parisians "add" an extra hour of daylight to save on candles. He reasoned that if the

clocks were set ahead an hour in spring, there would be more sunlight time. A New Zealander named George Vernon Hudson put forward the modern version of that idea in 1895. He suggested that in the spring we set the clocks forward two full hours, so that midnight would arrive at 2 a.m.

Hudson pointed out, "In this way the early-morning daylight would be utilized, and a long period of daylight leisure would be made available in the evening for cricket, gardening, cycling, or any other outdoor pursuit desired." This is such a cool idea. Let's carve out time to pursue our collective happiness together, during the summer months, when weather is warm. Hudson knew that he couldn't just do this by himself. He needed all of society to go along with him if he wanted to alter work hours, train schedules, and times of going to bed or waking up. He enlisted a very modern argument: physical and mental health.

"In favor of the scheme," said Hudson, "special attention is directed to the saving of expense in the lessened employment of artificial light; the greatly increased health and enjoyment to the numerous classes, who are obliged to work indoors all day, and who, under existing arrangements, get a minimum of fresh air and sunshine; and the probable resultant increase in the health, morality, and happiness of the community."

Call it eccentric, insane, out of the box, or whatever, but he was onto something. Time, and especially the twenty-four-hour day, are fairly recent constructs, invented by humans for humans. It has little to do with anything in nature and a lot to do with factory hours and train schedules. I'm sorry, but your

brain doesn't really have to work that way.

And why stop at daylight saving time? Here's a new idea: why not ditch the standard twenty-four-hour day in favor of a day divided into twenty-five hours? An hour of this "new" time would be equal to 57.6 minutes of our current time. Seriously, are you really going to miss those extra 2.4 minutes? No, you are not. But add that 2.4 minutes to each of twenty-four hours and you pick up fifty minutes a day, or almost 350 hours a year. Three hundred and fifty hours—that's about eight days of additional time every year. Eight days! But wait, there's more. It would be eight old-fashioned analog days that you would recover. In the new, twenty-five-hour-day scheme, that would add up to exactly fourteen days—two weeks.

What is time, anyway? It's a regular, constant, and repetitive process to mark off equal increments of life. So, with this new twenty-five-hour day, your employer would still get you for forty hours a week. The hour would be a little shorter than it used to be, but who would care? And you'd pick up fourteen days, or 112 hours, every year. And as for the old twenty-four-hour clocks? Send them to the place where they put all the rotary-dial phones, VCRs, and old, fat TVs.

Here's the point to all this. Time is an arbitrary convention that we all agree to observe because it gives us order and helps us to play well with others. Let's allow ourselves on occasion to refuse to conform to the requirements of modern time and instead observe and listen to our own intuitive and much more interesting personal clocks.

If you need to sleep for twelve hours one night, do it.

If you need to sing for three hours, do it. If you need time to mourn a loss, take it. If you need a month to travel the world or shop for shoes, do it. Listen to and trust your own clock.

Alone

> This is my simple religion. There is no need for temples; no need for complicated philosophy. Our own brain, our own heart, is our temple.
> —the Dalai Lama

The focused time alone that is needed to create is something that only you can arrange for yourself in your life.

I'm addicted to going to the local hardware store. My trips are more than just errands. They are zones of peaceful thought, when time can stand still and I can give as much attention to the directions on a bag of fertilizer as I normally would give to a movie script. It is time to be alone with myself. A frightening thought for some, but for me, this time alone to rummage, without pressures or worries, through the bins of my hardware store is the food that feeds my creative spirit. With me it's hardware. With you it may be books, theater, politics, or cooking. Whatever your area of interest, it really doesn't matter. What does matter is caring for and

feeding your creative self in a truly personal way.

After almost two centuries of industrialization and middle-American work ethic, it's very hard to convince ourselves to step away from the day-to-day grind for an hour or so each week and drift with the wind. Our logical brain protests. We should be working, or at least balancing the checkbook or sorting laundry.

Once again, in the pressure of daily life, we continually undercut our abstract brain. Don't do it. Make time once a week to do something that you want to do, to recharge your creative batteries. Get away from your home or office and into a new environment. Here are the rules:

1. You don't need to ask anybody's permission.
2. You must go it alone. Friends, spouses, lovers, and kids are great, but not now. After making the obvious arrangements to care for your kids, spouse, or dependents (which is why they invented Top Ramen), leave them at home and go in search of images and experiences that satisfy you, and only you.
3. Make your date with yourself for a regular time so you are more likely to keep it. We are schedule-oriented, so go ahead and schedule at least two hours each week (yes, a whole two hours) to spend with yourself. If you don't make it a scheduled date, you'll miss the opportunity.
4. Use this time to take flight into the previously

unexplored. Do something different and challenging to your intellect. See an opera, eat eel, read Keats, learn to ski.

5. Make it a guilt-free zone: aside from the normal ethical and moral boundaries that you might want to set for yourself, go ahead, and don't feel guilty. Don't feel guilty that you spent an hour staring at the ocean. Don't feel guilty that you bought a favorite lamp at a junk store or spent two hours playing computer games. No matter what your logical brain may scream at you, it's not a waste of time.

6. Make it a censor-free zone: if you feel like joining an improvisational acting class, your logical brain will shower you with protest, but go ahead and follow your muse. Your creative self will thank you.

You may, no doubt, feel like an idiot sometimes, but you are doing a truly important thing for yourself by making this crucial time alone for reflection and regeneration. And you really have to ask the question: why do I even care if I make a fool out of myself? It's called living, and while we are yet alive shouldn't we do things that living people do? So embrace your inner idiot. Allow yourself time really to look at things, really to listen to a piece of music, really to savor a fine wine.

And it doesn't always have to be fun, or even happy. A few years ago, both of my parents died within a period of months. I needed some sort of closure, some place where I

could put their lives into perspective, so I drove back to my old neighborhood in Bellflower. I could remember the pink Rambler parked in our driveway, and I could almost hear my mom and dad laughing at *The Andy Griffith Show* late at night. I remember the Little League baseball diamond across the street from the parsonage near where I grew up. It's been gone for decades, but on this day it was back, in my mind. We used to buy snow cones from the neighborhood moms who worked there in the snack shack on Saturday afternoons. The announcer was a dad with a heavy Scandanavian accent, and all the boys would giggle with delight when he said, "He's rounding sekund base unt heading for turd." That neighborhood walk years later was bittersweet, melancholy, and ever so evocative of a period of my life that I'd almost forgotten.

Remember that this personal time-out is your opportunity to collect impressions. Your personal creative expressions draw from your well of experiences and impressions. If your well has run dry, then your ideas will soon do the same. Time on your own lets you follow your muse and your interests and, as such, fills up your well of impressions so that you can again begin to express yourself in your work and art. Filling up your creative well is so important that it can't be left to chance. Your work depends on a regular and fresh flow of ideas into your brain, and those ideas come from real, visceral experiences. Your well needs fresh images, sounds, colors, smells.

Go to a coffee shop with a good book and camp out all night. Go to a newsstand and buy a paper from another city. I love small-town newspapers. I read a Sante Fe newspaper once

where the lead story on the front page was "Boy Detained for Laxative Prank." It doesn't get much better than that.

You'll find that for a few dollars, some things are tried-and-true for recharging your batteries: art galleries, bookstores, travel, concerts, movies. It's just as effective, though, to recharge yourself without spending any money by visiting places like thrift shops or salvage yards or even by walking on the beach or watching people at the mall. Try not to shop, eat, or run errands. You do these things too often for them to be a replenishment for your creative soul. If you must do these things during the time you've set aside for recharging, then at least shop at a store you've never been to or eat an unusual meal. It's easy—just sample your mood and act. Go out by yourself once a week and play.

A lot of people stop and ask me, "Well, Don, where exactly do you go to have some quality time alone?" So here, in response, I have compiled a list of my favorite places to go for some creative fun.

Burbank on Halloween

Halloween is one of my favorite holidays. That's because we reveal our primitive side more on that day than on any other. People who on October 30 may seem quiet and conservative suddenly bedeck their houses with skeletons and fake head-

stones and walk around dressed like Elvis just twenty-four hours later. What a holiday.

I've always chosen something pretty safe for a Halloween costume. I don't look bad as a tourist (shorts, camera, black socks) or the lumberjack on the Brawny paper-towel package (jeans, suspenders, flannel shirt, long underwear, stocking cap, roll of paper towels). At the animation studio, we'd always have these elaborate Halloween parties, culminating in costume contests. My Brawny paper-towel guy never had a chance against the animators who would come dressed as Maleficent, Mount Rushmore, Lady Gaga, or Gladys Knight and the Pips. Even though my costume never qualified for awards, I looked good in flannel, and I came in handy for cleaning up spills after the party.

Back at home, the holiday took on the same aspect of wonder. When we bought our house and the seller was going through all of the closing papers, one of the declarations included the words "Halloween may involve street closures." How bad could that really be? But on our first Halloween, the police came and blocked off our street, and without warning about five thousand kids descended on our neighborhood.

Our neighbor had a bounce house full of kids. Hulk Hogan and Frankenstein were bouncing around with Elmo and Buzz Lightyear. Next door was a hot-dog stand where you could get free hot dogs from Napoleon and Bigfoot and candy from Iron Man. As we walked down the street, the reality of Halloween set in. Wonder Woman was adjusting the costume on her little boy, who was dressed like a hockey

player with an ax in his head. A dad dressed like Elvira comforted his little Jack Sparrow, who had just been scared by the yeti in the hot-dog line.

Mr. Spock sipped on a decaf cappuccino while he handed out Mars bars. Across from him, Superman and Spawn shared a beer with Sarah Palin (I'm not sure when Sarah Palin became a revered Halloween character, but I'm glad she did). These were normal people going about their day with festive abandon. It's as though people put a lid on themselves for 364 days and then once a year go completely nuts with self-expression.

All this is not new. The spirit of Halloween comes from the medieval Feast of Fools, which was a once-a-year opportunity for moderate social revolution—normal people could dress like popes and politicians and mock their power and dignity without fear of reprisals. This tradition in turn dates back to the Roman festival of Saturnalia, during which most everyone swapped social status, and slaves and masters alike partied for a couple of weeks each December. It's nice to know that we still keep to the same traditions the Romans did.

There is a spirit that dominates Halloween that we lose the rest of the year. I'm not suggesting that boardrooms be overrun with executives dressed like the guys from *Planet of the Apes* or that Congress be conducted in drag (although this would make for some killer pay-per-view). It seems that the collective creativity of the country swells up a little bit around Halloween time, and that if we tried, we could capture that feeling like lightning in a bottle and use it during the rest of

the year. And what the hey—it might be fun to see a congressman trying to put a bill through the House while dressed like Liza Minelli.

The Doo Dah Parade

An event closely rivaling Halloween for creative spirit happens every May Day (May 1) in Pasadena, California. Pasadena is a fairly sleepy suburb north of Los Angeles, home to the Rose Bowl, Cal Tech, and NASA's Jet Propulsion Laboratory. The town sprang up at the turn of the century when wealthy easterners came west in the wintertime to take in the warmth of the California sun, the fresh air scented with orange blossoms, and the stunning scenery surrounding the Arroyo Seco.

The early turn-of-the-century settlers came up with a way to flaunt their newfound Eden in front of their families and friends back in the frigid East. Every New Year's Day, they covered their buggies and automobiles with fresh-cut flowers and paraded down Orange Grove Boulevard in a parade—the Tournament of Roses Parade.

Fast-forward about a hundred years. Many of the current residents of Pasadena are now people from around the world who moved here after seeing countless sunny Rose Parades on television while they were shoveling snow and scraping

ice off their windshields. These new locals in turn began tiring of the crowds and commercialism that the annual tournament brought to Pasadena, so they decided to spoof the Rose Parade with an irreverent pageant of the absurd called the Doo Dah Parade.

The parade usually starts with members of the local Harley-Davidson club astride their shining hogs and wearing pig noses. Then comes the queen of the parade: this year, Her Majesty was a Queen Tequila Mockingbird. The spectators run the gamut from families with kids and senior citizens on Rollerblades to dogs with bandannas and buxom girls with cans of Silly String. Occasionally the crowd at the Doo Dah Parade will show appreciation for their favorite marching units by showering them with a barrage of corn tortillas thrown Frisbee-style, according to tradition.

Following the two-headed queen (there's a phrase you don't get to use too often) is the first musical unit in the parade, Snotty Scotty and the Hankies. The band rides on the back of an old flatbed truck. Scotty sits on the hood belting rock-and-roll lyrics astride an eight-foot-tall papier-mâché nose.

This group is followed by a marching band dressed in those Snuggie blankets you can find on TV, the Bagel Street Hockey Team, and a precision marching group who call themselves the Bastard Sons of Lee Marvin.

The Doo Dah Parade is also a time to voice deeply felt political statements, and so among the marchers is a group called Legalize Ferrets carrying signs saying, DON'T WASTE OUR TAX DOLLARS. To be honest, I wasn't aware that

any of my tax dollars were going toward the oppression of ferrets, or that ferrets were in fact illegal, but I was relieved to know that even ferrets and their owners have a voice in our democracy.

Some of the marching units in this parade are better than others. There's a drag drill team, for example, made up of guys in evening gowns with makeup and false everything. Maybe I saw *Some Like It Hot* too many times as a kid, but this idea is getting old for me. Then there are a few belly dancers plying their trade along the parade route. This, too, seems like something I've seen before, and what's worse is that both the drag drill team and the belly dancers seem to evoke in the spectators the need to scream, "Wooooooooooooo!" (And where did this come from? Reality TV? No one screamed "Wooooooooooooo!" when I was growing up. Why is everyone screaming "Wooooooooooooo!" all of a sudden? Please call me immediately with your answers.)

These minor disappointments along the parade route are eclipsed by the creative brilliance and raw energy of the next unit, the Barbecue and Hibachi Marching Grill Team. Each member of the grill team wears a personalized barbecue apron and carries his or her own grill or hibachi, complete with smoking briquettes and sizzling meat. Led by a drum major who twirls a lit tiki torch as a baton, the marchers wear Kingsford charcoal bags on their heads and beat an infectious rhythm on their grills with their long-handled burger tongs and forks. An adoring crowd showers them with tortillas.

Hawaii

Who doesn't love Hawaii? The islands are literally oozing with creativity and beauty. Lush jungles spring from incredibly fertile soil. Lava spews up from the center of the earth and hisses into the ocean to create virgin landscapes. The sea pounds the shore and sculpts the volcanic cliffs with ferocious tenacity. It's paradise.

And lest we forget, this is the place that brought us luaus, surfing, the ukulele, and Barack Obama. Not to mention the hula. I loved watching Ray Walston dancing in a grass skirt in the movie *South Pacific*. What a free spirit. Who knew you could have so much fun with a pair of coconut shells and a ukulele? The Polynesians, that's who. They knew how to live. White beaches, palm trees, and volcanoes. Now that's impressive. Yes, there's the occasional giant cockroach you have to kill with a hammer, but you can bet your poi they have a fine lifestyle, too.

As much as I respect the art and culture of the islanders and as much as I'd like to live in Hawaii, I know I'd make a lousy Polynesian. I probably wouldn't last a day in ancient Hawaii. I'll have to be content with being a tourist and risking modern dangers like airport solicitors and death by sand in my swim trunks while trying to reenact that kissing scene in *From Here to Eternity*. (And that Burt Lancaster, what a performer! He's kissing Deborah Kerr like there's no tomorrow, when suddenly an ice-cold wave slams into his crotch and he doesn't even flinch. Now *that's* acting!)

The Guy Store

Here's a place that doesn't exist, but if it did, I'd rush there immediately for some male bonding. I like to go out shopping, but I've noticed that there are lots of stores in our neighborhood mall that cater to what one might call ladies' things—not as in underwear but, rather, as in needlepoint, hair, nails, and potpourri. One store has lots of toleware supplies, embroidery floss, and paintings of candlelit cottages at dusk. Another carries doilies, teapots, coconuts, scrimshaw, and . . . no, wait . . . sorry, I'm getting them confused with Hawaii. Anyway, I do think it's nice that these "lady stores" exist, but I keep hoping that someday they'll open a chain of stores that sells everything that guys like.

Wouldn't it be a bonanza to open a Guy Store, which would sell nothing but massage chairs, combat fatigues, and deep-fried pork rinds? It could carry jumper cables, playing cards, Pop-Tarts, and Cheez Whiz, and maybe for the sensitive man it could carry some books about wine, copies of *Iron John* by Robert Bly, firecrackers, M-80s, and, once again, some Pop-Tarts and Cheez Whiz.

Choose from an array of videotapes about monster trucks, tractor pulls, and bull riding, and something called World's Coolest Things Dropped from High Places. Nothing can compare to the grin on a man's face as he watches a bathtub full of cheese being dropped from the top of the Chrysler Building.

Along with the seasonal products, it could have perennials

like smoked meat, motor oil, fly rods, and eight-track tapes of "Don't Stop Believin'" by Journey. If it also sold catapults, I don't think that men would ever want to shop anywhere else. And who knows—customers might enjoy the helpful employees who give them a high five and a little slap on the butt every time they make a purchase.

The Guy Store would also make the perfect place for your wife or girlfriend to shop for you, since anything purchased there would be a treasured gift.

If women only knew how easy it was to attract a man and keep him happy. Just go to the Guy Store and get some bulk supplies of macaroni and cheese, nachos, Beer Nuts, and a case of Pete's Wicked Ale, then pop in the video of *World's Funniest Missile Launches Gone Bad*. That's love.

Europe

> The world is a book, and those who do not travel read only one page.
>
> —Saint Augustine

I think it's one of those rites of passage—the first time you travel overseas. For me, it was Europe, with my friend Toad. I was so scared, I stayed up all night the day before, and finally threw up. I had been on a plane just once, for a half-hour trip

to San Diego. This was eleven hours, across the world. Threw up on the plane, too. When I got there I had never been so tired. I checked into a small room in the attic of a Belgian hotel. It was the size of my locker in high school. I remember the sounds were different, the cars were different, the food was different, the smells were different. It was as if somebody had played with all the adjustments on the TV set—it looked familiar, but everything was a little bit off.

This was Europe, the land of The Beatles, Coco Chanel, and Toblerone. The centerpiece of Western civilization. I felt so . . . well, American. You know, middle-class American kid in a foreign land making fun of the money and complaining about the food. The dialogue between Toad and me usually centered on body odor, food, and women with hair under their arms.

Europeans seemed to have a more mature sense of their creative selves. Architecture, art, and music sprang up from the cobblestoned streets where Bach, Voltaire, and Goethe had walked. I felt very self-conscious. It seemed as if all men in America thought that the world revolved around TV, beer, football, and girls. In Europe, amid the sophistication of centuries, a man's world seemed to revolve around opera, wine, football, and girls (subtle but important differences).

In Europe, there was a sense of great pride and heritage. It was the birthplace of Western music and literature, art and architecture. Each country seemed to contribute to the forward march of mankind. England fostered a great literary tradition. In Italy, the streets were full of historic buildings, and

the country had remnants of ancient Rome and incredibly stunning art. Germany had engineered the autobahn and the automobiles to navigate it. The French valued lifestyle above all; their culture of art, music, wine, and cooking reflected that appreciation.

I was afraid when the European Union adopted a common currency and began removing some of the distinctions that made each country special. Would the individuality of each tribe suffer? And would our distinctions begin to blend together, like the sauce and lettuce on a Big Mac?

Japan

Japan is a real eye-opener. Everything is as advanced and industrialized as it is in America, but created within a different cultural context. Simple things like sinks, plates, buses, signs, and trains have been created from a different perspective. It made my head spin. Open your eyes to observe different perspectives.

I notice a lot of creativity coming from the Japanese lately. Japanese television, for example: they have the most outrageous game shows I have ever seen. They don't watch shows like *Wheel of Fortune* or *Jeopardy!* Instead, they have these quasi-sadomasochistic truth-or-consequences shows. One time they made these three guys drink lots of beer and

then stand on a block of melting ice looking at the ocean till they had to pee. And I had thought *Dancing with the Stars* was good. The first contestant started squinting and doubling over, and suddenly he dashed to the outhouse and came out a few minutes later happy as a clam. The other two contestants must have had bladders the size of Osaka, because they stood and watched the waves come tinkling in for a long time before they excused themselves.

What's the prize, you ask? That's the thing. Once, the winner got a set of hot pads. Another time, the contest featured guys lying on aluminum foil on the beach with magnifying lenses focused on their nipples and an ice-cold beer just out of reach. The winner was the one who could stand it the longest. And the prize *that* time? Dinner for two. Dinner for two and toasted nipples.

Yes, they are dominant in the field of sadistic game shows, computer circuitry, karaoke, and sashimi, but I can't help noticing the fine new—how you say?—*toilets* coming from the Empire of the Sun. I discovered this during a trip to Tokyo to promote the release of a movie. We held a press conference in a modern office building where I was about to stand up and speak in front of a group of fifty to seventy-five elite Japanese journalists and answer the usual questions, like "How many people does it take?" "How long does it take?" and the ever-popular "Computers do most of this work now, don't they?" (The answers: six hundred people; four years; and no.) We got to our presentation area early, and I had a nervous stomach. I just needed to freshen up a bit.

After rehearsal and before going out to answer questions, I retired to the men's room to powder my nose, and there I saw it, the toilet of the future—the Toto S400. This welcome throne was all digital. The handy push-button selections had little drawings next to each button so you could see what might be in store for you if you pushed one. After some time, I worked up enough courage and curiosity to start trying some of the buttons, even though I hadn't a clue as to what they did. First, I found the button that we would have called POWER FLUSH (it lived up to its name). To my delight, the next button I pushed turned out to be a front and rear CLEANSING SPRAY (also living up to its name), which also featured a warm-air dryer with three temperature settings; what's more, it had a heated seat and, perhaps best of all, a remote control presumably in case you wanted to power flush while strolling some distance away.

Here, the Japanese have made innovations to an age-old technology and taken the most ordinary item known to mankind into the new millennium. I returned to the stage with a spring in my step and a faint smile. The journalists all smiled back. They seemed to know where I had been.

3.

Spirit

If only God would give me some clear sign!
Like making a large deposit in my name at a
Swiss bank.

—Woody Allen

I was raised in an old parsonage in a farmhouse in Bellflower, California, a town best known for being an enclave of Dutch dairy farmers. My dad was a pastor; my mom played the organ and directed the church choir. I lived in a world of potluck dinners, prayers, and pulpits. God was a powerful thing to me then. After all, my God was the God of Moses, Garrison Keillor, and ten million Norwegians. Church was a happy place. When you called on the phone, the secretary would pick up and merrily answer, "Holy Redeemer," accompanied by a melody that was vaguely reminiscent of Woody the Woodpecker's laugh.

One Sunday morning, I sat in my second-story Sunday-school classroom with the smell of doughnuts and brewing coffee rising like a demon from the kitchen below. My teacher, Mrs. Holtzendorf, casually read a Bible verse about Creation that would change my life. It went something like, "In the image of God, made he man and woman." Wow. That doesn't stink. Suddenly, I'm actually related to God. A creative relationship. The same relationship that the potter has to his clay, the painter to his canvas, the baker to his bread. God made me like him!

It always seemed to me that this higher power we call God was crazy about creativity. Sure, he must have had his frustrations and false starts—unicorns, dinosaurs, the Octomom—but just look at the successes: the Painted Desert, the northern lights, zebras, chickpeas, Megan Fox, and the planet Saturn to name a few. And if God was crazy about creativity, and I was created in the image of God, then somewhere deep inside I must be crazy about creativity, too. And why not? Why couldn't the great Creator enjoy creating?

We all experience this higher creative spirit in a personal way. Some experience it in nature. To others, it is a force, a flow, a Tao, a higher power, a great Creator, a unifying spirit. And everyone has a different name for expressing this higher power. When I was really little, I thought God's name was Hollow Ed, since the Lord's Prayer clearly states, "Our Father who art in heaven, Hollow Ed be thy name." I also remember hearing that he sits in "judge mint," which

presumably kept him smelling very fresh. But I was eventually set straight, and at the very least I wasn't as confused as Toad, whose favorite hymn was "Gladly the Cross-eyed Bear."

Defining God

The classroom had emptied out for recess, but one little girl stayed behind, focused intently on a drawing she was making. Her teacher was a little confused. She walked over to the girl and asked, "What are you doing?"

"Drawing a picture of God," the little girl answered.

"But honey, no one knows what God looks like."

The girl looked up.

"They will in a minute."

It seems natural for us to know God well enough to draw a picture of him. But as relationships go, this one has always seemed a bit strained. First, there was that Adam and Eve incident. As you recall, they got us off on the wrong foot when they couldn't help themselves from sampling the pippins in the Garden of Eden. Then there was the time Moses went away to get the Ten Commandments; when he got back, everyone was worshipping this gold cow. Talk about embarrassing.

I could go on, but I think you can see that it's no wonder God seems angry at us sometimes. And even when he doesn't seem angry, it seems impossible to get close to him.

He seems so distant. First of all, he's a monarch, a king, a lord. He's surrounded by his entourage of saints, apostles, and God knows who else. And secondly, he's got to be unbelievably busy. Why would a God so powerful and secluded need anything else from us except our worship and praise?

God seems to be a hard thing for us to define and deal with. Most polls show that more than ninety percent of Americans say they believe in a higher power. This is an astounding statistic, since we can't usually get ninety percent of Americans to agree on anything. Beneath this statistic on belief there lies a hidden story. Even though we may believe in a higher power, our belief is buffeted by uncertainties and confusion. How can this God be so powerful and invisible and yet still be everywhere at the same time? And why doesn't this higher power stop cancer, war, and *Dr. Phil* reruns?

Throughout history, we haven't even been able to bring ourselves to talk about God without using a powerful string of metaphors: king, lord, judge, lawgiver. At times he's a warrior, a lion, an eagle. Some metaphors refer to God in more tangible terms, calling him light, fire, wind, rock, and fortress. But so often our most dominant image of God is that of the powerful monarch in robes and long white beard, an image borrowed from the Greek god Zeus—the creator who long, long ago built the universe and sits in judgment somewhere out there on his cloudy throne. God seems distant from us.

At the opposite end of the spectrum, there are also powerful and compelling metaphors that offer us an understanding of the force that is a near and present spirit. God,

the guy with the robes and beard, may have presided over Creation in some distant past, but God the spirit is here now, creating during every moment in front of our eyes, in endless ways.

The metaphors that we use to describe God the spirit (as opposed to God the monarch) seem very connected to our need for a partnership with a creative force. God becomes a cherished companion on our creative journey, where we see him more as a shepherd, a potter, a healer, a gardener, father, mother, and friend. Our knowledge of this spiritual force is based, then, less on guilt and sin and more on a living relationship that demands love, trust, fidelity, and intimacy.

The higher spirit that ninety percent of Americans believe in is already in a relationship with us, and we need only be open to the companionship and comfort that this relationship can bring to our creative spirit. In her book *A Return to Love: Reflections on the Principles of a Course in Miracles*, Marianne Williamson wrote:

> Our deepest fear is not that we are inadequate. Our deepest fear is that we are powerful beyond measure. It is our light, not our darkness, that frightens us most. We ask ourselves, 'Who am I to be brilliant, gorgeous, talented, and famous?' Actually, who are you *not* to be? You are a child of God. Your playing small does not serve the world. There is nothing enlightened about shrinking so that people

> won't feel insecure around you. We were
> born to make manifest the glory of God that
> is within us. It's not just in some of us; it's in all
> of us. And when we let our own light shine, we
> unconsciously give other people permission
> to do the same. As we are liberated from our
> own fear, our presence automatically liberates
> others.

You may argue that there are plenty of highly creative people who have absolutely no belief in God, and of course you'd be right. Some people feed off their strong spiritual links not with God but with other artists, mentors, or peers, or their strong connections with nature, all of which are fantastic. Those connections are incredibly valid spiritual relationships that we can rely on in our creative journeys. Regardless of your personal beliefs, the creative process can be enhanced only if you approach your art not as an isolated loner but as an individual connected to the endless spiritual links around you. If we are open, however cautiously, to the possibility of a spiritual influence in our creative lives, then we open ourselves to an unlimited supply of inspiration.

No matter how you define your personal spirituality, what we all really seek is a link to the creative energy and flow that powers the universe. We were formed from the stuff of the cosmos, we live and breathe and eat the energy of the cosmos, so why shouldn't we easily and even instinctively draw on that energy to propel our lives? It's the same energy that

fuels the galaxy, the rise and fall of the tides, hurricanes, Lance Armstrong, and Oprah.

Now that we are pumped up with the power of the cosmos, let's stop and consider our everyday up-at-dawn, get-dressed-and-go-to-work life. We are creative all day long. We create things like reports, coffee, stomach acid, and gossip, and we get a paycheck to thank us for our creativity. Not exactly communing with cosmic power.

We wish we could bring some creative power to our office or, better yet, get out of the office and pursue our dreams. We probably feel as if we were more creative than we seem, but can't quite tap into that creativity. Sometimes we yearn to break into more overtly artistic pastimes, like writing or drawing. Sometimes we even look at people we feel are highly creative and long to have lives like theirs—lives full of openness and freedom.

Our days seem ruled by the boring tasks of survival. We know that deep down inside we have good ideas, but we don't know how to realize them. Sometimes, we can't take a step forward even when we know specifically what we want to do. We sit and chant the modern-day mantra: *If only I had the time, if only I had the money, if only I had the access.*

Many of us had moments of great creativity when we were young but can't seem to ignite those feelings anymore. Others have suppressed their own aspirations and thrown themselves body and soul into the creative lives of another and are too afraid or weary to acknowledge their personal creative dreams.

In short, we will find any excuse possible to abandon our dreams.

> Too busy.
> The kids need me.
> My husband (spouse, lover) needs me.
> I'm too tired.
> I'm too old to learn.
> I'm too fat (thin, tall, short).
> I'm too ethnic.
> It's too selfish.
> It's egotistical.
> I don't have time.
> I should be happy with what I have.

We are born with an unlimited potential for our light to shine bright, but if we aren't careful, we may never realize it. We put our precious physical energies into many distractions, and we neglect to call upon those energies in the service of our own dreams and aspirations. We may even feel that the pursuit of a dream is a luxury we can't afford. Even if we do raise our creative spirits from near death, we are hit with the realization that creativity does not always equal success or happiness.

It's true that following your muse is fraught with upheaval. We suffer withdrawal from the predictable routines of our lives, no matter how bland those routines were. We exchange perfectly comfortable lifestyles for months of hunger spent trying to create at the typewriter, or at the canvas, or at the potter's wheel. We doubt ourselves. We say to ourselves,

"People must think I'm a fool" and, worse, *"I* think I'm a fool."

If you had been searching for more creativity in your life three hundred years ago, I'd probably have said, "Forget it, it's hopeless." You'd have been an indentured farmer who would spend his whole life in the service of some fat guy with a powdered wig, so why bother? Heck, I'd probably have said, "Forget it, it's hopeless" fifty years ago. You'd have been an indentured worker who would spend his whole life in the service of some fat guy with a red nose and a cigar, so why bother? Things are different today. We live in an age of more tolerance, access, and openness than any other. There has never been a time like now.

Yes, there are intolerant, closed-minded individuals in every generation. There is always some naysayer there to say, "It can't be done." Take these examples from the past century:

Everything that can be invented has been invented.

—Charles Duell,
commissioner of the U.S. Patent Office, 1899

Who the hell wants to hear actors talk?
—Harry Warner, founder of Warner Bros., 1927

While theoretically and technically television may be feasible, commercially and financially it is an impossibility.

—Lee De Forest, inventor

I think there is a world market for maybe five computers.
—Thomas Watson, former chairman of IBM

The concept is interesting and well-formed, but in order to earn better than a "C," the idea must be feasible.
—Fred Smith's professor at Yale, commenting on a proposal for an overnight delivery service. Smith later founded FedEx.

We don't like their sound, and guitar music is on its way out.
—Decca Records memo rejecting The Beatles

If you look for them, you can discover naysayers and obstacles everywhere. Though imperfect, these times are prime for the spark of your creative self to start shining through. Besides, if we wait for circumstances to be perfect, if we wait for our muse to speak, if we wait for someone to help us, we will never begin. The circumstances will never be perfect, your muse is a fickle companion at best, and no one will help you until you take the first step. Therefore, as much as you may be suspicious of the following six lines, I believe them to be true:

You're not too old.
You're not too poor.

Your spirit has endless energy.
You have a right to have an ego.
Who cares if they think you're crazy?
Your dreams don't have to die with you.

Billions of souls have lived and died on this planet, and most have never had the choice of considering a more creative life as an option. Our twenty-first-century life-style affords us the option of taking control of our time and control of our dreams. Our ancestors invested a lot of hope in us. Their dreams and yearnings, their genes and aspirations, now sit within us like pent-up potential, waiting to be released. The least we can do is take a leap of faith that those hopes were not in vain.

Joy

Children today are tyrants. They contradict
their parents, gobble their food, and tyrannize
their teachers. —Socrates

Somewhere, somehow, find a group of young children at a preschool or kindergarten and ask to observe them. Don't judge or label them, but observe them. Their emotions are right on the surface. They bring enthusiasm to everything

they do. Sure, they are full of insecurities and fears and they do gobble their food and tyrannize their teachers, but young children are optimistic little creation machines. And they love to play. Playing makes them happy. It brings them joy.

You can't plan joy. You can't put it on your calendar and say, "A week from Friday let's go out and have some joy." Joy is not a place you arrive at. How many times have you caught yourself saying, "If I can just make it through this next week, then I'll be happy"? We don't arrive at happiness as we do some destination. In fact, the times that we focus on joy as a conscious target are the times when it becomes most elusive.

There is no road map that shows us how to be joyful, although bookstores and talk shows are full of people who seem to know. It's not an arrival that produces the sensation of joy but the total immersion in the journey. Happiness comes from a very personal place inside that has to do with feeling deeply involved and in control of your life's journey.

Happiness doesn't always come from a ski vacation or a summer in Europe. The happiest and most exhilarating times in our lives don't often happen on a Hawaiian vacation with a box of dark chocolates . . . well, actually, I take that back. Forget I said that last bit.

Exhilaration comes from being stretched to your limits in trying to accomplish something that has been incredibly difficult for you. The personal feeling of accomplishment after the birth of a child, for example, or after the completion of an arduous project, can be intoxicating and can create lifelong

memories of happiness. Happiness can be born out of pain and struggle, out of striving for worthwhile things. When you feel that you are in control of your life and an active participant in the content of your life, that's when you come closest to feeling a sense of joy.

Ten Thousand Hours

In music school, the best musicians had one thing in common. They practiced all the time. It wasn't talent, though they had it; it wasn't money or pedigree; it was the passion and huge commitment to time alone with your ax. (That's a musician's slang for his instrument. I don't know why, but it's probably because it takes a lot of woodshedding to get any good at it.)

In college, I studied music with a jazz vibraphonist who played with the remarkable George Shearing. I was amazed by his talent and ability to improvise. I would watch him again and again perform long solos, never coming back to any idea twice. He'd move around and make up lines of melody and rhythm that would turn my impressionable head. Then it was time for my lesson. I really looked forward to discovering the secret. I was going to learn how to improvise. First, we did scales. Up the keyboard and down, then up a half step and do it again, for half an hour. Finally, he gave me my eye-opening

homework. He tossed me a Charlie Parker album and said, "Go home and write down these improv solos and bring them back next week."

Write them down? Copy them? What? Where was my vision of dancing cleverly around the keyboard? I had thought improvisation was the ultimate personal expression. Why was I copying other people's solos? Weeks went by as I copied dozens of albums' worth of solos and learned them all.

I smugly came to my next lesson ready to launch into a version of a tune called "Bags' Groove" that I had memorized in the key of B-flat. He stopped me and said, "Let's play it in D-flat instead." For all you nonmusicians, that's the equivalent of saying, "Let's repeat that last conversation word for word, but this time in Chinese."

After many frustrating months, I finally graduated to my own solos. My lessons taught me two important nonmusical facts: art comes after an incredible load of work, and only one thing will see you through that work—passion.

Author Malcolm Gladwell in his book *Outliers* suggests that ten thousand hours are required to achieve the level of mastery associated with being a world-class expert—in anything. How, then, do you explain those instant successes like The Beatles, who just jumped from Liverpool to stardom on the world stage? Gladwell reminds us that one of the band's earliest gigs was performing near the military bases in Hamburg, Germany. They played eight hours a day, seven days a week, for eighteen months. So the hit band that seemed to drop out of nowhere had played together for an astounding

1,200 gigs by the time their first hit single made the charts. They had put in the hours.

Once I gave a lecture to a group of people at the studio extolling the virtues of creativity, and one guy raised his hand and said, "I'm in technology, so I'm not in a creative job here, but I want to know how I can put my story ideas forward." That's like saying, "I'm not in a creative job, and I want to do an appendectomy." Go to medical school and intern, and then come back and do that appendectomy.

And how do I put my creative story ideas forward? If you're serious, then spend ten thousand hours studying, reading, and writing, and you'll be closer to earning the moment when you can put your ideas forward. The streets of Hollywood are littered with a hundred years' worth of abandoned movie ideas from every corner of the planet. At least do your homework.

Picasso, Degas, Frans Hals, and other painters spent a large part of their youth copying paintings and imitating the style of the great masters. Copying old masters' drawings and paintings can jump-start you and provide you with a strong foundation. The same is true for architecture and dance and writing.

Degas once said, "A painter must copy endlessly from the old masters, and not until he has copied hundreds of paintings and studied the brushwork and color and composition of the master should he attempt to paint a radish from nature."

Sometimes we resist this ten-thousand-hour idea. There

must be a simpler way. Copying from the great masters of our craft makes us feel uninspired and seems like cheating. What we are really doing is gaining insight into another person's creative journey. The more we can glean from the mistakes and successes of our idols, the more we can apply the lessons of their journeys to ours. We need to look deep into the creative lives of our heroes and see them not only at their best but also at their worst. How did Edison deal with adversity? How did Miles Davis sound on a bad day? What did Steve Jobs do when he was fired from Apple? Let's see a bad drawing by Rembrandt. The journals and the accounts of the ways in which great artists struggled to express themselves can provide a valuable road map for our own journeys.

Don't try to find a creative place solely by yourself. Let someone help you as you navigate your ten thousand hours. Others have been there before you. Use their examples and their work as beacons to illuminate your path. Mozart used Haydn as his inspiration. Putting in your hours to give birth to your creative idea is a long and painful process. You don't have to do it alone. Use a midwife to help. It's okay to seek out someone you admire and ask that person for help and advice.

Mentors

A teacher affects eternity.

—Henry Adams

There are many people in my life I consider mentors. Teachers who took a special interest in me, or my older brother, Jim, who taught me how to make a fart sound on my upper arm (which later got me in trouble in school: "We do not want to hear from your arm, Mr. Hahn.").

When I was twenty, I met an animator named Walt Stanchfield at the studio. Walt was the closest thing to a true mentor I've had. It's not that Walt drew better than anyone else, or taught better than anyone else (although he did both); I admired him as much as I did because he seemed to *live* better than everyone else. I liked the way he played tennis every day at age seventy; the way he did paintings and sketches in the car without looking while driving down the freeway from his home north of Santa Barbara. I liked that he slept in the back of his van in the parking lot at work and the way he always seemed to have a bag of fruit with him. Walt was a character. He loved life. When he wasn't drawing, he was playing guitar or making baskets in the style of the Chumash Indians. Walt's life was his art. He was forever intrigued with everything. When I first met him, he was doing woodcuts (carving an image into a woodblock and then using ink to make a print

on paper). A year later, he was mad about fauvism; later it was cubism, and later many other "isms."

Walt was interested in everything. When I was a budding artist at the studio, I took my drawings to him. I'd work for hours on a small stack of drawings that, when flipped, would form a simple animation. I thought I was impressive. But the minute I took my drawings in to Walt and he put them on his desk, I would find myself wincing. What had I been thinking? There was something magical about Walt's desk that made me see all my mistakes. Then again, it could have been his gentle manner as he sharpened his pencil and started talking: "Too many converging lines here; play this line straighter; watch this arc here." It was sweet and painful.

Years later, I asked Walt to come to London when we were preparing to make *Who Framed Roger Rabbit*. The artists would crowd around him on the third floor of an Edwardian-era factory building we had rented. They hung on every word he said and seemed to absorb every line of his drawings. When it came time to pose, Walt would seem to become Jessica Rabbit. We had a leggy supermodel dressed up as Jessica, but Walt was the one who moved like her and helped us see what made her beautiful and sexy. On weekends, Walt and his wife would head out into the English countryside; they'd come back on Mondays with a million stories about sheep, the price of Scottish woolens, and the silly-sounding places they had been, like Titsey, Shropshire, and Whaping Hedgehog.

Walt was a tireless sketcher. If he was away from his studio,

he would render his drawings by dipping a brush into his cup of coffee at breakfast. He filled the pages of his sketchbooks with his "coffee" drawings. At restaurants near home, waitresses who knew Walt would bring him two cups of coffee right away, one for drinking and one for painting. Tea worked just as well when he traveled in England. Red wine worked at dinnertime. The drawings were loose and impressionistic and alive.

Walt collected things, too. On the beach, he would be fascinated by interesting driftwood and rocks. Every Monday I would drop by his room and see his weekend collection. One week it was pinecones. The next it was photos of clouds and the next, stories about some painting he had seen in a gallery somewhere that had stopped him in his tracks.

I had never been around anyone like Walt. Part artist, part poet, part philosopher, and part bag lady. But all passion, all vision, all curious, all loving.

Get Me John Huston

Before I started working at the Walt Disney Studios, I thought being an artist was kind of a geek thing. Lots of my friends practiced the "commune" arts of pot throwing and dulcimer playing. Some did lovely needlepoint, macramé, or sand candles, and my aunt Beverly once did an oil painting. But no one I knew, with the exception of a few teachers, seemed

very serious about art. The artists I knew were hobbyists who pulled a shoe box from the closet on Saturday morning and toiled with their crafts—almost apologetic about their art. Art wasn't important. Art was for amateurs—or so I thought. Then I met Woolie.

His full name was Wolfgang Reitherman. I had been at Disney for a couple of years and had known Woolie by reputation. His work was strong and dynamic: the whale chase animation in *Pinocchio,* the dinosaur battle in *Fantasia*, and Maleficent as a dragon in *Sleeping Beauty*. He took a break from animation to be a World War II fighter pilot, flying missions in Africa, China, India, and the South Pacific. He earned a Distinguished Flying Cross medal. Then he came back to Disney to produce and direct *The Jungle Book* and a string of other movies in the sixties and seventies. One morning, I got a call from the front office asking me to go see Woolie because he needed a new assistant director.

I sheepishly walked into his wing of offices on the second floor of the animation building, nodded to his secretary, Lorraine, and took a seat in the waiting area. That was when I heard him speak.

"Lorraine, get me John Huston on the phone." Wow, so that was what a producer sounded like. And John Huston? The guy who directed *The Maltese Falcon*? It was that easy? He continued to talk; his side of the conversation was a sort of loud, monosyllabic artillery of words.

"Hey, how ya doin'? . . . Ya . . . ya . . . ya . . . say, we want you to read the opening narration for our next picture . . .

great . . . love to . . . yep . . . same here . . . you, too . . . okay . . . great . . . ya . . . okay . . . take care, John . . . you, too . . . bye, now."

After the call, I was ushered in. A perfect mix of John Wayne, General Patton, and Dean Martin, Woolie was a man's man. He always wore a Hawaiian shirt and held a big unlit cigar in his mouth, which he chomped incessantly. He offered a big, warm smile as he reached out to shake my hand. His grip was strong, the kind of grip you might use to grab an ax or to strangle a man. As he talked, his cigar got soggy, and he'd reach into his drawer, produce a pair of scissors, snip off the end, and then start chomping again without missing a beat. Here I was, shooting the breeze with one of Walt Disney's finest animators, who looked as if he could have kicked my butt if he wanted to. We chatted about our favorite movies. His was *The Guns of Navarone,* mine was *Willie Wonka.* He was no hobbyist. Here was a man who was as comfortable drawing cartoons as he was flying a Spitfire or having lunch with James Coburn.

Woolie's crew of animators was equally grown up. I was struck by the attitude these guys had toward art. It was sophisticated, unapologetic, matter-of-fact. Everybody drew hard, laughed hard, worked hard. It was the first time that it had dawned on me that art could be a grown-up thing to do. I wanted to be a producer. I wanted to "get John Huston on the phone."

Building Brain Trusts

By now, you've caught the feeling that a creative human journey is not an isolated, lonely experience. You get to draw on the experience of others, living or dead, to shape your own life. With that in mind, a priority for any artist is to assemble a brain trust of experts as a support network. Think of your brain trust as a safety net, your own personal board of directors to help guide you. The people on your brain trust aren't just there to stroke you on the top of the head and tell you that you are doing all right. They are your trusted friends and colleagues, whom you can count on for the truth.

Take another look at Pixar. Whenever a filmmaker needs a fresh eye, she or he can call in a brain trust of writers and story people to help navigate story problems as they happen. This is a secret weapon that far too many studios ignore. If you were to walk into a note session at Pixar, you would think you had walked into a huge family argument. People are shouting and talking over each other as though their lives depended on it, and you know what? They do.

You have two distinct choices when you are making a film or, for that matter, writing a play or painting a landscape. You can keep the process to yourself and hope the audience likes it on opening day. Or you can share it with trusted colleagues and get the critique early. Much better to hear how the movie is working from friends than from

Kenneth Turan on the front page of the *Los Angeles Times*.

In your creative life, this personal brain trust may include a friend or two, but it really needs to include people who will challenge you and your ideas. When you serve up a creative idea, your brain trust has to consist of people who can, to use a tennis metaphor, return your serve. You don't want admiration from this group—you want honesty and even anarchy. You want a critique that will challenge your vision and send you back to work with new eyes.

One of my painting teachers is a Western landscape painter named Scott Christensen. Much of my time spent with Scott is focused on seeing with fresh eyes. I had done a small color landscape sketch in oils that I had flooded with green—green trees, green grass, green mountains—but I honestly couldn't see that everything was green. Scott had me turn around and face away from my easel and then bend over so that I was looking at my subject upside down. Now the mountains looked purple and the trees looked yellow ocher, and almost nothing looked really and truly green.

In painting and in drawing and in most anything that you do, try to look with fresh eyes. Look upside down at your subject, look at it in a mirror, and suddenly your eyes will be opened to what you've really done. Look to your brain trust to do the same thing. You need their eyes and their brains to tell you what you cannot see.

You may even expand your creative brain trust to include people like a life coach or a personal trainer, both great investments you can make in your creative soul. If you can afford it,

add to your trust your tax accountant or a neighborhood kid to mow your lawn or do the errands that you are not great at, but still need to get done. It's very worth your money to pay someone and thus buy back some of your own personal time.

You can't possibly carry in your head all of the expertise that these people will bring to the table on a regular basis to help solve problems as they come up during the course of your creative journey.

Collaboration

> None of us is as good as all of us.
> —Ray Kroc, founder of McDonald's

A few years ago, when Ed Catmull, the head of Disney/Pixar, had lunch with the head of a major motion picture studio, the executive declared that his central problem was not finding good people—it was finding good ideas.

For Ed, this executive's belief was rooted in a misguided view of creativity that exaggerates the importance of the initial idea and not the talent. When it comes to producing breakthroughs, both technological and artistic, Ed believes in adherence to a set of principles and practices for managing creativity. A film studio is a community in the truest sense

of the word, a community in which talent is rare and valued and relationships matter.

A collaborative community, when it is working, is a huge weapon. For the community to be working, there must first be a safe way to tell the truth. If everyone is trusting enough to tell the truth in a constructive way, then everything—the products, the process, the problems—will be fair game for positive discussion.

This ability to tell the truth in a safe environment has to be encouraged even when a company is successful. No one goes shopping for problems when you are successful, just as you don't go digging for illness when you are healthy; but in a way, that's exactly what an organization needs to do to remain healthy. Pixar's culture is to dig for potential problems and solve them before they turn into life-threatening issues.

This truth-or-consequences style of behavior is tough. First of all, it demands a free flow of information. Most organizations operate in a hierarchical way, in which information is passed up to the top management and directives are handed down to the workers. This may work for some manufacturing businesses, but in collaborative creative organizations, the information and communication have to flow in every direction. It has to be okay for everyone to talk to everyone about everything, without fear of losing your job or having your ego crushed when you're not the first one to hear about something.

Managing a creative team means encouraging truth-telling and building a capacity to recover when failures or problems are discovered. All this takes smart, talented people

who are willing to make hundreds of decisions a day without waiting for the boss.

This is a really different way of going to work in the morning. Now, instead of waiting for assignments from the boss, we have to get up from our desks and talk to others face to face, eat lunch with them, listen to them, help them, and let them help us. We have to shine a light on problems, flawed thinking, and pitfalls.

This kind of collaborative behavior needs one more ingredient: risk. Not everyone is comfortable with the concept of risk. In fact most people, from Wall Street executives to your mother, would rather that you not take too much risk in your daily life. It is more comfortable and predictable to play it safe and stay in your comfort zone.

As Ed Catmull puts it, "If we aren't always at least a little scared, we're not doing our job. We're in a business whose customers want to see something new every time they go to the theater. This means we have to put ourselves at great risk."

Sometimes that means picking risky-sounding film ideas: let's tell a story about rats in a kitchen, for example, and let's title the film after an obscure and unpronounceable French dish. Or let's make a movie about an eighty-year-old man who travels with a Boy Scout to South America in a house held aloft by balloons. These frankly sound like horrible ideas for films. But with the right people, *Ratatouille* and *Up* turned out to be wonderful and lasting feats of entertainment.

If you want to live in a collaborative creative community, you have to be able to live with the uncertainty of the

process even when it's uncomfortable, and you must have the capability to recover when your organization takes a big risk and fails. What's the key to being able to recover? People! Talented, diverse, inquisitive, truth-telling people.

If you're looking for a secret weapon hidden inside Pixar, or Google, or the LA Lakers, the answer is the people—all of the people. Like a large orchestra of individual players, when we come to work in the morning, we check our egos at the door because we won't be needing them. The team becomes more powerful than any one individual. The team is like a living, breathing, creative organism. The team knows all, shares all, sees all, achieves all, creates all.

This can be very hard for the world at large to understand. The press likes the idea of a single spokesperson or celebrity, and a large collaborative team doesn't offer that celebrity quality—and does not photograph as well as Scarlett Johansson. Yes, there are leaders, directors, quarterbacks, vice presidents, and CEOs, but the revolution in creativity comes when those leaders support and challenge the creative team.

Ed Catmull feels so strongly about this responsibility to provide a creative home for artists that Pixar and Disney animation do not put their people under contract. The concept seems risky, but it puts the responsibility on the studio to provide great projects and an exceptional work environment. If the team is both challenged and supported, there is no need to go elsewhere, and conversely, a contract that arbitrarily keeps an unhappy person in a place where he is not going to grow or contribute is not good for the artist or the team.

Collaboration. It's the same in animation as it is in music, manufacturing, hotel management, or professional basketball: it takes a team to win the game. Not just the coach or the star players, but the entire team. Here are some rules for group creativity that may scare some people away at first; none-theless, these rules are worth careful consideration.

1. Knowledge is everything, and everybody needs the knowledge.
2. Meet often, meet quickly.
3. More meetings in the hallway, fewer in the conference room.
4. Listen to everyone; no one has a stupid idea.
5. No one person takes credit; all take credit.
6. Reward the group, not the individual.
7. Feed your idea, not your ego.
8. Less controlling hierarchy, more controlled anarchy.
9. Never underestimate the power of free stuff (food, T-shirts, hats).

Collaboration doesn't make you a faceless contributor who labors for the good of the commune. It is crucial that the group remain a collection of individuals who believe in and trust one another. This may sound impossible, utopian, superhuman, or unworkable, but consider the alternative as exemplified in the following set of rules.

1. Tell them only what they need to know.

2. Please save all your issues for the weekly marketing meeting.
3. Stay at your desk.
4. Better to remain silent and thought stupid than to speak and remove all doubt.
5. Reward the individual, shame the others.
6. Feed your ego.
7. Every man for himself.
8. Just do what the big guy tells you.

A Place to Socialize

When I was twenty years old, I moved out of my parents' comfy house into a new apartment building a few miles away. Another Disney artist, Dave Spafford, moved into the same building.

We were constantly working. We had both just landed jobs at the Walt Disney Studios the year before and were now working sometimes ninety hours a week on *Pete's Dragon*. We'd work until two in the morning shuttling drawings, Hostess cupcakes, and beer up and down the hallway of our apartment building. Next day, we'd do it all over again. Ten years later, Spafford and I ended up in London, living in Camden Town and working with master animator Richard Williams on a movie about a rabbit who gets framed for murder. Dave was the Daffy Duck guy. He animated the scene

of Donald and Daffy Duck's piano duet in the Ink and Paint Club. But Dave was gifted in another way too, which was just as important as his skill at drawing. He was about to become the social magnet of the studio. I learned two things from the British animators. They have a huge capacity for focused, hard work, and they have a huge capacity for focused, hard beer drinking.

Friday nights were the best time to make the transition from work to beer drinking. Everyone at the studio would escape to a pub and begin to sample the bitters and lager. I didn't get it at first. It was kind of smoky and loud, but this was the place where the real creativity took place. Here the artists could decompress after their long hours of seclusion at the drawing board. It was a healthy way to vent, complain, encourage, and counsel one another and eventually become a family.

Going to a separate place to socialize and talk about politics and art was not a new idea. The New York intellectuals gathered at the Algonquin Hotel. The painters and writers of 1920s Paris gathered at Deux Magots. The California impressionists had Laguna Beach, the Rat Pack had Las Vegas, and the beatniks frequented Ferlinghetti's City Lights bookstore in San Francisco. All of these groups had a place to call their own, and it was all essentially for the same reason. A place to unwind, a place to talk, a place to vent, a place to dream, and a place to spend time together with friends.

I think Americans, and particularly American men, are all a little embarrassed to talk about bonding. Unless it involves

football, smoking a cigar, or watching the new Blu-ray disk of *Predator*, we're hesitant to get together and talk.

After *Roger Rabbit* and the London experience, we returned to Los Angeles, happy to get back to our ample parking and sunshine, but sad that we were missing the community of the pub. For years after our return, Spafford opened up his house on Friday nights so that the animators could come and hang out. Spafford's place became an institution, a place to socialize, a transplanted pub among the backstreets of Burbank where body and spirit could be fed.

Community

There it is around you. Don't pass it by—the immediate, the real, the only, the yours, the novelist that it waits for. Take hold of it and keep hold and let it pull you where it will.

—Henry James to Edith Wharton,
about New York

When we choose where to live, we make a choice that profoundly affects who we are. The house we choose, the schools and libraries we go to, and the restaurants we frequent are all sources of impressions in our life. All artists use their communities as a palette in their work. The associations

are endless: Cervantes' Spain, Jane Austen's Regency England, James Fenimore Cooper's American frontier, Dostoevsky's murky St. Petersburg, and the wilds of west Yorkshire, in which unfolded the isolated lives of the three Brontë sisters and in which their work is rooted.

Some writers, like Washington Irving, were wanderers but would still bring their literary gifts back to their roots. Irving was a product of the American Revolution; some say he was the first American writer, from a time when professional writers were scarce in the New World. During the long periods of expatriation in Irving's life, he traveled to England, Germany, France, and Spain, collecting folktales along the way. Two of his most popular stories, "Rip Van Winkle" and "The Legend of Sleepy Hollow," are actually Americanizations of German folktales that Irving transplanted to the Hudson River Valley.

Even when we have been displaced from our hometown, our work is still reflective of our roots. Robert Louis Stevenson spent the first twenty-nine years of his life in Edinburgh and then traveled to France, California, and eventually Samoa, but even in literary exile, his work was reflective of his Scottish roots. Victor Hugo, the symbol of French Romanticism, was in political exile on the island of Guernsey when he wrote *Les Miserables.*

Sometimes writers are so strongly identified with a place that their names become used as adjectives. For example, no writer has been more associated with a community than Charles Dickens, with his haunting literary treatments

of foggy rivers, debtors' prisons, taverns, and coaching inn yards—all vivid re-creations of the sights and sounds of Dickensian London.

Writers grow in communities: Mark Twain's Missouri, Ibsen's Norway, James Joyce's Dublin. Painters grow in communities, too: Canaletto's Venice, Monet's garden in Giverny, Van Gogh's Provence. Filmmakers grow in communities: Woody Allen's New York, Barry Levinson's Baltimore, Ingmar Bergman's Sweden. You grow in communities: Linda's Orlando, Jared's San Antonio, Toad's Bellflower.

When our minds become stagnant or unfocused, sometimes we have to look back to the soil from whence we came. Where do *your* roots reach down for nourishment? What are the stories of your youth? What were the influences that were left in your mind—influences that you can call on as rich inspiration?

Look around. Even if you are in an urban environment that seems vast, faceless, and anonymous, the immediate "village" of shops and people around you are a reflection of you and your life. You are a part of them and they, you.

The shops in the village where I live aren't at all upscale, but you can find anything you need in them. There is a pharmacy in my town that has been in operation since well before World War II. It hasn't changed much since the forties, and sells the usual pills, salves, and ointments along with greeting cards, fountain pens, scented candles, and fifths of Scotch whiskey. The store also sells notions. (I'm not sure what notions are. I spent one summer working in a department store behind the

notions counter and I'm still not sure what they are. I suspect they're those little essential items that you seldom think of but people need every day, like makeup pouches, cotton swabs, ChapStick, and a copy of the *National Enquirer*.)

Next to the pharmacy is a butcher. It is so rare now to find a butcher shop that's not a part of a supermarket that we're not sure anymore what to do there. I had a thought that if you needed a large order of meat for, say, a barbecue for a thousand, you could get it there. Or if you needed something unusual, like a cow's tongue or a steak that wasn't prepackaged in Styrofoam, you could get it there. Otherwise, people just walk by and look into the window with confusion at the neatly lined rows of pork and beef, shake their heads, and move on to the produce store next door. I really admire the butcher in our town, because he clearly loves what he is doing, and when I talk to him, I get the strong feeling that he has never wanted to do anything else.

The produce store is also a vestige of another era. It sells only produce. Well, yes, there are a few canned goods and a freezer full of ice cream, but other than that, it's all legumes, tubers, and squash. There are a few other distinguished stores in my village. There is a small Italian restaurant named Pizza Boy. It's the kind with red vinyl booths and wrought-iron light fixtures with several dozen bunches of plastic grapes hanging from trellises. Pizza Boy is not like most contemporary Italian restaurants that serve risotto with arugula. It's more the kind of place where you can get a big plate of spaghetti with meatballs the size of your fist or a cheesy fettuccine Alfredo

that could stop your heart. I'm not sure why they call it Pizza Boy. Maybe they were trying to tap into the "boys" craze: Pep Boys, Bob's Big Boy, Backstreet Boys. Or maybe they thought that their original choice, Pizza Monkey, just didn't have the same ring.

Next to Pizza Boy is a video store owned by a sweet Korean couple. Video stores may soon go the way of the blacksmith shop. In an age when you can get any movie on demand on any device anywhere, anytime, there is very little incentive to get in the car and drive down to the video store, but I'm glad these owners are still hanging on.

The video store is organized like no other. They have a few new titles on DVD hopelessly shuffled in no apparent order along with older, well-worn VHS cassettes in sun-faded boxes. There is a small but growing Blu-ray section, and the only movies that seem to be meticulously grouped together in any alphabetical order are the car movies: *Car Wash*, *Christine*, *Corvette Summer*, *Days of Thunder*, and so on. This is presumably so you can run in and yell, "I need a car movie, quick!"; otherwise it is a grab bag of titles. *Jerry Maguire* is next to *What's New, Pussycat?*, which is next to *Shaft*, *Patton*, *Iron Man*, *Gandhi*, and *The Hangover*. I find the combination of titles refreshing. Sometimes I think the combined titles would make for better movies: *What's New, Gandhi?* Or maybe a kid's Saturday-morning show: *The Shaft, Patton, and Iron Man Superhour.*

Across the street from the video store is one of the three car-repair shops in our town. This one is run by Tony and

his family. We have taken our car there for years, and each time he replaces some part that I have never heard of before, like the differential or the rocker bars or points. By now he's replaced so many parts that I'm starting to feel as if it's no longer my car. In fact, for a while I was suspicious that Tony was trying to steal my car one piece at a time and replace it with one he didn't want. We started out with a 2005 Volvo and slowly, piece by piece, ended up with something that looks strangely like a 1977 Mercury Montego with a landau top. It seems odd, but I'm sure it's just my imagination.

Next to Tony's is a shoe-repair store that sells handbags, too. On the same side of the street there are three beauty and nail salons and one barbershop. Grooming must be important in our town, since the salons always seem full of ladies getting things done. The men go to the barbershop, where Razvan will cut your hair for six dollars and tell you all about the political conditions in the former Yugoslavia as you gaze at the *Sports Illustrated* swimsuit calendar or leaf through the latest copy of *Guns & Ammo* magazine. At six dollars, I find this one of the best values on the planet. Razvan doesn't even own a blow-dryer or hair spray, although he can give you something called a Vitalis head rub for an extra buck.

Oddly enough, at the salons, only a small amount of the business that goes on inside involves cutting one's hair. These places offer things like frosting, tipping, tiger-striping, manicures, pedicures, facial treatments, and bikini waxes. They can wax your legs, armpits, face, and neck. One place even had

an ad in the window for a full-body wax. I couldn't in my wildest dreams imagine someone waking up in the morning, downing a cup of coffee, and shouting, "Bye, honey, I'm late for my full-body wax," but I'll keep an open mind. Luckily, these things are handled behind closed doors in the salon, where no one can see the act of full-body waxing and, more important, where no one can hear the screams.

There is a coffee shop in our town and an antique store, but I'm happy to say that there isn't a Starbucks or a Burger King on our main street. These chains are becoming so ubiquitous that parts of my town are starting to look an awful lot like parts of your town and everyone else's town, too. It's hard to feel as though your community were still a unique place.

A hundred years ago, towns sprang up because there was a river nearby or some sort of access to water. Maybe the location was a stagecoach stop at one time or a geographically unique setting. Maybe an itinerant preacher had set up a church there.

It's different now.

If I were founding a town, I'd call Wal-Mart first, since they can put up a store in the middle of nowhere faster than anyone. Then I'd call McDonald's and Burger King and maybe some exotic fast-food place like Taco Bell or KFC. Then I'd call Boise Cascade to build some houses and Marriott to build a hotel for the people who were waiting for their houses to be built. I'd call Texaco and Shell to build gas stations, Starbucks to supply coffee, Barnes & Noble for books, Gap for clothes,

and AMC to build a twenty-four-theater multiplex. For sinful pleasure, I would call Häagen-Dazs and Cinnabon. Yes, with twenty calls, I could have my very own town.

But somewhere along the line I'd miss something. I'd miss the personal qualities that I have in my town. I'd miss knowing that when I rent *Corvette Summer* from the Korean couple, my three dollars goes to them and not their home office in Chicago. I'd miss buying a cow tongue wrapped in butcher paper or getting my car tuned up while I'm having a full-body wax next door.

There are wonderful qualities in all of the businesses that operate as chains around the country. But every time a mom-and-pop business closes and a nationwide chain moves in, we lose a small part of what makes us a community. If our homes are the soil from which our creative souls grow, then the uniqueness of that soil is crucially important.

It's hard for the corporate headquarters to know us by name or know what our needs are. Besides, Tony knows everything about my car, and the pharmacy keeps track of my preferences in nasal spray and whiskey. You are a product of your community, and it is incumbent upon you to seek out, understand, and nurture what is precious and unique about the town in which you live.

The Audience

Your audience gives you everything you need. They tell you. There is no director who can direct you like an audience.

—Fanny Brice

The audience is a generous group of people, collectively giving up their time and attention to experience your creation and inevitably also offering up a conclusion about that experience. If you've decided to venture out of the safety of your studio and put your work in the critical spotlight of the audience, you should be prepared to deal with what that audience will say about your work. You should be prepared for its honesty; in fact, you should pray for its honesty.

The audience is trusting. The audience extends an unbelievable amount of goodwill toward an artist—at least at the start. Most people go into a movie theater, for example, with openness and a fair amount of trust, letting the filmmaker take them on a journey. That open, accepting trust lasts only for a short time. From the point at which the first images appear, the audience is launched into a trance—that willful suspension of disbelief that allows us to believe in almost anything if it is presented convincingly. The situation on-screen can be impossible, as long as it is plausible. We know that the Na'vi people are not real, but in *Avatar*, we not only believe in them,

we cheer when one of them kills that nasty guy with the scars on his head. A good film completely steals your brain away from your own thoughts for a couple of hours.

The minute audience members start saying to themselves, "That's stupid" or "I think I forgot to feed the dogs," they've lost the imaginative connection to the screen and have started focusing on their own thoughts again. The most involving films have a way of keeping you so immersed in the experience on the screen that you willfully suspend your disbelief and go along for the ride in the hands of the filmmaker.

Now, take that same audience mentality into the art gallery. When I first started looking at paintings in galleries I felt a need to have this big inner monologue with myself about the composition or the technique, when all I really had to do was simply open up and trust the painter. Some paintings completely enmeshed me into the frame and engaged me emotionally, and others left me cold, swamped with thoughts about why the artist did this or that.

When we see an engaging piece of theater, we are swept into the story by the emotional content of the live performance. We don't notice the lights or the props or think about how much work the costumes must have taken to make. All those are thoughts that will occur to us only if our minds aren't on the story. If our minds are on the story, we once again willfully suspend our thoughts and are enveloped by the spectacle in front of us.

People love to be emotionally connected to art either through stories—as with opera, film, or literature—or

through music or paintings that evoke emotions. Even in works that have no narrative, like Brahms' German Requiem or a Beethoven symphony, we are still transported to a place of incredible emotion.

For the creators of art, the audience is a spiritual partner— our link to humanity. When we write a poem or a song, or when we sketch or throw a piece of pottery, we are doing it to communicate life. This is never more the case than in live theater. Theater is a tactile, real experience. We feel the effect of the actors' gestures, their sweat, and their tears. We join together with them onstage and agree to reinvestigate the everyday with fresh eyes. At its best, the social experience of the theater transforms us, and the venue becomes more than just a place of entertainment. It becomes a sacred place where humans share their humanity.

The arts have a way of focusing us as an audience. Music has a way of taking a roomful of people and focusing their attention on a single emotion. It's unique among the arts. We as the audience trust the creator of the music to take us by the hand and illuminate an emotion or reveal a truth that we may not have seen. The closest comparison I can make is to sports, when you have a stadium full of baseball fans focused on the crack of the bat and a small, white ball sailing toward the outfield fence. At that single moment, the com-bined attention of 40,000 people is fixated on a single white dot. Will it go over the fence? Will it be caught? Will we win? Will we lose? It all comes down to that tiny white dot and the laserlike focus of that huge audience. The arts are like

that. The best of musical and visual arts can take a crowd of people from diverse backgrounds and focus them on a pin-point of emotion.

It is our job as artistic creators to take the audience on that kind of experience and give them that kind of focused experience.

4.

Forces

Every body persists in its state of being at rest
or of moving uniformly straight forward, except
insofar as it is compelled to change its state by
force impressed.

—Sir Isaac Newton's
first law of motion

You're probably filled with the passion and desire to find a more creative place in your life. So now what? How do you master the forces that drive your creativity? Not forces like gravity or magnetism, but odd-sounding forces like simplicity, spectacle, and truth. Here are a few creative forces that make my pulse race and my face flush with color. (I tried to focus on a short list of forces of creativity. Of course there are other forces, too, like dark chocolate and strong coffee.)

Education

If you are a normal human being, all the blood just drained from your face when you saw the word *education* appear on this page. Universally, in every culture in every land, people say that education is at the top of their list of objectives for their society, but walk into a cocktail party and start talking about education, and witness an exodus. Of course we want education for our families and ourselves, but do we really have to think about it now? After all, that's what our school boards and our state and local governments are for: educating our precious young.

There's where we're wrong. First of all, there was virtually no public education before the nineteenth century. It sprang up in Victorian times to bring literacy to all in an effort to give children the tools they would need to fill the assembly lines and desk jobs of the industrial revolution. People knew there'd be a need for accountants, laborers, and managers in the workplace, along with doctors to take care of them and policemen to keep the peace.

Education was a means of giving the common man the fundamental tools to exist in an industrialized society. It still is. And education itself has become an industry. In the next thirty years, more people will graduate from colleges and universities than have graduated since organized schooling began. A huge workforce is on the way—all with college diplomas,

all looking for jobs in the industrialized world. Either you will be one of these people, or one of these people will be after your job.

Children starting school now will retire in 2070. We don't have a clue what the world will look like then. Most of us don't have a clue how to fully prepare our kids for a field trip today, much less ready them for life in 2070.

While I acknowledge that there are amazing people working in education who are far more qualified than a cartoon producer to question our curriculum, here's a thought. Let's not train kids for jobs only. Let's train them to be adaptable, creative, and improvisational so that they will be able to move with the flow of time. Let's train them to ask questions and offer up answers without being afraid to make mistakes. Kids have a vast, unending, built-in capacity for creativity.

Kids will take a chance. If they don't know, they'll try. They are not frightened of being wrong. In modern education, we stigmatize mistakes with failing grades, and we create a deep fear of them. We educate kids into a small, safe place of right answers, when in reality the world is made up of questions that have no right answers.

Every education system around the world, without exception, has the same hierarchy of subjects. At the top are subjects we all need: mathematics, languages, and the humanities, and at the bottom, the arts. It's universal. But what if visual expression, musical expression, and movement were as important in education as literacy? And what if we treated them the same?

Creativity is diverse; we think visually and with sound and we use the whole body to express ourselves, sometimes with gesture or abstract movement. How many schools teach dance to every student the way that we teach math to every student? We all have bodies, and we use them not just to carry our brains from place to place. To create is to call on every aspect of our brains and bodies to fire in an interactive storm of connections. We don't need to be taught this when we're children; we know it already. But we do need to give kids permission to hold on to all those attributes as they mature.

So often we abdicate responsibility when it comes to education, thinking of it as something for someone else to take care of. I have great respect for all my teachers, who are in no small part responsible for what I am today, but in the same breath I promise you that no one out there is going to pay more attention to your education or your child's education than you. If education is a force, then it is *your* force to control, and not a force for you to delegate to someone else.

Change your concept of education from something that is supplied by the state to a force that is yours to use as a tool to investigate the richness and limitless capacity of human beings to be creative. Otherwise, no matter how noble your intentions, you are using education as a manufacturing operation in which each kid is trained as a commodity to fill a desk in some future world that you don't yet understand.

Craft

Craft means ability, skill, knowledge, command, expertise, mastery. It can also mean slyness, cunning, cleverness, craftiness. Craft is knowledge cleverly applied. Pasteur wrote, "Chance favors the prepared mind." The more you know about your craft, the more force you can exert on your creations.

Everyone has to learn his or her craft. When life begins, most animals have some sort of innate and instinctive mechanism that allows them to survive and prosper. Horses know to give birth at night to avoid predators. They carry a kind of genetic memory that their ancestors have passed on to them. Some animals have a special guidance system built into their genes. Geese know when to fly south, bats know how to navigate by sound, and some birds even know the patterns of the stars so they won't get lost during a nighttime migration. Humans have very few genetic migratory urges—with the possible exception of the male Thanksgiving migration from dining table to sofa.

Unlike our cousins in the animal kingdom, much of what we need to prosper as human beings is not instinctive. We don't normally emerge from the womb singing show tunes and doing long division. We don't even know essential life skills like how to brush our teeth or bunt a baseball, or that you should stop wearing white after Labor Day. All of these things have to be learned.

To learn something, we need to pay attention, and attention is a very precious commodity. First, we need to carve out the time to focus on our craft, and second, there is only a limited amount of information the brain can take in at one sitting. Make no mistake—it's the work on craft that makes for great achievement. Kobe Bryant carries a handheld DVD player with him so he can study his games or those of the players he will face in a coming series. Great artists like animator Glen Keane have drawn millions of drawings to get to their high level of accomplishment. It's the work and focus that help us master our craft.

If we need ten thousand hours of real experience before we can start to achieve at a high level, then the sooner we attain that milestone, the sooner we get to the better work. The sooner we get ten thousand bad drawings out of our system, the sooner we get to the good drawings. The one consistent, irrefutable truth that all great creative people have mastered is this: it's about art *and* craft.

Andre Agassi was a tennis legend and master of his craft. But the story of how he got to the top of his game is harrowing. He recounts in his autobiography, *Open*, how his father, Mike, an ex-Olympic boxer, taped a Ping-Pong paddle to Andre's hand to teach him the perfect swing. He was a kid just out of diapers. Mike bought a house in the Las Vegas desert because it had a yard big enough to build a tennis court on. He created his own ball-serving machine and called it the Dragon. The machine could serve up balls at lightning speed all day long. Twenty-five hundred balls a day. Mike's

theory was that if Andre hit twenty-five hundred balls a day, he would hit one million balls a year. Nobody could beat a kid who had hit a million tennis balls.

At age thirteen, Andre was sent off to Nick Bollettieri's Tennis Academy, in Florida, a place where the kids went to classes in the morning and did tennis drills all afternoon. Off the court, they lived a *Lord of the Flies* existence. Andre hated tennis. To rebel, he cut his hair into a Mohawk and grew his fingernails long. He was so bored with his academic studies that he dropped out of ninth grade and just played tennis, hoping that at least this would please his dad. At best, he'd be expelled, and could get out of what he saw as a prison and go home. Neither happened.

What happened was that Andre became a tennis player who went pro at the age of sixteen and whose life had become unbearable. Years later he was stuck in a sport he hated, and his marriage to Brooke Shields was failing. He turned to crystal methamphetamine to escape. He failed a drug test administered by the Association of Tennis Professionals, and wrote a desperate letter in protest, claiming that his drink had been spiked. It was a lie, a call for help, and a turning point in his career.

Here's a guy who hated tennis, and had learned his craft through the brute force of an overzealous dad. He survived meth abuse, a broken marriage, and a string of bad mullets to come back from the brink of personal disaster and win sixty men's singles titles, including eight Grand Slam tournaments, and become the top-ranked player in the world.

By the time he retired, after the 2006 US Open, he'd earned $30 million in prize money and much, much more in endorsements. He could have walked away, but instead he came back home to Las Vegas, and used his name and resources to build a school for kids to get the education that he never got. The Andre Agassi College Preparatory Academy is a tuition-free charter school for at-risk kids, and, in 2009, it graduated its first senior class with a one-hundred-percent college acceptance rate.

In his commencement speech to the first graduating class, Agassi said, "I realized that tennis wasn't my life; tennis was my job. Life was my life. And doing work that could impact other lives, work that could help others to change their lives, was what made me feel good and hopeful in the ten minutes before I fell asleep each night." Now that's using your craft!

Earn the Red Nose

I'm a huge fan of an actor named Bill Irwin. Bill has had a great TV and film career in everything from *CSI* to *Sesame Street*, but at heart, Bill is a clown. I don't mean just clowning as in having a good time, but real circus clowning. Bill wanted to know everything there was to know about clowning, so he read about it and studied the great clowns of

recent history: Emmett Kelly, Red Skelton, Charlie Chaplin, Buster Keaton.

Bill went to the Ringling Brothers Clown College to study the craft. The school, which operated for some thirty years before it closed in 1997, was a unique institution for several reasons. First, the ratio of applicants to students admitted made acceptance there statistically more challenging than acceptance into Harvard Law School. Would-be students wrote extensive personality profiles that gave the faculty an opportunity to gain an understanding of the applicant's psychology, interests, and previous experience.

At the Ringling Brothers Clown College they taught juggling, stilt-walking, and pie throwing. Students heard lectures with titles like "An Introduction to the Spit-Take" and learned the art of dousing one's burning butt in a pail of water while yelling the obligatory "My biscuits are burning!" or "Fire in the hole!"

Another class covered rodeo clowning or, as it is now called, "How to Be a Diversion Artist." It takes great skill and knowledge to distract three thousand pounds of angry bull while wearing nothing but chaps and a smile. Some great entertainers like Bill Irwin and Penn Gillette (of Penn and Teller) were grads of this exclusive school.

These guys take clowning seriously. You can't just show up one day with big shoes and a red nose and call yourself a clown. They commit to immersion in their crafts before they can even begin to call themselves clowns. If there are schools for clowning, then surely there are places where you can go

to learn everything about the tools and fundamentals of your chosen craft.

If you want to be a writer or an animator or a chef, don't just expect to show up with big shoes and a red nose and automatically be one. Immerse yourself completely and with commitment—and earn the right to wear the red nose.

Finally, the part of craft that is hard to teach is the sly, clever, cunning part. To be clever suggests to us being able to present a fresh, unexpected way of doing things—an approach that skirts convention and exceeds our expectation. Learning our chosen craft is a lifelong proposition. One might even say it's a lifelong *preoccupation*. We can always get better at and more insightful in our creative expression if we adopt the idea that we never truly arrive at a point where we can say with any confidence, "I know my craft." Artists attend a lifelong university, majoring in everything, minoring in nothing, and without one big commencement ceremony at the end.

Tools and Technology

Technology as we know it is pretty much a twentieth-century word. It means the use of tools, techniques, crafts, or systems to control and adapt our natural environment. Control our environment? Now that's a force!

When we create, we set out on a journey to bring a mental image to life. The more we can master the tools (brush and paints, software, cello—whatever the tools of our trade) the more we can assert our creative vision and turn thought into reality.

A tool can be a computer or a pencil. Each has a function, and each can create in the hands of a human. Each is a form of technology. The pencil is a very familiar tool since we've been using it for a long time, but there was a time when the pencil was new technology.

In about 1564, the English found a huge deposit of graphite near Burrowdale and started using it to mark their sheep. Graphite left a darker mark than lead, but was soft and brittle and required a holder. So early pencils were bits of graphite wrapped in string or inserted into wooden sticks that were hollowed out by hand.

By the 1660s, they were being mass-produced in Europe, and came to America as imports. Ben Franklin offered them for sale in his *Pennsylvania Gazette* as early as 1729. William Monroe, in Concord, Massachusetts, made the first American wooden pencils, in 1812; years later, another Concord-area cabinetmaker, Henry David Thoreau, made pencils, too.

During the 1800s, the best graphite came from China, so pencil producers in the US needed a way to let buyers know that their pencils contained it. They painted their pencils yellow.

Over the years, a number of patents were filed for the process of making the pencil and for supporting hardware

such as Bernard Lassimone's pencil sharpener, patented in 1828, and Hyman Lipman's 1858 patent for attaching a rubber eraser to one end.

We often fear technology. There are entire social movements against technology, like that of the Luddites of nineteenth-century England, who went around smashing looms and fighting the industrial revolution. Technophobia still is alive today. One could argue successfully that technology has taken jobs and polluted and destroyed the earth. But technology has also lengthened the span and quality of our lives and given us everything from refrigerated food to noninvasive surgery to the iPhone.

In our attempts to navigate creativity, the tools and technology of our times are nothing to fear. Art and tools have been joined together since the first cave paintings, and all technology—from the pencil to the most cutting-edge computer—has great potential to extend and complement our lives as creative and innovative creatures.

Light

Light is everything. It is a life-sustaining force. It is a force at the center of nearly every religious and spiritual movement. It is a force at the center of science: Einstein's theory of the universe linked the four corners of Newtonian physics—space

and time and energy and matter—to one thing: the speed of a beam of light.

Light is a force in the arts. Society relies on innovators and artists to illuminate the truth. Creating brings things into the light.

In religion, in physics, in art, in life, light is everything. There is a prevailing and ageless concept among all humankind that light is a gift from a greater source.

Diwali is one of the biggest festivals of the Hindu year. In this festival of lights, fireworks dot the sky, and earthen lamps, candles, and colored lights fill the darkness of night. It is a celebration of light as a gift from God that reveals the beauty of this world and serves as a symbol of whatever is positive in life.

To Hindus, darkness represents ignorance, and light is a metaphor for knowledge. Therefore, lighting a lamp symbolizes the destruction, through knowledge, of darkness and the negative forces of fear, injustice, oppression, and suffering.

Judeo-Christian scripture is full of references to light, from "Let there be light" in the book of Genesis to the Psalms' "The lord is my light and my salvation; whom then shall I fear?" Jesus of Nazareth called himself "the light of the world" and said, "He that follows me shall not walk in darkness, but shall have the light of life."

The Koran calls God the light of the heavens and the earth. Numerous Native American religions share a common thread: some sort of great spirit that is manifest in various colors of light. Others, from the ancient Romans to the Incans, have worshipped the sun god—light.

Light also represents heat and intense physical energy. The advertising world knows it as "don't sell the steak, sell the sizzle"—the energy, the light. The orange light of the setting sun in commercials for cars, jewelry, and hamburgers elicits feelings of contentment, romance, and warmth at the end of the day.

Painters have a special relationship with light. Chiaroscuro is the technique most identified with Rembrandt and Caravaggio, whose paintings made light advance from a sea of darkness. Other artists, like Turner and Van Gogh, filled their canvases with abstract impressions of light and color. Film noir directors used similar methods.

The absence of light is forceful, too. So much so that humankind has developed a way of dealing with the fears of the loss of light during the darkest days of winter. For thousands of years, people have celebrated a wintertime festival on or around the shortest day of the year. Early pagan celebrations featured anything-goes celebrations like the ancient Festival of Fools, in which people dressed in costume and ran through the streets with drunken disregard (not unlike fans during an Oakland Raiders game). These secular celebrations on the darkest winter days were eventually co-opted by the Christian tradition, which needed a holiday to celebrate the birth of Christ. The Christmas celebration, with its yule logs blazing and its evergreen trees decorated with bright candles and other ornaments, became a reason to bring the light inside during the longest, darkest nights of winter.

Our human rhythms are physically affected by the changing light of the seasons and by the light of the rising and setting sun. We respond in subtle and endless ways to changing forms of light. The manipulation of this powerful, primal force is central to painting, film, photography, theater, architecture, sculpture, and nearly every other creative human endeavor—from fireworks celebrations to candlelit dinners for two.

Chaos

The important things are simple.
The simple things are very hard.
No battle plan survives the first shot.
Perfect plans aren't.

—Murphy's Law of Planning

Chaos a force? Yep, and a big one. The random nature of nature, of seeds blown into the wind and lives changed in an instant, is incredibly powerful. It's important to recognize the randomness and chaos of our thoughts and daydreams as a positive thing. Many of the theories on the creation of the universe have their roots in a kind of divine chaos. Chaos is vibrant energy waiting to be harnessed.

It is not the chaos that creates, but rather the way we

choose to react to the chaos. In our accidental universe, the way in which we react determines our entire life path.

Chaos is the soil of creativity. It is the fertile ground from which all ideas spring. The universe itself sprang from the chaos of a cataclysmic explosion, and nature's creations come almost exclusively out of the chaos made by the elements: earth, wind, fire, and water.

Our caveman brain associates chaos with the disruption of order and sees it as an open threat to our comfort. We have done everything to protect ourselves from chaos. We have invented clocks, calendars, meetings, seasonal accessories, and day planners. We have standardized a once-chaotic language by means of dictionaries that make definition and pronunciation uniform. We have labeled the universe with Latin names and created whole industries that teach management, order, and control. We can't imagine why we should have an interest in disorder, anarchy, and confusion.

Chaos is raw energy waiting for direction. If we try to direct the energy too soon, we may snuff it out. In our business or our personal or artistic lives, chaos is loud and scary. Our impulse is to shut it down as quickly as possible. But just for a brief and scary moment, let the chaos reign, and try to listen to what it is saying. People never sit still during chaos. It is almost always an uncomfortable and unbearable thing for human beings to tolerate. People talk during times of chaos. They literally explode with ideas, opinions, and panicked cries for order. From that apparent panic comes a wellspring of deeply felt emotion and profound ideas

for change. As uncomfortable as it is to bear these times, there is a galvanizing quality to a chaotic experience. The great ideas of politics, medicine, and art have often come from an unstable era during which great men and women were stirred into action by the chaos of their time.

In some cases, chaos comes slowly. Most projects start with a wave of careful planning, optimism, and hearty handshakes. The test comes when the project, along with the elements that were once carefully in place, all slowly erode into disarray. How we deal with that midproject chaos separates the great from the feeble. We are not always able to put order into chaotic situations, but all we can hope for, as Willem de Kooning once said, is to put some order into ourselves. If we appreciate that chaos is the soil from which all creation springs, then we will learn to welcome it, if only for a moment, and listen to its cries. Therein lie opportunities of great risk, great stupidity, and great genius.

Balance

The definition of balance is simple—not falling over. Balance is seen in everything from the alignment of the planets to an ant carrying a leaf. Sometimes it's the balance between good and evil, or comedy and drama. And sometimes it's the balance between work and play or cheesecake and broccoli. Not

surprisingly, much of art and drama comes from an expression of imbalance in life.

You read a lot about stress reduction. Scientists are working on a "cure" for stress. The problem really isn't stress; the problem is an imbalance of stress. The pain of stress can be a positive force in igniting our creative fire and can help drive us toward the completion of an idea. If you define stress as pressure, tension, and strain, then the opposite, balancing component would be release. The tension between characters in a play creates drama, and the resolution of that tension usually means justice and a return to balance. Action-movie plots are a convincing stream of moments of tension and release.

The very act of creating requires an almost endless flow of tension-and-release experiences. Call it frustration and discovery, or research and breakthrough, or even impression and expression, and you'll have the general idea. Stress is the tunnel through which we navigate to get to the other side.

Balance also has a million applications in business and the arts. In business, it can mean the relationship between product and marketing or investment and return.

Painters balance forms: soft versus hard, curved versus straight. They balance size, space, texture, and colors.

Composers balance their music by contrasting forms. Most symphonic forms of music balance a heroic opening with a slower, second movement followed by a fast movement, and so on.

And then there is the issue of balance in life itself. The

pages of art history are strewn with stories about unbalanced people and the art they create. This may lead us to believe that imbalance is a trademark of artistic greatness. It is not. There is no compelling evidence to suggest that you must be eccentric and nuts to be creative.

In color theory, artists talk about the color wheel, in which all the colors of the spectrum are arrayed. There are analogous colors that lie right next to each other (red–orange and yellow), complementary colors that oppose each other (red and green, yellow and purple), primary colors (red, yellow, and blue), and secondary colors, which you get when you mix the primaries together (orange, purple, and green). Great paintings find a balance among colors. Even though the painting may be predominantly yellow or blue, it relies on all of the colors to make it complete. Corot used to put a small dot of red in the middle of a big green painting full of green trees and grass. This tiny dot—in a color that is completely opposite on the color wheel to green—made his greens stand out even more.

Look for an opposite to balance your work. If you are an accountant, take up dancing. If you are a musician, follow the stock market. If you like to cook, go out and play a little football from time to time. That speck of contradiction will give your creations great range and color.

Let's say you're a businessperson and you are trying to bring more creativity into your life. You should indeed read those books about ten ways to a better bottom line and such, but you'd do yourself a bigger favor by introducing a

balancing element into your life. Pack up and travel to Tibet, read a good piece of fiction, get into a heated political discussion with your father-in-law, buy a foreign newspaper, eat a fine meal, paint a painting, or take a singing class. If we broaden our base of experience, those outside influences will begin to cross over into our day jobs.

From the time we attend grammar school to the time we enter the job market, society encourages in us the development of professional strengths and tends to discount mental balance and wholeness. We are even encouraged in unspoken ways to follow career stereotypes in educational systems that embrace the theory that art has no scientific basis or that business is not creative. Modern culture even rewards this thinking, because it needs specialists to achieve its short-term goals. It's not natural to encourage balanced, unfocused education. This focus on preparing only for the job tends to limit our need to think expansively. From the moment we decide what our careers will be, we focus in and disregard the brain's capacity and its need for input from all of life's sources. We get frozen in our mental attitudes at a pretty young age. The task before us is to thaw out and reawaken the interests that might bring more balance to our lives and wholeness to our thinking.

Curiosity

There was a child that went forth every day;
And the first object that he look'd upon, that
object he became . . .

—Walt Whitman

When we were children, our curiosity was boundless, or so it would seem. Everything was interesting to us: bugs, leaves, toes, trees, pigs—everything. As we mature, we are still furiously curious, but what we tend to do is to focus our curiosity on one line of work and then eventually down to one topic that becomes our life's work.

I have a friend. We'll call her Inge Voitberge. At a young age, Inge was interested in everything. She loved drawing and history and journalism and badminton. As Inge got older, she became fascinated with government and, over time, decided to study law. After law school, she decided to work as a lawyer in trademark-infringement protection for a major company, where she still works today.

There is nothing at all wrong with Inge; in fact, she has followed the path of her curiosity to a small corner of the legal profession that suits her well. She has gradually discarded the need to investigate other areas of life and has chosen to follow her passion and insatiable appetite for everything related to trademark litigation.

Now, I enjoy a good trademark as well as the next guy. The Michelin Man is nice, and I like the Nike swoosh, but I can't imagine spending my waking hours poring over the latest in trademark law. Our ability to focus our energies on a specialized field of study allows us to take what may be our very expansive mental capacities and focus them on a tiny detail. Someone pursuing the arts similarly needs focused concentration. The greatest artists, be they ballerinas, painters, or even trademark attorneys, keep their focus small and their curiosity wide. The nut to crack with creativity in any career is that one must cultivate a lot of curiosity about a lot of things, and then bring that knowledge to one's very specialized chosen field of focus.

Composition

The composition of elements—active versus passive, bright versus dark, loud versus soft, violent versus peaceful—is at the core of artistic expression, be it a painting or a master plan for a city.

I always think of cooking when I think of composition (I always think of cooking anyway, but this gives me a legitimate reason). Cooking ingredients are important. Stir-fry, for example, can be very artful. Before the creation begins, the chef prepares a recipe and chops quantities of onion, chicken,

shrimp, squash, pepper, garlic, and spices. The pan is heated and prepared with oil, and then the event happens. The chef instinctively mixes the ingredients in the right order and at the right time to produce a perfect dish where the chicken is done but the veggies are not limp.

In a painting, the ingredients may be a tree, a cloud, a mountain, and a stream. The canvas and palette are prepared and the intellect is made ready to assemble the ingredients. The painter instinctively mixes the objects in the right order to produce the perfect painting in which the arrangement of objects and the application of the technique are just right.

A writer can work the same way. Before the writing begins, the writer prepares an outline and lists of characters, locations, research, and possible scenes in a story. The writer sits poised in front of the blank page and this set of parts is ready to be assembled. The writer is always searching for that perfect composition in which the literary chicken is done and the veggies are not limp.

Classic story composition owes a lot to three-act structure, which is something that Hollywood borrowed from Aristotle. "Aristotle's incline," as it is called, is the art of sending your character through a series of escalating obstacles until he finally triumphs against his greatest fear. For some reason, we humans have found this a very reassuring story structure ever since the time when we sat around the primordial campfire eating bison, wearing bear skins, and telling stories (which for me was just last August at a Disney executive retreat—more on that later). We love to hear the story again and again. We

thrill to that constant build of tension and complication that results in a hero saving the day against his greatest fear. We love it because on some level we see ourselves in that story, and we can relate our journey to the hero's journey. If he can win against such formidable odds, then maybe we can too.

It's writing for Hollywood 101:

Act I: Introduce your character and chase him up a tree to get him in peril (the inciting incident).

Act II: Get him out on a limb and start throwing rocks at him (complications ensue).

Act III: Get him down out of the tree via an act of personal heroism against his worst fear (the resolution!).

Simplicity

Simplicity is the ultimate sophistication.

—Leonardo da Vinci

Simplicity. To some, the word means elegance, grace, and sophisticated restraint. To others it means weakness, naivete, and ignorance. In our culture, where our lives are complex and multilayered, we sometimes fear that simplicity—whether

it is in design, technology, or business planning—is somehow a sign of weakness. It is not.

To create with elegance and restraint is what every child does naturally. To the child, the sun is a yellow circle, and a bird is a V in the sky. A house always has a chimney, and a face has two circles for eyes and a triangle for a nose.

As we mature, there is a natural human tendency to add complexity. The details of life become very important, and we often miss the simplicity of the underlying forms. As an adult, the sun is a confusing array of fiery gases that blinds our eyes, and the human face is so wondrously complex that we have given up trying to draw it.

In art school, much time is spent learning how to see simple underlying forms. Great artists, and for that matter great scientists and great businesspeople, have the ability to look beyond the crushing details of the real world and see the simple underlying ideas upon which life is built. Can an idea be simplified and reduced to one sentence? Can a drawing be made with one or two lines? Can a business plan be captured in one statement? Great things are built on simple foundations.

Great stories can be expressed in one high-concept line also known as the elevator pitch, in the event you need to tell the whole story and make a movie deal in an elevator (more common than you might think):

- A despondent man gets a chance to see what life would be like had he never been born.
 —*It's a Wonderful Life*

• A businessman risks everything to save Jews during the Holocaust by hiring them to work in his factories.

—*Schindler's List*

• An outcast baby elephant becomes the star of the circus when he finds out he can fly.

—*Dumbo*

• The adrenaline addiction of a bomb-disposal team challenges family and tests the limits of military duty.

—*The Hurt Locker*

There is great complexity and diversity in each of these stories. Being able to distill each of them into a simple sentence provides both focus and a united vision for the team of filmmakers.

Simplicity is elegant and sometimes even naive, but it is not weakness. In a complex and detail-laden world, simplicity is a very powerful thing. Life is noisy and complex. Simplicity is a strong and compelling counterforce.

A blank page in a cluttered magazine has power.
A silence in a symphony has power.
Vanilla ice cream has power.

Spectacle

One day, my sixth-grade teacher, Mrs. Wills, sent home a notice to all the parents stating that she was taking the kids to see a movie. But not just any movie. We were going to go see *Camelot* at the new Cinerama Dome in Hollywood. I'd never heard that word before—*Cinerama*—but Mrs. Wills promised that it was something special, so we all signed up to go, since Mrs. Wills certainly knew her special things. We had studied the story of King Arthur for weeks before the field trip and knew all of the salient points of the legend and what to look for in the movie.

After a long trip in a hot, yellow school bus, we arrived on Sunset Boulevard in the parking lot of a big domed structure. This was around the time Buckminster Fuller had made a big splash with his geodesic dome, and it seemed as though everyone was building one. The only difference here was that this one promised the biggest screen in the West.

Wow, I said to my impressionable prepubescent self, flashing back to the jumbo dancing corn dogs at the Rosecrans Drive-In, *this oughta be somethin'*. We lined up in twos and filed in through the front door, where we were each given a giant-size popcorn and a bladder-challenging Coke.

As I walked in the door, the first thing I noticed was that there was no screen. They were hiding it behind huge

curtains. I sat next to my friend Toad, and we happily jammed our mouths with popcorn and slurped generous portions of Coke while we waited.

At the stated hour, the lights dimmed and the curtains began to open. It grew quieter as the curtains parted further. *Oh my god*, I thought, *it's huge.* The curtains were still parting and the white screen was becoming bigger than my back-yard—bigger than the Rosecrans Drive-In. "Holy crap . . . it's massive," Toad whispered. "Oh man, oh boy . . . this doesn't suck . . . oh man . . . it's huge." I nodded in agreement, for who could possibly disagree with Toad's form of haiku?

As the opening scenes unspooled, we got our first glimpse of Richard Harris prancing about, smiling a wicked smile that easily measured ten yards across. He was ruggedly handsome, with piercing eyes and a towering nose the size of Guam. Then came Vanessa Redgrave, draped in flowing robes that seemed to fill my entire field of vision. She smiled a ten-yard smile, her beautiful eyes the size of sperm whales. The scale was meant to create a sense of spectacle and an aura of respect for the story being told.

Mrs. Wills had told us about Lancelot, but still there was an audible gasp when Franco Nero appeared, resplendent in his fifty-foot-tall tights, sporting a codpiece the size of a Buick.

I had never seen a screen so big, eyes so big, a Coke so big. There was nothing like this in Bellflower. Toad and I swore that when we were old enough, we would come back to Hollywood again together and see more spectacles one day. We never did.

Surprise

There is something in our genes that enjoys a good surprise. We love watching magicians, opening birthday presents, playing peekaboo, playing hide-and-seek.

At the first hint of impending surprise, our pulses quicken and our eyes widen. The surprise may be wondrous or terrifying. A surprise represents a turning point in life. Something good or something bad usually happens as a result of a surprise.

A letter arrives in the mail and contains a check for ten thousand dollars. Another letter arrives in the mail and contains a notice that your husband is leaving you. Both are surprises and both are life-changing.

We have had so many surprises in our lives, and the tension and release that come with surprise is so satisfying to us that we always look forward, albeit with mixed feelings, to the next one. As we grow older, it becomes more difficult to be surprised. The birthday clown just doesn't do it for us anymore. Our yearning for surprise fulfills itself in activities like travel, reading, or watching the evening news—all activities where we sit patiently waiting for the next jolt of delight.

Magicians and filmmakers have always valued the basic human joy in surprises. Magic shows and horror movies are full of surprises. One thing that has united the great artists, scientists, dancers, and poets—indeed, every great creative

spirit—is the ability to surprise with his or her work. We come to a gallery or a theater or to a printed page with a certain expectation. Our enjoyment of the work is directly related to the way the artist exceeds our expectation. The surprise can come in the form of shock or in the form of profound insight or in the form of comedic delight or physical human prowess, but the surprise is the thing.

Aristotle would have appreciated this. It is our creative, imaginative side that helps us peer through the muck and mire of everyday life in search of the surprises that present possibilities for a happier life.

Memory

> Every man's memory is his private literature.
> —Aldous Huxley

I'm in awe of people who have great memories. I was having dinner in New York with a group of director and animator friends, and we got one of those waitresses who didn't use an order pad; she simply took mental note of each person's order, and then left without writing down a thing. It wasn't as if we ordered a round of pizza and beer, either. It was a restaurant with a menu full of choices and daily specials, so each person ordered an appetizer and a main course from a list of

seemingly endless possibilities. How did she remember who ordered what? I figured she used one of those key-word techniques you read about. For example, if you want to remember a name like Bonnie Brownlow, you may associate Bonnie with the Scottish word for pretty or happy and Brownlow with something down low that is brown, like dirt. Bonnie Brownlow is now unforgettably Happy Dirt. Only, sadly, the next time I see her I can remember only the words *happy dirt* and stare blankly at her for minutes thinking, *Happy Dirt, Happy Dirt, Happy Dirt.* I can't for the life of me remember what it stands for.

But I digress. Anyway, I'm convinced the waitress associated each of us with our order to remember who ordered what: the guy with the black hair ordered seared tuna; the guy who couldn't decide ordered the flounder; the short guy ordered shrimp; the bald guy ordered the angel hair pasta; and the guy who was middle-aged and forty pounds over-weight ordered the prime rib. I can't believe the memory that woman had. She would even stop to answer questions people had, and she *still* remembered everything. I thought briefly about hiring her myself. She could follow me around so that when I met people and forgot a name or something, she could give it to me.

ME: Oh, hello . . .
MEMORY GIRL: Bob.
ME: I haven't seen you in a while, not since . . .
MEMORY GIRL: we had lunch at the holidays.

ME: How's . . .

MEMORY GIRL: your wife, Gail, and your two
 lovely daughters?

ME: Are they still . . .

MEMORY GIRL: into ballet and soccer?

ME: Maybe someday we can . . .

MEMORY GIRL: work on that joint venture with
 PBS and Britain's Channel Four chronicling the
 Olympic marathon runner from Swaziland.

ME: See ya later . . .

MEMORY GIRL: Bob.

ME: Oh, and . . .

MEMORY GIRL: thanks for the thoughtful message
 you enclosed in your birthday card. It really
 made my day.

Sense memories are powerful things. Actress Jessica Lange said once that she carried a handkerchief with her onstage in *A Streetcar Named Desire* with the cologne of a childhood sweetheart, and whenever she launched into her role the smell of his cologne brought back feelings from her past that flooded her character. Just mentioning a phrase can elicit a strong sense memory.

> The feel of freshly washed sheets.
> A candlelit dinner table.
> Driving a brand-new car.
> Out-of-control speed on skis.

Cat purrs.
Crickets on a hot summer night.
An ice-cream headache.
Dill pickles.
Cold, day-old pizza.
The shirt you bought in Hawaii.
Cold milk and warm chocolate-chip cookies.
A Starbucks venti soy latte.

As a tool for the creator, sense memories are very powerful forces, since they elicit a physiological reaction to the work and often a connection to a time and place. We bring our own emotional memories to the art gallery, cinema, or theater. If we are truly engaged by what we see, we get to not only enjoy a show, but also revisit the most profound, sensual, and emotional moments of our lives and bring them to bear on the work we are viewing.

We recognize a piece of music as our first dance, the smell of a wood fire evokes our weekends at the family cabin, a film reminds us of our own life in a way that we can relate to it and be moved by it. Our brains are very quick to complete images or phrases or bits of drama based on our recognition and memory of similar situations.

These sense memories are part of the palette of creativity. Artists, musicians, writers, and dancers all draw on these sensory emotions to create pieces that are not just superficial exercises, but deeply felt emotional experiences.

My one and only experience as an actor was in my high

school's production of Thornton Wilder's *Our Town*, in which I was cast in the less-than-starring role of the "belligerent man at back of auditorium." I got this role mainly because I didn't quite qualify for the two other bit parts, "woman in the balcony" or "lady in a box." My character had to stand in the back of the theater and shout a question to the stage manager (played by my idol, Harry Cason, a senior) and then storm back to his seat. I rehearsed my line in the mirror for what seemed like months: "Is there no one in town aware of social injustice or industrial inequality?"

It was opening night. Our moms and dads settled into their seats, the lights dimmed, and the curtain rose to begin the play. I wanted to use the Jessica Lange method and evoke a sense memory that would make me feel the part of an enraged citizen. I needed a scent that would remind me of mature outrage and social responsibility. I chose a cologne that was called something like "Sex Panther" (which I was told was illegal in nine countries). I not only splashed it on my face and neck, but I also poured it into a handkerchief I was carrying in my coat pocket. I felt locked and loaded, ready to emote. My big moment came in the middle of the first act; I had what seemed like hours to review my line. Should I pronounce it as *social* injustice or social *injustice*? A throat clearing might be nice. I wasn't sure what industrial inequality meant but if it was okay with Thornton Wilder, then it was okay with me.

After reciting pages' worth of beautifully delivered monologue, Harry Cason peered out from the stage and

asked, "Are there any questions from the audience?" This was it—my cue. I stood up, cleared my throat, paused, and took out my handkerchief for one last whiff of Sex Panther. I felt outrage, a mature outrage that made me want to grow a mustache, eat cured meats, and participate in motor sports. I felt the raw power of ten score people looking at me. The entire history of Western drama seemed to rest on the padded shoulders of my Sears sport coat as I shouted belligerently, "Is there no one in town aware of social injustice or injustial intemology?"

I sat down. Strangely, no one seemed to notice my impassioned plea for something that sounded vaguely like unjust insect study. Several people came up to me afterward and asked what cologne I was wearing. Thanks for the tip, Jessica Lange.

Dreaming

Our conscious thoughts seem to follow a logical, predictable path. We think, *What will we have for dinner? How about pizza? No, we had that last night . . . spaghetti? No, too starchy. What I really feel like is some sheep guts mixed with oatmeal and spices and boiled in the animal's stomach for three hours . . . that's it!* Our thoughts move in a pretty orderly fashion that leads to a solution—in this case, haggis.

But when our attention is on some mundane task like walking, our thoughts move on to a more undefined place. Even though we are occupied with some menial task, our brains daydream on their own. Asleep or awake, our brains dream naturally.

From this playful and intuitive part of our brains come unexpected solutions and jolts of brilliant possibilities that drop into our conscious minds like voices from heaven. If part of your day is filled up with routine tasks like laundry or lawn mowing, great. It's that kind of repetitive task that can occupy your body while your mind has time to think. And all the better if you have time to stop and meditate on a regular basis, a practice that not only has mental health benefits, but also physical ones.

When you feel like your creative well has run dry, you don't have to agonize at a blank canvas all day hoping for the muse to speak. It can be just as productive to get up and hit a tennis ball hard for an hour or take a long walk. Do some gardening or bake a cake. Swim, take a drive, clean the house, make some head cheese—just pick a boring, repetitive task (life is full of them) and dive in. And don't think about it too much, either. Just go ahead and jump into your task and your brain will intuitively go into play mode.

A lot of people keep notepads by their showers, bedsides, or in their cars. Maybe there's something about the flow of water or traffic that elicits motion and energy in our thoughts. Some people go to bed thinking about a problem and let their subconscious work while they rest. I did this once and

woke up at about 3:00 a.m. with what seemed like a major idea for a new motion picture. I jotted down the idea and went back into a deep and contented sleep. When I woke up the next day, I remembered being thrilled with my idea. I couldn't wait to expand on it in the bright light of a new day, and I glanced at my notepad to read, "Men fight ants." (This film will not be in production anytime soon.)

My favorite place to daydream is the bathtub. My tub dreams started when I was living in England. I would have really busy days dealing with artists and technical problems and then at the end of the day in London, the calls would start to stream in from Los Angeles, where it was only nine in the morning. By the time the entire planet was informed, it was nine at night for me and time to walk home. I lived less than a mile away from our studio. The walks home were times to decompress and sort through the day's thoughts, pick up some groceries at a corner grocer run by a tall, conservative woman who looked vaguely like Al Gore, and head home for a glass of wine.

At home, I'd check the mail, put out the milk bottles, and turn on the tap to fill the tub. All of my best thoughts seemed to come to me while I took a bath. I lived in a basement flat that had one of those really big English bathtubs that uses all the hot water produced that day by the NATO allies just to fill it up. When it was full, I'd tune the radio to BBC 1, and slip into the water with only my eyes and nose sticking out (like that gator stalking the chicken at the Jumparoo). After soaking in a comfortable place for a while,

I'd prop a towel under my head and start daydreaming. Then the ideas would come.

Sometimes I'd think about work. Sometimes, try to solve a problem. Most of the time, however, my bathtub thoughts would just drift around from place to place, connecting unrelated topics. For example, one night I had just returned from a concert of classical music.

It was a program of Mozart, Brahms, and Wagner played by a very, shall we say, *mature* symphony orchestra conducted by a crazy, tuxedo-clad man from Venezuela (obviously a Gustavo Dudamel wannabe). It wasn't great. The Wagner was insufferably long. Rather than enjoying the music, I focused on the sleep-apnea sufferer behind me, who lost consciousness during a particularly overwrought and boring movement of the Brahms symphony. Don't get me wrong—it was a perfectly fine program of music, but all in all, it was really boring.

It's sad, I thought, *but it seems like symphony orchestras are in decline. How could we spice things up a little?* At the same time, I couldn't help thinking that sports franchises are booming and incredible money machines. What are they doing right? Stadium construction is at an all-time high, and players' salaries have eclipsed the national budget of Burundi. Why aren't symphonies thriving like baseball? They're both entertainment. They both take place with a crowd gathered to watch the players. Why don't they borrow ideas from professional sports to make the experience in the concert hall more enjoyable for the fans and therefore more successful?

The typical symphony program includes several tried-and-true compositions by a small handful of composers like Mozart, Beethoven, Wagner, and the like. The typical concertgoer has heard the pieces a million times before, and knows how they will turn out. The entertainment comes from the exquisite mastery of the music and the ensemble playing of the orchestra. There's really no drama or shock at the concert unless the conductor's pants were to fall down.

A baseball fan might go to see her favorite catcher or batter. A concertgoer never goes to see his favorite viola player. I think there should be more stars in the symphony. How? Introduce the players like they do at a ball game or even a boxing match: "Sitting in the fourth chair and playing first viola . . . Sid Friedberg [*everyone cheers*]. On bass drum, and later playing xylophone . . . Mel Shemp [*more cheering*]. And the starting conductor, in the orange trunks and weighing in at one hundred sixty-five pounds, from Venezuela, Maestro Gustavo Duuuudaaaameeeellll! [*sounds of crowd screaming, dogs barking, and those vuvuzela horn thingies from the World Cup*]" This would add a little more personal contact between fan and player.

The other problem I find with attending the symphony is that you always know the outcome. You'd never go to the baseball game if you knew that the final score would be 3–0. Even if the players execute their game beautifully, a game with a predetermined outcome has lost its drama. And I'd also do away with the printed program that tells what they're going to play next. Why do it? Can you imagine opening a

baseball program and finding a list of their plays? "In the fifth inning, Mr. Piazza will attempt to get on base by bunting the ball, after which Mr. Scott will hit a pop foul into the nacho shack on the mezzanine. There will be a brief intermission in the seventh inning."

I don't think the fans would go for this, and I don't see why concertgoers should tolerate this, either. Let's sit in the concert hall and be surprised by the next number. You heard me—let's be surprised. Maybe they start playing a violin concerto and end up playing Stravinsky. Maybe if a conductor's not doing so hot, the manager can come in and take him out of the concert. Why not? I don't have to see a struggling pitcher; why should I have to see a struggling conductor? They could even get into a shouting match and start kicking dirt on each other. I'd pay money to see some viola player get ejected from the game.

And would it be so wrong to put luxury boxes in concert halls so that you could eat gourmet food and drink beer with your business clients? And while we're at it, how about free Wi-Fi, so you can look up opera librettos on your iPad while you're listening?

Of course, all this would start to attract advertisers and television. I can imagine that Nike swoosh on everyone's tuxedo jacket. There would be new shoe endorsement deals, a dance squad, a furry mascot, and probably the equivalent of ESPN that would carry the latest scores and news about trades: "In a major development, Philadelphia just traded away two first violinists to San Antonio in exchange for a flautist,

two oboes, and a first-round draft pick. Next week is the All-Star-break concert where once again the East will try to overcome the dominance of the West over the past five years. And now back to live coverage of Mahler's Fifth."

As I drained the water from my tub and started to towel off, I was convinced that the philharmonic should merge with Major League Baseball. They could celebrate by having a free horned-helmet night for kids ten and under the next time they played Wagner. There might even be an ESPN2 that carried extreme events, like bagpipe music.

Sure, all of this might breed problems. Musicians might start spitting chaw and grabbing their privates, and yes, occasionally you'd have a bench-clearing brawl between opposing orchestras. But in the end, I think classical music events would have more vitality and drama, and we'd be better off for it.

Free-associating in the bathtub may seem pointless, and it probably is to a degree, but it does give us some much-needed mental playtime. And the intellectual muscles that we daydream with are the same muscles that we think creatively with. It stands to reason, then, that a certain amount of bathtub thinking will foster a sense of comfort when it comes to brainstorming new ideas with colleagues or thinking blue-sky thoughts at the workplace. Sometimes dreaming has no other specific purpose than to let our spirits fly.

I never did anything with this idea, but last time I went to a concert, I did sort of wish that the peanut guy would come around.

Communication

Kevin Warwick, a professor of cybernetics at the University of Reading, England, does research in artificial intelligence, robotics, and biomedical engineering. Kevin is into microchip-implant research in a big way. He's not waiting for the future. He implanted a small device in the median nerves of his left arm in order to link his nervous system directly to a computer. A company called Brain Gate (which uses a proprietary technology to sense electric impulses from neurons in the brain and analyze them into a language that can operate a prosthetic arm, for example) makes the device.

At first, the transmitter under Kevin's skin was used to control doors, lights, heaters, and other devices in his general proximity.

You can imagine the possibilities this research may yield for the disabled (and, frankly, for practical jokes at the workplace). This first experiment tested the limits of what the human body could accept and how easy it might be to get a signal from an implanted chip.

The second stage involved an implanted device that interfaced directly with Warwick's nervous system. It was a chip containing an array of one hundred electrodes that picked up the signals in Kevin's neurons and translated them into an electric signal detailed enough that a robotic

arm, developed by Warwick's colleague, Dr. Peter Kyberd, was able to mimic the actions of Warwick's own arm.

This implant also connected Kevin's nervous system—and I am not making this up—via the Internet to Columbia University in New York. From where he was, he was able to control the robotic arm. As an added bonus, he also got "touch" feedback from sensors in the fingertips of the arm. Take this idea to its insane conclusion, and you could have doctors operating on patients halfway around the world with a complete sense of touch. A person with a physical disability such as Parkinson's could control devices with their thoughts.

But wait—there's more. In an expansion of the experiment, Warwick implanted a similar device into his wife (I suggested this to my wife with very little success, so hats off to you, Mrs. Warwick). The problem: using the Web to communicate a signal from afar, might it be possible to create some sort of empathy or Vulcan mind meld between two individuals? The experiment was successful, resulting in the first purely electronic communication between the nervous systems of two human beings.

The really intriguing thing about this research is the possibility that a very skilled artist could transmit the full force of his or her work to an audience. Imagine being able to receive the full force of thought from a great painter. Imagine a film that delivers the complete vision of a director directly to you. Imagine a recording of a great musical performance that you could feel as deeply and emotionally as if you were

there in person. This boggles the mind, though it is immediately clear that there could also be uses of such a technology that might be less than altruistic.

Let's pause to agree that there are social, ethical, physiological, and anthropological issues to be grappled with in this work, all of which Warwick and his colleagues in academia know. But having said that, it's thrilling to think of the possibilities for freedom that this technology would bring to so many people. Personally, I don't see a problem in putting something like this device in my body. We put hot-fudge sundaes, alcohol, and cigarettes into our bodies. We put pacemakers near our hearts and screws in our bones, and think nothing of it. For these reasons, I may someday get my own chip implant so that I can remember names and open garage doors in the neighborhood.

Let's reflect on this idea of transmitting your feelings to another person via a device. Now take a moment and realize that you already have that device at your disposal: the device is your brain. The vehicle needed to transmit your emotions and feelings may be a painting or a piece of music or a film, but our goal as creative beings is to form a connection with our fellow human beings in a way that is deeply empathetic, internal, and profound. You can already communicate to other human beings and affect their physiologies—with no implanted chip needed.

Symbol

Here's an unexpected force: the symbol. A symbol is an abstract thing that represents something else by association. We use symbols to convey meanings too subtle or too complex for verbal language. Every corporate logo, every dollar sign, every line on a piece of paper is a symbol. Something as simple as a pencil line can symbolize a horizon, a crease in a face, a cloud, or a smile.

Art often is little more than symbolism. A painting may be symbolic of an idea or a political movement.

Advertisers have long used symbols to communicate. A car is not just a car—it is a tool for attracting the opposite sex. A fragrance is supposed to evoke imagery of the French Riviera with white drapes billowing in arched windows. A T-shirt with the Ralph Lauren Polo logo is not just a T-shirt, but a lifestyle.

Celebrities often adopt symbolically freighted wardrobes: Michael Moore in a baseball cap, John Lasseter in a Hawaiian shirt, Marilyn Monroe with her skirt blowing up, and James Dean in a T-shirt and leather jacket. Some actors have even changed their names to a single, "gettable" symbol: Groucho, Cher, Prince, Madonna, Sting, Oprah, Demi, Whoopi. All achieve brand-name recognition within a single word that symbolizes them.

Motion-picture marketing is in the business of creating

symbols that make people want to go see movies. These symbols may be romantic, comic, action based, or arty, but their sole purpose is to create an instant impression of the film they are marketing and create a desire in consumers to see it.

Symbols of the family are extremely powerful. Think of all the products that are sold using glowing, slow-motion imagery of kids and puppies playing on the front lawn or of a father shaking his son's hand as he boards a bus to go off to war. Small-town America is another powerful symbol. An idealized American life probably exists in reality in only a very few places, but in our mind's eye, the image of a small town with a steepled church and a bandstand on the green is linked to America as much as images of mom, apple pie, Bruce Springsteen, and the Stars and Stripes.

Symbols were so important that the founding fathers knew they needed a complete set of graphic symbols for the new nation, and so they adapted a suite of symbols from the Roman Empire. The eagle as national symbol, the dome of the Capitol building, Palladian architecture, the Senate, the Congress, and the architecture of democracy in general are all Roman in origin, and symbolize strength, reason, and the republic.

One of the biggest treats of visiting Disneyland during my youth (aside from buying a giant dill pickle in the general store on Main Street) was the Circlevision Theater, then sponsored by Bell Telephone.

It was the kind of attraction that you didn't find at other amusement parks. Like Great Moments with Mr. Lincoln and

the Hall of Presidents, it was meant to teach as it entertained, because here, in the course of thirty minutes, you could travel the great United States from shore to shore and get a glimpse of the visual symbols of America as never before . . . in 360 degrees.

The queue area for the Circlevision Theater was a large room with benches where a peppy phone company employee would conduct a preshow talk about the virtues of long-distance calling. By far the biggest attraction in the waiting room were the booths around the edge of the room, where you could try out new things like touch-tone dialing and speakerphones.

When the countdown clock that hung above the hostess reached 0:00, the doors to the theater would swing out and open. I always tried to go with someone who had never seen Circlevision before, and I would tell him with considerable expertise that he should "hold on to the handrail, because you might experience the sensation of motion, even though there is nothing in the theater that moves."

Once we were inside, the automatic doors would close behind us, and some hidden computer would dim the lights and start the canned music as a single spotlight appeared on some good-looking college coed wearing an orange polyester jumpsuit with white go-go boots.

"Welcome to *America the Beautiful*," she would say to the hushed crowd, who hung on every word of her well-rehearsed spiel. She concluded with, "Hold on to the handrail, because you might experience the sensation of motion,

even though there is nothing in the theater that moves." I exchanged a knowing look with my guest, and the film started.

America the Beautiful hasn't been projected in years, but its symbolism still rings in my head. Not only did we hover over Niagara Falls and walk the front lawn of Mount Vernon, we also raced through the streets of Los Angeles on a hook-and-ladder truck and took the perilous curves of San Francisco's Lombard Street to the groans of the audience. It was Los Angeles in 1967, complete with period cars and young men dressed up with butch haircuts and skinny ties—a lot like contemporary young men, but with fewer tattoos and body piercings. In San Francisco, some of the female pedestrians wore gloves and dresses with slips and petticoats underneath.

It was a film the memory of which still can transport me to another time, when Florida tourism meant Cypress Gardens and Gatorland and Hawaiians farmed pineapples and did the hula. Along the way, we visited Lincoln's log-cabin birthplace, an old seaport village in Maine, and Cape Canaveral, in Florida. The film built to its final sequence in Washington, D.C., where, to the choral strains of "The Battle Hymn of the Republic," the audience gazed upon the imposing statue of the Lincoln Memorial; the film ended at New York's Statue of Liberty with what sounded like the combined voices of heaven belting out the chorus of "America the Beautiful" and rising to a full-blown, let's-kick-some-Russian-butt crescendo.

When I was a kid, the symbols in that movie defined me and my country, and I always exited into the adjoining gift shop feeling a little more American than when I had gone in. Now, looking back, I see that the film is also symbolic of past inequities. Life was full of liberty if you were white and male. Liberty and justice were there for all who spoke English. The film was a shopping list of American icons: the Statue of Liberty, Mount Rushmore, the Lincoln Memorial. It was a living, breathing symbol of all things American in 1967. What would the film be like if it were to be made today?

Truth

Art is a lie that makes us realize truth.

—Picasso

Truth is perhaps the most powerful and driving of the creative forces. Creative people must have the desire to communicate honestly the truth about life as they understand it. Be it through a painting, a photograph, a novel, or a play, artists can be society's primary keepers of the truth and can serve as mirrors of human values.

A lot of studies have been done examining the private lives of great artists. Most of these studies reveal that people who pursue the arts, apart from their drive to create, compose

a pretty normal cross section of people in general. In some sense, it matters less what an artist does in his or her private life. What matters is what he or she perceives. When we look at a painting or read a novel, we are looking for the unique perspective of the artist—a perspective that cannot help shining through and being reflected in the work. It is a reflection of what the artist sees as truth, which we can see through their eyes.

As creative creatures, we are keenly interested in other people's art. We're eager to study and dissect it. We go to museums to try to understand art. What is art, and how does one acquire an artistic hand? We are fascinated by the interpretation of the world that we receive from the artist's work. The irony is that art is an imitation, an illusion, of life. It is a sleight-of-hand trick. As Picasso said, it is a lie that makes us realize the truth.

Most people will tell you that creative life is grounded in fantasy and imagination. But that is not completely true. Creative life is also firmly grounded in reality. It is grounded in observation of what is real and truthful from the artist's perspective. The American painter Childe Hassam said, "The man who will go down to posterity is the man who paints his own time and the scenes of everyday life around him."

Even the most abstract works of painters, sculptors, and dancers are reflections of the lives of the artists and their feelings on the given day they painted or sculpted or danced. We get frustrated at the abstract and nonsensical in art. We can't understand it. Well, don't try to understand art, any

more than you would try to understand a beautiful sunset or a cataclysmic storm. It's enough to enjoy the beauty or tragedy of life and take in its truth. The same holds true for creative expression. Trying to dissect and understand artistic creations won't help your appreciation of them any more than understanding planetary physics will help you enjoy the sunset.

Everything around us is temporary and fugitive in nature. The French painter Paul Cezanne said, "Everything we see falls apart, vanishes. Nature is always the same, but nothing in her that appears to us, lasts. Our art must render the thrill of her permanence along with her elements, the appearance of all her changes. It must give us the taste of her eternity."

It's true that we can always go back to a beautiful sunset and study the atmospheric conditions that made it happen, but we'll never forget the visceral pleasure we had when we sat there and watched it for that fleeting moment.

We can study the ingredients of painting, music, cooking, or any human creation, but there is no harm in first openly experiencing the truth of the creation without rushing to comprehend its components. A creation represents one human being's unique perspective on a moment of her or his life—one person's truth. It may be beautiful, naive, cynical, jaded, egotistical, modest, bold, or tentative, but it is unmistakably that person's truth. This is what makes art.

Next time you are in a gallery, pick a painting, and then stand in front of it in the place that the artist would probably have stood when he or she painted it. For impressionist

paintings, the sweet spot is a healthy arm's length away, whereas for some paintings, like Vermeer's, it's very close to the canvas, since he worked with amazing detail. With Jackson Pollock's works, the zone can be pretty far from the picture, since he usually stood over his canvases and splattered his paint on them from overhead. By standing where the artist stood, you get a feeling of the energy of the painting. By standing literally where Degas stood, the painting fills your field of vision in the way it filled his.

When you stand in this space, there is an unmistakable human energy that comes to you. You're standing in the place where the gestures happened—where the physical energy was expended. It's as close as you can get to feeling the truth about the artist and the painting.

It's the same space that exists when you read a book and are on exactly the same wavelength as the author. You feel as though the author is standing there whispering in your ear. You feel as though you are hooked up electronically to the author's brainwaves and can sit back and enjoy her point of view with regard to the world.

This bond between writer and reader or artist and spectator is very personal. It's a very intimate relationship. Not all canvases or books will speak to you this way, but when they do, the result is pure truth—and an intimate and direct link between you and the artist.

Seeing

The eye sees only what the mind is prepared to comprehend.

—Henri Bergson

We do a lot of looking, but very little seeing. Seeing implies a deeper look—more than the cursory glance we give most people, places, and things. If we're meant to interpret their world, then we had better start seeing the world with more than superficial eyes. Think of the intensity of a park ranger peering through binoculars in search of fire, or a Wimbledon champion watching the ball hit the racket. Can we bring that intensity to the way we see the world around us when we create? The trick is to not only observe the world we live in, but to create a focused point of view of that world for the consideration of others as if to say, "I'm here, I'm unique, let me show you what I see." The audience may laud or hate the view, but as artists, it's our job to point to a specific viewpoint so that others can see.

When we spend time with children, we cheerfully explain the world in great detail because we know they are open and receptive to our ideas and knowledge. Then when we go to share our vision of the world with other adults we stop short. There's that small but powerful part of our ancient lizard brain that needs us to be socially accepted so we think twice

about explaining our point of view for fear of being dismissed and ridiculed. But that's where we'd be wrong. If you believe that we are all created with a unique brain and environmental history, then we have a literally one-of-a-kind story to tell. And how would you feel that if in all of human history, you were the one story that really mattered, but you didn't share your story with anyone?

Impossible? What would have happened if Martin Luther King Jr., Cezanne, Alfred Hitchcock, or Walt Disney had not shared what they saw? It was their unique vision of their world that changed our world view. No one else sees it the way you do, so please don't screw up the future. Share with us your unique vision of the world via your story, writing, painting, acting, poetry, dancing, or pie making. It is your eye that gives it meaning and a unique sense of place and value.

Listening

There is a man in Hollywood who, for the purposes of this illustration, we'll call Günner Alpenhorn. Günner is a pollster who recruits and surveys test audiences for movies. He is either the most beloved or most hated man in Hollywood, depending upon how your film is testing with the audience. Market research for a motion picture is a cruel process.

Here's the process: when a film is almost completed, we

take it to an out-of-town theater, and Günner recruits about
five hundred people from a shopping mall to come and see
our unfinished movie. The film is screened, and then the audi-
ence is asked to fill out a questionnaire about their feelings.
Was it too long, boring, confusing? What did you like about
the characters? The music? Would you recommend this film
to your friends?

After a typical preview screening, the directors and I
huddle with the team at a local restaurant, drinking beer
and eating deep-fried cheese logs with blue cheese dressing
(research has proven that a sudden intake of cholesterol and
beer dulls the effect of getting preview notes). Sometime half-
way through the cheese logs, Günner bursts in with the results.
We are told that eighty-seven percent of the audience would
recommend this film; forty-five percent liked the opening
song best; fifty-seven percent had families and children with
them. Every demographic is nailed down, and every reaction
quantified.

And what you find after this grueling process is that most
of the movie works, but some parts were unclear and need
work. You also learn that some jokes didn't work like you
thought, and that you get severe acid reflux by eating deep-
fried cheese logs with blue cheese dressing just before bed.
The scrutiny of Günner and his audiences will force you to
listen carefully and make some changes based on what the
audience felt and, just as important, what the filmmakers felt
while screening a film for an audience for the first time.

The Lion King previewed to very favorable reviews, but

the directors had a strong feeling about a moment in the film after Mufasa's ghost had appeared to Simba. The moment ended with Simba sitting silently on a hillside in awe at what had just happened, and then we faded to black. We were really missing a moment where someone "framed" for the audience the events that had just happened. At the same time, Michael Eisner felt like the audience loved Rafiki; he sensed that we needed more of him in the film.

The next day we wrote a scene with Rafiki and Simba. Simba says he's worried about his past, and then Rafiki steps up and thumps him on the head with his stick.

"Hey, what was that for?" cries Simba. Rafiki responds, "It doesn't matter, it's in the past."

In almost riddlelike fashion, Rafiki outlines a crucial theme of the movie: you have to put your past behind you. We previewed the movie three weeks later with the new scene included—a scene that the audience hadn't asked for but that we felt they missed—and not only did the new scene give context to the moment, but it also did it with a big laugh.

We listened to Günner's audience, but numbers and statistical analysis only go so far. There's been a huge trend in baseball over the past decade to do statistical analyses for every aspect of the game to try to field the best team, but when it comes down to it, it's people who play the game, and people are analog, not digital, beings. We work by intuition and gut.

For *The Lion King*, the key was not in giving the audience what they had literally asked for, but in giving them a

clearer vision of what the filmmakers were trying to say. Film-making, like baseball, is played by humans. It's not about studying market surveys, statistics, or trends in pop culture. The market research never showed us that the audience was asking for a film about a lion cub that gets framed for murder and takes refuge with a flatulent warthog and a show-tune-belting meerkat. That came from great directors like Rob Minkoff and Roger Allers and our great team at Disney Animation, who put their vision up on the screen in a personal way.

Smell

Diane Ackerman says in her book *A Natural History of the Senses,* "Nothing is more memorable than a smell. One scent can be unexpected, momentary, and fleeting, yet conjure up a childhood summer beside a lake in the mountains; another, a moonlit beach; a third, a family dinner of pot roast and sweet potatoes during a myrtle-mad August in a Midwestern town. Smells detonate softly in our memory like poignant land mines hidden under the weedy mass of years. Hit a trip-wire of smell and memories explode all at once. A complex vision leaps out of the undergrowth."

We have deep associations with smell. And it's not the same for everyone. One person's great smell is another person's stinky one, and vice versa. There has been amazing

progress in the field of odors. It's not enough to enjoy life's naturally occurring odors, like a freshly mowed lawn or bread straight from the oven. Now we can have pleasing odors on demand. It happened to me at the car wash the other day. I drove up and asked for a wash and a hot carnauba wax, and the gentleman with the clipboard asked me, "And what scent would you like today?"

If memory serves me right, that was the first time in my life that anyone asked me that question. I guess the idea of selecting a scent for your body in the form of a cologne isn't that unusual, so why not pick a scent for my car?

"What do ya have?" I asked.

"Well, we have lemon, cherry, mint, pine, vanilla, and new car."

I was leaning toward pine, since the rest sounded more like Kool-Aid flavors than car scents, but I was fascinated by "new car." I love the smell of new car. On warm summer evenings after dinner during my childhood, we'd sometimes go out to the driveway and sit in the car so we could smell that smell.

"New car," I said.

The car was then whisked away from me, washed, dried, and rubbed with hot carnauba, which I presumed was a small mammal from Central America. When all was done, I tipped the attendant and hopped in the driver's seat, poised for a nostril full of memories. I exhaled deeply to clear as much room as possible in my waiting lungs, and I drove off. Then, as I started my big inhale, my eyes widened in confusion. This

wasn't the smell of new car. Not at all. I spun around and roared back to the attendant.

"This smell, it's not new car—what is it?"

He stuck his head in and sniffed. "Oh, that's new car, all right."

I got the guy with the clipboard to come over and smell it with the same results, and then I got the vacuum guy, the manager, the lady in the gift shop, and the buff-and-detail guy to all come over, until about sixty people were hovering around smelling my car.

The vacuum guy was the most poetic, sounding more like a sommelier discussing a fine wine: "It's not new car, but it has overtones of berries and tobacco with a finish of leather."

"Oh, no, no, no," said the manager. "It *is* new car, but it's mixed with the smell of the hot carnauba." Well, I don't know about you, but if this was true, I didn't want to drive around smelling like a hot Central American mammal for the next six weeks. I started wondering if the cherry and the pine smelled that bad, too. They'd have a lot less customer dissatisfaction if they'd just ask you up front if you wanted the hot Central American mammal. You'd say no, they'd wash your car, and everyone would go home happy.

Finally, after much group sniffing and discussion, the investigation proved conclusively that the attendant definitely gave me the new-car scent, and the fact that it smelled more like the new cars smelled in Costa Rica was moot. It was to be my odor for weeks to come.

I wanted so desperately to relive those nights from my childhood when after dinner we went out to take a whiff of the new Cutlass, but it wasn't to be. Some sense memories just can't be re-created.

Sensing and Feeling

Feeling doesn't come just from your hands. It's a full-body experience. Many years ago I actually looked forward to going to the family dentist because it was a sensory smorgasbord. Upon arrival, we would sit in a waiting room that was festooned with magazines. As my mom would flip through the latest *Life* or *Time*, I would gravitate to a children's magazine called *Highlights*. It was the kind of magazine that was full of puzzles and riddles: Why was the cookie sad? His mother was a wafer a long time. Or: Why was Cinderella kicked off the soccer team? She always ran away from the ball. Riddles were a great way to torment my mother.

"Why did the bicycle lean against the fence?"

"I don't know."

"You have to guess."

"Because no one was riding it?"

"No, because it was too tired . . . *get it*? Two tired . . . two tires!"

This usually elicited smiles from the patients in the

waiting room because the punchline was funnier than the root canal that was waiting for them behind the next door.

Every few minutes, that door would open, and the dental assistant, Miss Welch, who looked like Raquel Welch's pretty younger sister, would chirp out a name. The chosen one would turn ashen and rise slowly to follow her to the inner office. Then Miss Welch opened the door and called "Mr. Hahn?" I was relieved that she was calling for my father until my mom reminded me that *I* was Mr. Hahn.

I followed Miss Welch who, I must say, was quite pleasant to follow, as she led me down a long hallway of doors. The faint sound of whirring drill bits and saliva being sucked through a tube at high rates of speed reverberated through the hallway. I was ushered into the examination room where my visit began with a staggering series of mouth X-rays. Miss Welch said that this used extremely low levels of radiation that would cause absolutely no harm. Then she put on what appeared to be a lead barbecue apron and gloves, and she pointed a cone-shaped ray gun at the tip of my nose.

She placed a piece of cardboard in my mouth and said, "Bite down and hold still." Miss Welch disappeared behind a lead screen to press the button. While I waited for my jolt of radiation, I sat frozen with a mouthful of cardboard, and glanced around the room at what appeared to be a small machine shop.

Just then the dentist broke in and, upon seeing that I

was being bombarded with radiation, said the comforting words "Oh, *jeezus*," while ducking out to avoid being exposed. When Miss Welch was through, she stripped off my lead apron and gave the dentist the all-clear sign. He burst in with a hearty "Good morning, how ya doin'? Those are just routine X-rays that cause absolutely no harm," and he went to work. As he examined me, I couldn't help but notice that amid the machinery were large cutouts of Goofy, Chip 'n' Dale, Bugs Bunny, and other cartoon characters who were presumably selected because of their abysmal teeth, as if to say, "If you're not careful there, Donny, you'll end up lookin' like the Goof."

As the dentist worked away, he would tell me what he was doing with his tools, which he had named something like "Mr. Mirror" and "Mr. Pick." This was supposed to make his young patients feel better, although I was never quite sure why a child would find comfort in having his young gums explored by Mr. *anybody*. The environment was like nothing I had ever seen on planet Earth. I stared up at Goofy while Mr. Pick probed my incisors and Miss Welch hovered nearby, and I thought, *how would you describe this to someone from another planet?*

So I was shown into this sterile, dark room and forced to sit in a chair. A beautiful girl in a lead suit bombarded my body with radiation, and then a guy in a white coat came in and shined this impossibly bright light into my eyes while he started investigating my mouth with a metal probe.

I even have this theory that a lot of people get confused

as they get older and mistake this childhood experience for an alien abduction. The tabloids are full of stories that read just like this. I loved the dentist's office because it was a place where I could feel all the known sensations at one time—fear, love, joy, hate, pain, sorrow, suction—right there in the dentist's chair.

Taste

Every year at Christmas I go to lunch with Roger and Irene. Roger and Irene are the amazing writers of *The Lion King* on Broadway. We go to the SmokeHouse across from the old Warner Bros. Studios in Toluca Lake. It's a place like Sardi's or the Brown Derby that serves not only food but nostalgia. Their waitresses are warm and friendly and have a combined age of three hundred thousand years. It's a place where Roy and Walt Disney would take their wives. Bob Hope came here to have lunch with Bing Crosby.

When I have lunch there, I always feel like having a martini and the prime rib. The taste of horseradish gives me the nose-clearing sensation that I had thirty years ago when I had my first "king's cut" over there in booth thirteen. And then there's the garlic bread. I always thought that if the planet were being destroyed tomorrow and I had to get on a spaceship to leave but was only allowed to take ten things,

I'd take the *Mona Lisa*, a copy of Shakespeare's *Hamlet*, an iPad, a Bible, the remastered Beatles anthology albums, a print of *Citizen Kane*, the 1967 Volkswagen Beetle, Miss Welch, a change of underwear, and an order of garlic bread from the SmokeHouse. With these things one could form a suitable colony on any planet.

Taste is more than just a sensation of the tongue. I love these foods because I associate them with the memory of good times and good company—of dinners long past with family. The chicken teriyaki reminds me of my sister, and the cheesecake was my mom's favorite. When I was a teenager I couldn't wait to get out of there to something more important, like the Helen Reddy concert that night. But now I have trouble leaving because the place is so full of wonderful ghosts.

The tongue not only tastes bitter, sweet, salty, and sour, but it also tastes memories. Our experiences with food and family around the dining table breed into us a taste for certain flavors and sensations that are more than just food for the body. They taste familiar, comforting, and reassuring. It's almost like someone whispers in our ear, "What a relief, it still tastes the same, it hasn't changed, it's the same taste I had when I was ten years old." When I taste my grandma's meat loaf recipe today, I know that it's her meat loaf even though she's been gone for thirty-five years. It's her gift that keeps on giving. As much as I love to experience new flavors in life and in food, Roger, Irene, and I come back to the SmokeHouse to taste the familiarity of warm garlic bread and burgundy

booths. I can see my grandpa opening his birthday presents and laughing over by the lobster tank and imagine myself in booth thirteen tossing back my first prime rib and now, decades later, it still tastes the same.

5.

Fear and Loss

Life is short, art long, opportunity fleeting,
experience treacherous, judgment difficult.
—Hippocrates

Here I stand, equipped with an arsenal of forces. I am armed
with hope, astride my best intentions, my eyes filled with
passion, my stomach filled with acid, ready to be outstand-
ing in my field—when suddenly I find that my field is a
battlefield. And there across the battlefield stand the long-
faced naysayers who are ready to shoot me out of the saddle.
These fierce warriors look right through me, their famil-
iar names striking fear in my soul. Names worse than Attila
the Hun, Bluebeard, or Bin Laden. There stand Fear and
Insecurity, side by side with Withdrawal, Stagnation, and Mrs.
Loots, my kindergarten teacher, who said that I would never

amount to anything unless I slowed down to color inside the lines. Before I face this awesome phalanx, I take solace in the fact that others have faced these fears and emerged victorious.

The voice of Insecurity speaks to us with the measured certainty of a mother saying "I told you so" after we tried to do something and failed. We start to think of reasons to avoid the risk of failing again. We have pointed little monologues with ourselves in order to validate our fears, and we come up with reasons that we should never create again. Maybe some of these sound familiar to you.

> Everybody hates me.
> I can't draw (or spell or read fast).
> I don't want to be alone.
> I only have a tiny amount of creative capital, and
> I've spent it.
> I'll die poor and lonely, surrounded by bad
> paintings.
> I'll drink, take drugs, and have sex.
> I'll feel terrible if I make money, because I don't
> deserve success.
> I'll find out that I'm gay.
> I'll find out that I'm straight.
> I'll go nuts.
> I'll have to brood too much.
> I'll hurt my family's feelings.
> I'll never make money that way.

I'll turn up some dark, sick side of myself that
 will embarrass me.
I'll walk away from my family.
I'm too old. If I haven't become a _____
 by now, I never will.
My family will leave me.
My ideas are only average or worse.
My parents will get mad.
My work will stink, but I won't know it, and
 nobody will tell me.

We get so concerned about the public perception of us and of our art that we throw our hands up and say, "Why make art at all if I'll have to hide my feelings?" Or sometimes it's just the opposite: "Why make art if I'll have to reveal my innermost private feelings?"

For one reason or another, many of us began as highly creative kids and have gradually become broken adult artists. As children, we may start with warm support from our mom and dad as we color at the kitchen table. As we age, our creativity is put in check by well-meaning adults who shower our fledgling creative efforts with unwanted surveillance, unneeded evaluation, tests, and contests in which our art, music, dancing, and writing are rated against those of our peers. Society's need to reward the "best" negatively shapes our early years, and we start to view our work as unworthy.

As creative adults, we crave and need support, but it's

not always there for us. One of the animators at the studio suggested we hire a mom to walk around from room to room and compliment our drawings, give us hugs, and feed us Rice Krispies Treats. We'd love to have our families embrace our creative dreams, but it doesn't always happen that way. Either they don't get what we are trying to do and think we're wasting our time, or they are understanding and supportive and *we* feel full of guilt about spending so much time away from them in the pursuit of our art.

As artists (especially those of us who are young artists), we long for someone, anyone, to tell us we are worthy or on the right track—to acknowledge our quest and share our failures. Yet so often we don't feel support and we lose hope. We stop at the frustration part of the creative process and give up our dreams altogether.

It's easy for parents to envision their sons and daughters as doctors, firemen, teachers, and nurses. It's much harder to encourage daughters to be actors or sculptors and sons to be painters or clowns. For most, the arts are only frosting on the cake.

In some schools, the arts are seen as nonessential electives, along with auto shop and dance squad. The message is that the arts are a wonderful diversion, a hobby, but not real work. This message carries into adulthood, when we find jobs that require us to put our creative dreams on the shelf—thinking perhaps we'll come back to them someday.

Fears and impossible obstacles all come down to one thing: art is hard, and life is short. If it was that way for

Hippocrates twenty-five centuries ago, why shouldn't it be hard for you? Get over it. You can beat yourself up for years on end because you haven't acted on your dreams—or you can leap with conviction into your future.

To overcome fear, we need to start with a more aggressive look at the life we've chosen for ourselves. Are you working in a field that you love and have chosen, or are you marking time in an okay job until you get your break? When you were a kid, did your parents and teachers encourage you to follow your muse, or did they unwittingly fill you with doubts and low self-esteem? Are you truly happy with your chosen profession and do you just want to bring your creative spirit to the task, or have you fallen into a comfortable job that pays the bills but leaves you spiritually bankrupt?

The creative journey is forward-facing. Even if you have shelved your passion in the past, you can grab it, dust it off, and take some baby steps toward a more engaging creative life. Expect that you will be rusty and that some of your first steps may cause you to stumble, but the pain and fear of those failures are sure signals that you are moving forward once again. Write a bad screenplay, but write it now. Draw a few hundred bad drawings—the sooner you get them out of the way, the sooner the good drawings will start to appear. Make a bad film, paint a lousy painting, write a hideous novel, but learn from whatever it is. And, most important, there will be power in your decision to invest in your creative spirit, rather than push your talents to some subordinate place in your life.

Don't wait to get started. Note the way in which lecturer Julia Cameron, author of *The Artist's Way*, responds to her students' concerns about the investment of time it will take to learn their craft. When they say, "But do you know how old I will be by the time I learn to really play the piano [or act or paint or write a play]?" she responds with a simple "Yes . . . the same age you will be if you don't. So let's start."

Pressure

It was all set for three o'clock on a hot day in the fall of 1990. Angela Lansbury was scheduled to fly to New York to sing Mrs. Potts' charming ballad from *Beauty and the Beast*. She had worked tirelessly for weeks with a vocal coach. The day came, the orchestra tuned up, and the control room filled with anxious songwriters and nervous executives. Three o'clock came and went and Angela didn't show up. I called her hotel—no one answered.

It turns out her flight's landing was delayed because of a bomb scare. I ran to the phone and checked with the airline. A phoned-in bomb threat had forced the plane to land at an airport along the way, and all the passengers had had to deplane. The passengers boarded another plane and made it to JFK Airport four hours late.

Angela had every reason to go straight to her hotel, to rest

and not show at all, but she knew that the orchestra was there, and she knew that the directors and songwriters were assembled, so after perhaps one of the most stressful experiences imaginable, she walked into the recording studio, greeted everyone cheerfully, put her headset on, and proceeded to sing. Three hours later, the result was "Beauty and the Beast," the song that went on to win an Academy Award. I learned volumes from Angela's exquisite mix of work ethic and grace under pressure on that day in New York.

Pain

Pain. It's horrible and unbearable and, oddly, it's nature's blessing in disguise. Pain and the fear of it are nature's way of keeping us from stupid, self-destructive situations. Pain keeps us alive by acting as a warning system that helps us locate and deal with physical and mental problems. But humans, more than other animals, can recognize and overcome fear and pain with a conscious act of will.

We know that the process of creativity is full of disappointment, frustration, and pain. There is the pain of failure, of inaction, of humiliation. Nothing can really soften the pain of creation, since each new project brings failures. The creator has to find a way to live and deal with that pain—even to welcome it as a necessary adjunct to success.

We fear that during the creative process we will expose painful parts of our lives, so mostly we just want to flee. Just as we might cover our ears when a loud siren sounds or plug our nose to keep out a bad smell, we protect our sensitive mind from possible pain by closing it down. We stop short of expressing ourselves completely and honestly for fear of exposing some dark side or, even worse, some boring and stupid side. Innovative people learn to deny this self-protective instinct and stay mentally open to the impressions offered by life despite the threat of pain.

Sometimes we experience paralysis in the face of the need for action. Feelings of stage fright or writer's block are less about the fear of failure and more likely to be grounded in a fear of taking any action at all. We may be searching for our big break in life, but when opportunity knocks, we sit tongue-tied. To overcome this paralysis, we need to embrace it and understand that all of these fears of expression are signs that we are opening up and arriving at the very vulnerable place where creation takes place.

There is pain, too, in the realization that what we have created is flawed. Finding the flaw in our work presents a choice. We can throw out all or part of our creation and start over, or we can cover up the flaw and press on, pretending it will be fine. Both options are painful. Throwing out the product of your own hand seems somehow suicidal, but even worse is the guilt associated with covering up a fatal flaw. It is the essence of creative life to find the flaws in our vision and flush them out in favor of a better idea. If we lose our

critical eye and stop short of the self-criticism needed to create, then we are throttling the boldness and risk needed for great innovation.

The flaws in the work often come from the boldness required to create it. Flaws are the by-product of the process, and when we recognize that the flaw is in the work and not in us—that the creator and the creation, though linked, are two separate entities—we can discard the flaw in the work without discarding a piece of ourselves.

The willingness to discard flawed work breeds a belief in the ability to rejuvenate yourself, a trust in the flow of new ideas, and optimism in the future of your creation.

Consider these words on the heroism of the creative journey by author Robert Grudin in his book *The Grace of Great Things.* "Pain and fear of pain, finally, are the necessary conditions for courage. Creative achievement may seem solitary, even peripheral to society, but there is something genuinely heroic about it. And from an evolutionary perspective, it is they who most fully embody that form of heroism which gives force to the whole human project: the heroism of the seeking mind. It is perhaps this sense of heroism that makes creative endeavor so uniquely enjoyable, that justifies all the pain."

Bad Days

It was the end of a very long October day, and my office in an ornate Edwardian building in Camden Town was dark save for the warm light of my desk lamp (this is sounding like the beginning of a cheesy novel, isn't it?). I don't normally drink tea, but that night it was late, and the English coffee machines made a brown, bean-flavored liquid that didn't quite qualify as coffee for me. So I stuck with the local custom and made a pot of tea as I pored over the production statistics on *Who Framed Roger Rabbit*.

The numbers were bad. No one had made a movie like this ever before, and the strain brought about by the technique showed up in the form of really low productivity from the animators. The crew was the best that we could find, in an age long before anyone had ever dreamed of a *Lion King*. It was a United Nations of artists from Canada, Spain, France, Belgium, the United States, and, of course, the United Kingdom, gathered together to work on this mysterious project about a rabbit who gets framed for murder. The average age at the studio was twenty-five.

When I had gotten halfway through my Darjeeling, Peter Schneider called from Los Angeles. Peter had gone from a successful career in the theater to become vice president of Disney animation at a time when the artists were making unfocused, lackluster films like *The Black Cauldron*. Since

then, he had presided over a renaissance of the art of animation, but on that night he wasn't interested in anything but getting this movie done. He summoned me and producer Robert Watts to New York. Studio chief Jeffrey Katzenberg and the other filmmakers would meet us there for a summit meeting (aka a butt-kicking).

Twenty hours later, I was in a car watching the sun set on the London evening traffic on my way to Heathrow with Robert Watts.

Robert was my idol. He had produced James Bond movies before he started working on films like *Return of the Jedi* and *Indiana Jones*. His producing philosophy, which he defined casually to me one day while munching on sausage rolls around the tea trolley, was this: everyone on the production, from the producer to the lowliest runner, was there for one reason—to help the director tell a story. He had casually summed up the entire movie business with a few sausage-filled words, and he was profoundly right.

To get to New York on time, the production booked tickets for Robert and me to fly on the supersonic Concorde from London to New York. The Concorde was for people in a hurry, people of power and people of privilege. As I walked down the cabin aisle, the first thing I noticed, aside from how out of place I felt, was the lack of women and children onboard, and the second thing I noticed was that in the front row, Princess Anne of England was sitting next to Itzhak Perlman. I was in good company.

As we took off, I looked out my tinier-than-usual

window to see the dimly lit patchwork of the West Country recede from us at alarming speed.

Everything about the plane was small and built for speed: the seats, the food, the flight attendants. Even the bathroom was small—so small that I had to arch my back and bend my knees as if I were doing the limbo to fit in. It took me twenty minutes and seven of the ten basic yoga positions to relieve myself.

Once we had cleared Cornwall, the pilot floored it, and I watched in amazement as the display at the head of the cabin indicated that we were traveling at twice the speed of sound. Of course, I asked myself a series of cocky questions based on my extensive knowledge of high school physics—questions such as, "If I'm going twice the speed of sound, then what happens if I talk? What if I turn toward the back of the plane and talk? If I make a phone call to someone on the ground, will I have to speak very slowly for it to sound normal?"

I amused myself with these things until I noticed that the night sky was actually getting lighter. *We must be catching up with the sun*, I thought. Another round of questions: "If we keep flying, will we pick up an extra day in our life? If we stay flying long enough, will we actually get younger?"

Mercifully, we soon landed at JFK in New York. I flashed Princess Anne a big smile and jumped into a waiting car in time to see the sun set again, this time over Manhattan.

The next day, there was a meeting at the Disney offices in midtown Manhattan. The studio had just acquired space from Pepsi-Cola, and the boardroom was still notorious as the

place where Joan Crawford had held court during her brief tenure on the board of Pepsi.

Robert and I arrived at the office by cab and dodged ditch diggers and construction crews to make our way to the front door. We got in and headed for the boardroom, where we huddled at one end of the massive table near Dick Williams and exchanged pleasantries with Bob Zemeckis and Frank Marshall, who had flown in from Los Angeles with Peter and Jeffrey. Tim Engel from finance, Marty Katz from the production office, and associate producer Steve Starkey sat with Ken Ralston from ILM.

The meeting began. The problem was this: we were all working on a movie that we thought would be brilliant and that we knew would be impossible to finish at the rate we had been going. The creative and financial assets of Disney and of Steven Spielberg's company, Amblin, were tied up in the results, and the results depended on animation. What existed now on film was essentially an invisible-man movie that was waiting for the animation crew to add its ink-and-paint cast of toons.

We talked about schedule and how to get the movie done, and we talked about the huge technical problems we were having, and then Jeffrey turned to me with a big grin on his face and said, "Ya know what? Don Hahn will get this movie done, because if he doesn't . . . you see that guy down there digging that ditch? If Don Hahn doesn't get this movie done, that guy will be Don Hahn." He said it with a big smile on his face—that same smile that the banditos flash in *The Treasure*

of the Sierra Madre. Then he said something nice like, "And if he does get it done, he can have a job here for the rest of his life," or some such meaningless promise that you would never hold anyone to.

It was the kind of moment you don't forget. I kept hoping the dance squad would rush in and break the tension. The urge to vomit projectile-style was intense, but, showing restraint, I mumbled some sheepish pleasantries as everyone joked about my likely lack of a future as a New York construction worker.

As the meeting broke up, we said our good-byes and I dashed for the street with Robert Watts. Throwing "See ya soon!" waves to the ditch digger in front of the building, Robert and I made our way to a pier on the East River for a helicopter ride to the airport and the flight back to London. When the helicopter landed at the airport, we noticed people glued to televisions and stacked three deep waiting for telephones. It was October 17, 1987—Black Monday, the day the stock market crashed.

We did what all good producers do in the face of unsettling odds: we made jokes. We joked about the day, we joked about the meeting, and, to illustrate how pathetic our condition was, we even joked about the stock market crash. As we settled into the seats on our Pan Am flight back, we agreed that tomorrow would be another day. Robert reached over to pull the window shade down, and the entire window frame came off into his lap. It seemed like the longest day of our lives.

Impostor Syndrome

I met Arnold Schwarzenegger backstage at the Golden Globe Awards. *The Lion King* had just won the award for Best Picture, and Arnold had been the presenter. As we waited for the press, I realized that I was standing next to him. This was a man whom I'd seen driving a Harley through a plate-glass window while firing twin machine guns, piloting a Harrier jet, kissing Jamie Lee Curtis, and muttering "I'll be back." Here I am, little Donny Hahn from Bellflower—the guy who smuggled a colander into bed in his pajama bottoms—standing next to a man who is used to carrying a missile launcher in his pants. I spoke: "I just wanted to say I'm a big fan, I really love all of your movies." He smiled broadly and said in his charming Austrian drawl, "Oh, I loved *Duh Lion King,* too. You know, it's so nice to have a film you can take your chooldren to, movies are so violent nowadays!" He stopped for a moment and slapped his forehead with his bearlike hand: "Vut am I saying? I go around shooting people for a living!" I was surprised by the charm and humility of this former cyborg killer.

Great actors, directors, writers, and scientists have all had bouts of impostor syndrome, when they sat and asked themselves, "Who do you think you are? You don't know anything."

Our inner monologues can be pretty biting. We have a way of ripping ourselves apart with lengthy and accusatory

speeches that confirm our worst fears—that we are worthless as creators. When we're done with ourselves, we turn on others. We call them lucky, talentless bozos, but what we are really saying to ourselves is, "Why can't I be like that? I'm an impostor, that's why."

When we try to right the situation by being more positive and to harbor loving, caring thoughts about ourselves, we roll our eyes and interrupt with more inner "Who do you think you are?" dialogue.

What we need is a sense of hope and confidence in our creative lives. As sappy as it sounds, we do want to find a sense of self-love and trust that will allow us to move forward with our work.

You may gag at the thought of having a positive internal conversation about yourself. After all, we've had years of internal talks about how lazy and unworthy we are, and it's become a very comfortable conversation to have. And every time we start saying things like, "I love myself and I deserve self-respect and a voice in society," we start sounding like Stuart Smalley on *Saturday Night Live* saying, "You're good enough, you're smart enough, and doggone it, people like you."

But still, somewhere deep inside, in a quiet, personal, and nonverbal place in our souls, we must believe that we've got something incredibly special and unique to offer. Our conscious minds may differ, our inner editors may object, our inner children may throw up, but beyond all of the voices to the contrary, you must believe in this fundamental truth: you are unique.

So here is a suite of positive affirmations. They may sound cloying at first glance, but to help me illustrate my point, try to pause for a moment, check your cynicism, and then read these statements as though they are completely and irrefutably true.

> I am a creative being.
> God creates through me.
> By creating, I express the love and truth
> about life.
> I will not be afraid to express my
> creativity.
> I am worthwhile; my creative voice is
> important.

What if these statements were all true? I know it's much easier to believe that we are crass, cynical beings of questionable worth, but what if somewhere deep inside us we believed we had an important creative voice? What would we do then?

Would we write a novel if we knew people would read it? Would we paint fearlessly if we knew that our paintings expressed the love and truth about life? Would we work late into the night if we knew for sure that God was creating through us?

People will react to these statements in either a dismissive or a curious way. I hope you will at least be curious about the possibility that your unique creative voice is important.

Criticism

Attention to health is life's greatest hindrance.
—Plato (427-347 BC)

Plato was a bore.
—Friedrich Nietzsche (1844-1900)

Nietzsche was stupid and abnormal.
—Leo Tolstoy (1828-1910)

I'm not going to get into the ring with Tolstoy.
—Ernest Hemingway (1899-1961)

Hemingway was a jerk.
—Harold Robbins (1916-1997)

There once was a baker who lived in a small and remote village where no one had ever seen an actual cake before. He wanted to bake the most beautiful cake imaginable so that everyone in the village could enjoy it. He had an idea of just how the cake would look and taste when it was done and just what ingredients he would need. And so he went to the grocer and bought some butter, eggs, milk, flour, and sugar. "You can't make a cake with this," the grocer said, staring at his ingredients. "You can only make cookies with this." But

the baker just smiled and went home, where he began mixing his ingredients together. His neighbor the farmer came in and tasted the batter. "Is this what cake tastes like? I don't like it," he said, but the baker just kept on mixing.

Then he put the batter into three round pans and put them in the oven. The village constable came by, peered into the oven, and said, "Is that what cake looks like? It looks more like bread. Is cake like bread?" The baker kept baking, and when the cake was finished, he stacked the three layers together on a plate. "That cake looks silly," his neighbor the seamstress said. "I've seen a picture of a cake, and this looks nothing like it." But the baker kept going and frosted the cake with thick chocolate frosting. When the cake was done, the baker served up a big slice to all the villagers, and they all smiled and said, "Oh, so *that's* cake."

The moral of the story is this: you may want people to see your work before it is finished, but they may misunderstand it and be critical of your half-baked cake. If we show our ideas too early, we may gain some useful input, but we also risk hearing demoralizing comments that will be hard to get past.

Criticism is a powerful force in a creator's life. If we internalize and believe every criticism, it can shut down our desire to create. In some cases, we will leap into a piece of work with enthusiasm, only to suddenly lose interest near the completion of the project. This last-minute loss of interest is our way of coping with the fear and vulnerability of criticism, by stopping the process altogether before the critics have a chance to speak.

We can't control criticism; it will go the way it goes. It will come in the form of questions: "Are you sure that's what you want?" It will damn with faint praise: "Well, I certainly haven't seen anything like *that* before." It will try to make you change direction: "Ooh, I wouldn't have done it that way. Here, let me show you."

Understand that your art is revealing something very personal about you, and that it's going to provoke a reaction. In fact, you should pray that your art provokes a reaction. Our instinct is to respond to criticism with a rousing defense, full of articulate testimony designed to make the critic look bad. But you don't have to respond at all. Most negative criticism is meant to be sifted through, learned from, and then discarded until next time.

As you cultivate the creative spirit in your life, there will always be other well-meaning people there to comment. They will want to evaluate you, reward you, control you, restrict you, and pressure you to conform to their way of thinking. But creativity is *your* way of thinking. You don't have to compete with anyone or please anyone unless you decide that you want to.

People will tell you anything to discourage you from creating.

> You'll go broke.
> You're not hungry enough.
> You'll go hungry.
> You're not tortured enough.

You have no taste.
Your work is meaningless.
It's not as good as your last one.
Only paintings by dead people are worth anything.
Writers are a dime a dozen.

It is important to point out that criticism is not universally true but merely one person's opinion of the truth. Many a praised artist has dropped from early renown into obscurity, and many a brilliant piece of music has been panned at its first performance only to resurface as an acclaimed work of genius in the next generation.

Criticism is in fact a healthy component of the creative process. Here, then, is my foolproof method of dealing with the tough moment when someone walks up and criticizes your work.

1. Imagine that the critic is wearing no pants.
2. Listen to the criticism.
3. Don't feel that you have to respond.
4. Don't try to defend yourself.
5. Pick out the valuable comments.
6. Discard the comments that you disagree with.
7. Thank the critic (he or she really is doing you a favor).
8. Consider what you'll do about the comments, if anything.
9. Weep openly in the privacy of your own bathroom.
10. Get back to work.

The combined voices of the critics in your head—both real and imaginary—make for a noisy accompaniment to creativity. At some point you must walk away from the cacophony and be left alone to joust with your soul.

As painter and art educator Audrey Flack says, "When you're in the studio painting, there are a lot of people in there with you. Your teachers, friends, painters from history, critics . . . And one by one, if you're really painting, they walk out. And if you're *really* painting, you walk out."

Celebrity, Pedigree, and Hyperbole

This little light of mine, I'm gonna let it shine.
—from a song by Harry Dixon Loes

German composer Richard Wagner (1813–1883) was a brilliant self-promoter. At a young age, he moved to Paris with his wife and proceeded to fail miserably in the music business. Instead of whining about his failure, he returned to Germany and declared that the French didn't understand the new music he was writing. Over his lifetime, he wrote endlessly about his work and published books and periodicals extolling his new German music. As a preview of coming attractions, he performed individual selections from his *Ring Cycle* years

before the four operas were complete. He positioned himself in the press as heir to Beethoven's musical legacy and finally built an opera house in Bayreuth, Germany, constructed especially for and exclusively devoted to the performance of his own operas. He was a perfect storm of great musical talent with an amazing aptitude for self-promotion.

There is nothing wrong with self-promotion when you recognize that it is related to the creative process. The act of creation is in itself an aggressive gesture toward society, challenging the status quo. It is in effect saying, "You don't know what you're doing; here's a better idea." So, in a way, the desire for self-promotion comes from the same impulse as the one that drives us to create. Some innovative personalities are so self-assured about their accomplishments that they have the confidence not only to innovate, but also to want to share their innovations with the world. Then it's up to society to accept the innovation or dismiss it until times change and the innovation becomes valid or useful.

Self-promotion without substance is usually quickly sniffed out by the public, and I would like to think also that great creative ideas rise to the surface even in the absence of self-promotion and image management. We may discover a truth in our art that merits sharing with the world, or we may discover something so precious that we want to share it only with our closest family members and friends. Some artists can't help promoting their work, while others must keep theirs more private. You can't judge the worth of a piece of art by the fame or obscurity of its creator.

Far more important than any debate over the fame or obscurity of its creator is one thing: the art itself. Does it move us, does it challenge us, does it make a personal connection with us? If the art does these things, then it eclipses the fame of the artist.

We may be like the baker who loves to bake cookies and to sell them to everyone at the shopping mall, or we may be like the baker who loves to bake cookies and eat them alone in the kitchen while they're still soft and hot. Both types of cookie taste good, both are worth making, both are highly coveted. Some are good bought from stores and eaten in public, and some are better enjoyed in one solitary, rapturous moment, slumped over the kitchen sink with an ice-cold glass of milk.

I need to excuse myself for a moment. Pardon me; I'll be right back.

All right, then, as I was saying: please don't listen to all of the hyperbole that the fame-seekers generate. Hyperbole comes incredibly, extraordinarily, unimaginably easy to us in our age of media. In the last century we've heard things like:

The French Army is still the best all-around fighting machine in Europe.
—*Time*, June 12, 1939

Comet Kohoutek promises to be the celestial extravaganza of the century.
—*Newsweek*, November 5, 1973

> Rembrandt is not to be compared in the
> painting of character with our extraordinarily
> gifted artist, Mr. Rippingdale.
> —John Hunt, nineteenth-century art critic

Nearly every movie ad in your local newspaper is bannered with bold, blazing adjectives from the critical press. Even the most god-awful, horrid movies carry exuberant testimonials from critics: "THIS FILM IS EXTRAORDINARY," "BREATHTAKING," "AN INCREDIBLE CAST." All I can figure out is that the studios had to take these quotes completely out of context to make them work. What the critic must really have said is, "The fact that anyone in the unlobotomized world would even think of green-lighting THIS FILM IS EXTRAORDINARY" or "The snack bar had a BREATHTAKING assortment of Milk Duds and Junior Mints" or "The only reason I didn't run from the theater was that the guy next to me had AN INCREDIBLE CAST on his leg that blocked the aisle."

All of this hyperbole has a dulling effect on our senses. We want to know what critics think, because sometimes it's critics who point out those in our culture who should be validated by fame and public recognition. At other times, it's the groundswell of public sentiment toward an outstanding artistic achievement that brings fame, and then there are people like Paris Hilton and Kim Kardashian, who are famous for, well, being famous.

In any case, don't create just to be famous. I love what English cartoonist Gerald Scarfe says: "I don't want to be

famous; I want to be fabulous." There are fifty thousand actors in Hollywood, of whom we know about a hundred by name. The kid on the street is more likely to know the names of the Teenage Mutant Ninja Turtles (Michelangelo, Donatello, Raphael, and Leonardo) than the names of the great Renaissance artists (Michelangelo, Donatello, Raphael, and Leonardo).

And besides, there is no compelling reason that people should care about your work. Most of what you will create will be for your own enrichment or will be a stepping-stone to better, more insightful work. Maybe once or twice in a lifetime you will be recognized with public kudos, so in the meantime, create for yourself. Create because you have to, not to be famous, but because you are a living, breathing soul who must create or die a slow and boring death.

A postscript: Frederic Remington was a tireless worker who painted numerous canvases for books, magazine articles, and galleries. He became one of the most famous and celebrated painters of his age. Yet Remington had a tendency to go over his paintings again and again. He would even redo large sections of paintings that had been finished for years but perhaps still didn't rise to his expectations or weren't receiving the kind of audience acclaim he wanted. He went so far as to burn several canvases in frustration.

Why did he burn his paintings and continually rework his old canvases? Like all artists, from the epic muralist to the caricaturist at the county fair, Remington wanted what most artists want. He wanted to please. No quantity of fame or fortune could rid him of that wish.

Embarrassment

The first prerogative of an artist in any medium
is to make a fool of himself.

—Pauline Kael, film critic

Take a moment and address some simple questions to a group
of people sitting around your office or home. Ask them about
the marketing plan they're working on, and watch them talk
for minutes on end. Ask about their favorite football team or
movie; more talk. Ask about their family; more talk. Ask them
to sing their favorite songs; talk stops, pulses seem to quicken,
faces flush. Now ask them to draw something. Pupils dilate,
mouths seem to dry up, internal organs fail. Then come the
nervous responses: "Oh, no . . . I can't draw a straight line."
(By the way, who can and who cares?) People get embarrassed
when the spotlight is on them.

Now ask a group of kindergartners to sing and draw, and
the air is filled with songs and crayons spring forth. What hap-
pened? Somewhere between the time we were five years old
and now, we slowly left the fun and playfulness of creativity
behind. As adults, we have so separated ourselves from sing-
ing and drawing and dancing that we actually get embar-
rassed when we have to try. We'll sing in the privacy of our
own cars, and, with the help of a few beers, we'll dance at a
wedding (especially if they start to do the chicken dance), but

256

that's about it. A little voice inside stops us from expressing ourselves. We don't want to embarrass ourselves.

Embarrassment can be incredibly painful. The pain can be debilitating and stop you from working. It can open wounds of insecurity and start a fresh inner dialogue of doubt:

> My work stinks.
> I'll be revealed as the impostor I am.
> Criticism hurts, so why invite it?
> Just who do I think I am, anyway?
> Just shut up—nobody wants to hear you blab
> on about your idea.
> I'll look like an idiot.
> It's a great idea, but I won't be able to present
> it well.
> Nobody gives a damn about what I create,
> so why do it?
> I'm blocked. I can't write (paint/draw/cook/
> dance) anymore.
> I'm mediocre.

As a creator, you risk embarrassment and humiliation because your art requires that you step outside your comfort zone. All of the great innovators of history, all of the great actors of history, and all of the great scientists of history have, at many times in their careers, faced embarrassment, humiliation, derision, controversy, and downright hate. You will, too. It will

happen when you search for new ideas and fail. It will happen when you speak and are misunderstood. It will happen when the vision in your head can't be seen by others.

Junk

ZEPPO: The garbage man is here.
GROUCHO: Tell him we don't want any.

If you're like me, you get a lot of junk mail every day. Yes, occasionally there is a welcome note from a long-lost friend or a surprise check from someone who owes me money, but most of the time, I get junk. I don't understand junk mail. The whole premise seems to be based on trying to trick you into thinking that there's something great inside the envelope.

Sometimes an envelope has a window in it making it look as though there's a check inside. I opened one of these the other day. Through the address window, I could see the words "Pay to the order of" printed in large letters above my name and address. There was a big federal-looking eagle printed there, too. When I opened it, it looked like a check for $35,000, but of course the words "non-negotiable coupon" were printed nearby in the same size type that they use to print the Lord's Prayer on the head of a pin. I must be on a mailing list labeled INCREDIBLY STUPID AND GULLIBLE PEOPLE.

Another junk-mail envelope had used a typeface that was supposed to make it look as if the envelope had been addressed by hand. That way the recipient would think it was a very personal letter from a dear friend and would rush to open it.

One junk-mail envelope said, "Certificate of Recognition enclosed—Please do not bend!" I must have fallen onto the mailing list for the demographic that includes IGNORED AND UNREWARDED STUPID AND GULLIBLE PEOPLE WITH LOW SELF-ESTEEM. Another was a letter that looked as if it were from the White House. The words "An invitation" were printed on the envelope. It turned out to be from a political action group. I suppose they thought I'd rush to open it, thinking it was an invitation to sleep in the Lincoln Bedroom. I'm probably also on the mailing list consisting of PEOPLE WHO WILL RESPOND TO A BOGUS INVITATION TO SLEEP IN THE WHITE HOUSE.

What scares me a little is that these gimmicks must work—otherwise, why would these organizations still use them? What do people think? Do they expect us to call up and say, "Boy, oh, boy . . . for a minute there, I really thought this was a note from the White House! Oh, brother, I sure didn't see a solicitation for money comin'. But hey, I feel so embarrassed that I think I'll send you some money after all, just because I admire your marketing moxie."

The topper was an envelope from a time-share condominium that said, "You have already won one of these three valuable prizes: a spectacular two-week Hawaiian holiday, a fabulous new Chevrolet truck, or a toaster." Now, you don't have to be a Rhodes scholar to figure out that I'd won the

toaster, but I had to go to the sales office and endure a four-hour interrogation before I could pick it up. I wonder how many people gut out this sales presentation just because they desperately need a new toaster. I've got no experience with time-share marketing, but it seems like a pretty flimsy business plan if you have to base it entirely on people's overwhelming desire to have toast.

Junk mail can be alluring. It can look like found money or a note from a long-lost friend. It should be no surprise to find that the same brains that produce masterworks can also produce junk. At first glance, our creative ideas are precious to us because, after all, we have created them. But along with the breakthroughs we tend to create heaping buckets full of junk.

The fear of creating junk paralyzes many people and prevents them from even starting their work. We get self-conscious about our creations and think that our first brushstroke or our first soufflé has to be perfection, or that somehow we aren't as talented or as gifted as the next guy. We are frozen in our tracks for fear that we will create junk.

Well, it's true. If we just accept the fact that everyone creates junk along with good stuff—that the junk is the natural by-product of the good stuff—then we won't be so shocked and demoralized when we make something that resembles horse stool.

We don't get much help from art galleries and museums here. Since most artists and old masters never release their stinky work, it's normally the good stuff that makes it to museums. Every once in a while, a museum will gather a

show that exhibits the sketches, discards, and failed experiments of the masters, and then you can see the human being at work inside the mythic exterior.

I've always wanted artists to be brave enough to exhibit their junk along with their good stuff (myself not included, for fear of gross humiliation). Yes, show the beautifully painted final piece, but also show the fifty sketches, the dozen stupid ideas, and the three failed attempts. That would show the whole story of creation.

Learn to love the junk as a bridge to the better idea. Learn to understand its place in the process. It's okay to come up with a stupid idea. Nobody is going to frame it and stick it on the wall . . . well, actually, that's not true. I once saw an exhibition of fast food that had been pressed between two sheets of Plexiglas at incredibly high pressure to create a sort of fast-food roadkill that was then framed and hung in a gallery. I thought that the squished Shakey's pizza and the dozen Dunkin' Donuts looked like boring junk, but at the same time I found that the flattened KFC two-piece chicken meal with coleslaw and mashed potatoes was strangely compelling.

We need to be able to tell the difference between our gems and our junk. The creative process demands that we create freely, openly, and in large quantities. We shouldn't start a project by looking for only a few good ideas. Early on in a project, it's actually more important that we create lots of ideas that reflect our feelings and thoughts. Then we can go back and sift through the ideas to find the gold.

Junk, however, may not be junk forever, and it should not be thrown away. Ideas that seem out of date and useless today may come into fashion in the light of a new day. I also advocate a garage-sale mentality: one man's junk is another man's treasure. The discarded ideas from the work of others can, when viewed in a new light, benefit and influence our work.

Take the case of a Dutch inventor named Cornelis Drebbel. Mr. Drebbel was actually a pretty well-known inventor back in the early 1600s, although he never made much money at it. He invented a submarine complete with pressurized oxygen to breathe, and later in London had this harebrained scheme to harness the sun's energy by focusing scores of mirrors on a central heating duct and then distributing the solar heat by means of an elaborate system of conduits. Pretty nutty, huh? It was—up until about thirty years ago, when scientists started building massive solar collectors to harness the sun in much the same way Drebbel had envisioned it nearly three hundred years ago.

Cornelis Drebbel became one of history's forgotten men because, as brilliant as he was, society had no interest in his ideas. And so, as his wooden submarine sat rotting and his solar collector drawings gathered dust, Drebbel finally met with success by opening a pub and serving beer to his parched patrons.

Drebbel's story teaches four important life lessons:

• Creativity needs a receptive society, or even the most brilliant of ideas will appear to be junk.

- Society has no way of keeping track of bad ideas or the work of "unsuccessful" innovators.
- Old junk can become new works of genius.
- When all else fails, serve beer.

Talent

The dictionary says talent is an innate capability—an aptitude, flair, inclination, or instinct for something. People talk about talent as though it were a measurable commodity. "She's really got it" or "He was absent when they handed it out." The most sobering question that we dare ask ourselves is, "Do I have enough talent?"

Our thinking on talent is very prejudiced. We think that talent in the arts is a God-given genetic thing, so much so that we don't teach the arts very much. We wouldn't dream of doing the same thing with reading, writing, or arithmetic. I've never heard anyone say, "Today's lesson is addition. I've put some pencils and paper on the table, and you can go ahead and just use your imagination and think up some addition problems and solutions."

No, on the contrary, we prepare carefully and drill our children on math and language so that these skills will not be left to chance. Why is it that we don't teach the arts in the same way? Well, you got me there.

There was a feeling expressed by the post-Gestalt psychologists that teaching art would damage creativity. Most of the old masters were carefully trained in painting and the other arts. In fact, the same skills needed in the arts—like perception and observation—are essential to other, more academic pursuits like language arts and math.

The world is full of people who are endowed with stunning talents yet never produce a thing. Talent doesn't make the creation of art any easier; it doesn't guarantee the artist will do great work or help weather the storms of change, doesn't deal with a frustrating medium or help to ensure artistic success. At best, talent gives a person a jump-start—a firmer footing on the slippery soil of the arts. What happens after that is about the same for all artists. Making art is hard, so instead of sucking on your lip wishing you had more talent, try this: take your passion, knowledge, and work ethic, and throw yourself naked, with arms flailing, into something you love to do. Challenge yourself to know more, love more, feel more, and work more. Continue to learn, practice, explore, dream, and believe in yourself. Give your art your best effort, and a funny thing will happen. Any question you have had about your talent or lack of talent melts away as your personal creative self is revealed.

What Would It Matter?

I've worked very recently on a couple of documentary films for the Disneynature banner, where I met an extraordinary filmmaker named Alastair Fothergill. At the time, he had a number of amazing films for the BBC under his belt, culminating in his award-winning series *Planet Earth*. Fothergill and his team camp outdoors for months on end in exotic-sounding places to capture nature on film. In the film *Earth*, he shot a long sequence of a pride of lions chasing and attacking an elephant in the dead of night. The lions far outnumbered the elephant and brought it down and killed it. I asked Alastair the obvious city-boy question: "Why didn't you intercede and save the elephant? Surely you could have fired a flare or sounded the car horn or done something to stop this terrible slaughter."

The balance of life in nature is so fragile that saving the elephant might have meant less food for the pride and fewer lion births the next year. Fewer lions might have meant more game. The circle of life could go slightly out of balance in any number of unforeseen ways. Alastair's policy is to look and to film, but not to touch. One small action on his part could affect generations of wildlife in unimaginable ways.

The moral of this story applies to human beings as well—one small action could affect generations of humans

in unimaginable ways. Many give up on their creative hopes and dreams for a simple reason: what would it matter? You have no idea what it would matter, and that's the point. There is no way that you can know the long-range effect of your creativity.

Physicists believe that nothing happens in isolation. All actions and nonactions, no matter how small, interrelate. They call it the Butterfly Effect, based on the theory that if a butterfly were to fly into your room right now and get eaten by your schnauzer, the effect of that accident would be felt in other galaxies. The whole of the universe is interrelated in myriad and impossible ways.

Commitment

Writer's block doesn't just happen to writers. You may be tired or sick. You may be out of ideas or inspiration. You may just be stuck in the mud of life. The worst thing you can do if you feel stuck is to do nothing. When the well is dry, walk away, regroup with new research, inspiration, and a box of dark chocolate, and try again.

Commit to returning and trying. Try writing more. Try painting more. Diamonds are forged from intense heat and pressure and you have to look through a whole lot of slop and soot to find one—but when you do, you're rich.

Ideas break through in the same way. If you were com-
pletely blocked and God dropped down from heaven and
said, "Oh, you're not blocked, you just have to work through
ten thousand boring, nonsensical words before you get
to the next great idea," wouldn't you start writing? W. H.
Murray talks about being blocked in this oft-quoted para-
graph from his writings on a Scottish Himalayan expedition.
Read it carefully:

> Until one is committed, there is hesitancy, the
> chance to draw back, always ineffectiveness.
> Concerning all acts of initiative and creation
> there is one elementary truth, the ignorance of
> which kills countless ideas and splendid plans:
> that the moment one definitely commits oneself,
> then providence moves, too. All sorts of things
> occur to help one that would never otherwise
> have occurred. A whole stream of events issues
> from the decision, raising in one's favor all
> manner of unforeseen incidents and meetings
> and material assistance, which no man could
> have dreamed would have come his way. I have
> learned a deep respect for one of Goethe's
> couplets: "Whatever you can do, or dream you
> can, begin it. Boldness has genius, power, and
> magic in it."

Madness and Suffering

Creativity comes from a very primal place. As we grow up, most people suppress these primitive voices, while at the same time, many highly creative people struggle for the opposite— to stay in touch with their primitive selves. To remain so in touch with these feelings sometimes means that we walk a fine line between sanity and madness.

Plato wrote that creativity is "divine madness . . . a gift from the gods." Van Gogh, Frida Kahlo, Jackson Pollock, Edgar Allan Poe, Virginia Woolf—these are names that remind us of greatness, madness, depression, and suffering. Artists are driven to create by their own psychological issues, and some have bigger issues than others. Highly creative people may have a greater sensitivity to emotional trauma than others. For some, art becomes a salvation, a protest against death, a way to struggle against adversity.

Anger, disillusionment, and frustration can be vetted and vented by means of artistic expression. Creativity is a constructive outlet and a healing force for painful feelings. Learning how to paint or play piano or cook a gourmet meal is more than just an idle way to pass the time. It is an important cleansing force that helps us deal with the problems of life and survival in a complex world.

Creating is a powerful way to face death and dying. Even our own feelings of mortality take a mental backseat while we are occupied with the act of creating.

Illness and Death

In 1982, two fairly unknown songwriters had written a musical based on an old science fiction film about a man-eating plant. One of the songwriters was a musician from New York whose father really wanted him to become a dentist, and the other was a lyricist from Baltimore. Alan Menken and Howard Ashman's work on *Little Shop of Horrors* won them international acclaim and landed them at the Disney studios.

There they collaborated on *The Little Mermaid,* which was seen as a triumph not only for the songwriters but also for the Disney animation team, because along with 1988's *Roger Rabbit, The Little Mermaid* was the bellwether of a soon-to-be animation renaissance.

During the last few months of production on *Mermaid,* we asked Howard to collaborate with us on *Beauty and the Beast.* He was hesitant to work on *Beauty* for many of the same reasons we were. It had a second act that was all about a beast who came down to dinner every night and asked a beauty named Belle if she wanted to marry him. She said no, he said all right, and he went away until the next night, when he came downstairs and started all over again. How do you make a musical out of that?

Over the next two years, Howard worked with us to do just that. When we got dispatched again and again to come to meetings with Howard near his home in upstate New York,

I thought he was just being a diva. He was not. He was sick and we didn't know it. Howard had AIDS.

Eight of us, including directors Kirk Wise and Gary Trousdale, traveled across the country and checked into the beautiful Residence Inn in Fishkill, New York, to start working with Howard, the master. It was Christmas, and we did the usual things a bunch of artists would do in upstate New York. We ate dinner at Hudson's Fish and Ribs, then bought a gallon of ice cream and some hot fudge and came back to the hotel to make angels in the snow and watch *A Charlie Brown Christmas* while we made sundaes.

The next day we got together with Howard in an upstairs meeting room at the hotel—the kind of place where a sales-man might discuss the financial benefits of siphon-pump technology. But we were armed with sketch pads, storyboards, and coffee as we sat waiting for the meeting to begin.

Howard Ashman was a tall, thin man who would show up wearing a white shirt and baggy trousers held up by sus-penders like some character from *Inherit the Wind*. He walked in with a requisite bag of sugar doughnuts for us all and sat down. Howard, like many creative people, could have chosen to do many things in his life with great success; he happened to be a brilliant lyricist, but he could have easily been a trial attorney. He was extremely articulate and drew on an end-less supply of character examples from old movies, Broadway musicals, and his childhood in Baltimore.

Alan Menken was like a short-order cook. He served up dozens upon dozens of ideas, quickly abandoning the

unworkable and expanding upon the good. Some songs emerged from well-trodden paths. Pastiche-sounding so they felt comfortable, almost as though you had heard them before, except they always had an important twist.

The directors of *Beauty*, Kirk and Gary, had put together a rough scene for the opening of the movie. The ensuing discussion was like watching a doubles tennis match. Howard would serve up an idea. Gary would return, and all would volley until a high lob ended in a smashing win. It was all done with camaraderie and respect, but also with competitive passion. After weeks of writing, the first songs to emerge from Howard and Alan were the opening number, "Belle," and "Be Our Guest." Howard was really nervous about these songs, so he traveled out to the studio to explain them while we listened.

Later came the ballad "Beauty and the Beast." We loved the song when it came in, and some executives even wanted another verse, but Howard countered that he had no words to rhyme with "beast" except for *priest, yeast,* and *creased*, all of which seemed to send the plot of the film in another direction.

After all of the songs were written, Howard rolled over to *Aladdin* to work on the song score. Even though *Aladdin* came out after *Beauty*, the *Aladdin* songs had been written years before, and now Howard and Alan set about polishing their old score.

But it had become apparent by the time we got around to the recording sessions for the "Beauty and the Beast"

ballad that Howard was becoming ill and losing strength. He had also lost his voice, and his phone conversations turned into strained whispers.

Howard had a singleness of purpose that amazed me. By this time, everyone knew he was ill, and he must have been in emotional and physical pain, but he soldiered on. Even after he had lost his voice, he would sit in the back of the control booth and whisper his notes to Alan. Later we rigged up a system so that the music could be piped in live to his living room in New York from our sessions in Los Angeles. He'd whisper over the phone while the whole room silently waited for his comments.

We added a last-minute song to *Beauty* called "Something There," which was to be sung from the objects' point of view concerning the romance of Belle and the Beast. Howard wrote a lyric that was full of whimsy and anticipation. Later that week, he was hospitalized. I called him as often as I could and sent him dozens of innocuous gifts that I was sure he didn't care about—*Beauty* T-shirts, hats, and our prized crew sweatshirt.

I sent him regular videotapes of the film so that he could watch the progress of the animation. He'd call me full of notes that were packed with vitality and authority.

I flew to New York in February of 1991 to show some reels of *Beauty* to the press. Kirk and Gary and I joined Roy Disney, Peter Schneider, and Jeffrey Katzenberg, along with some of the animators, to talk about the production. We rolled in a piano so that Alan and Paige O'Hara could perform the ballad.

The reaction was something we didn't see coming. They

didn't just love it. They adored it. They loved the story and the characters and, above all, they loved the music. That afternoon, Peter Schneider and I shared a car down to the hospital to tell Howard. We arrived at the same time as Jeffrey and David Geffen.

Howard was very sick by now and had lost his sight. When we walked into his room, I was faced with the most bittersweet sight I have ever seen. Howard was lying there with his mom at his side, and he was wearing his *Beauty and the Beast* crew sweatshirt. We all stood and talked for a while and then shared the good news about the press conference. He was very happy.

One by one, Jeffrey and David and Peter said their good-byes and offered words of encouragement. Somehow, I was the last one to go. Like the others, I bent over and whispered in Howard's ear. "It was great, Howard, you should have seen it, they really loved the movie. Who'd have thought it?" And then, in true fashion, he waited a moment, gathered his forces, and whispered, "I would have."

Of course he would have thought it. He had poured every ounce of his spirit into his work on *Beauty and the Beast*, and he trusted his own ideas like no others. The four of us left and rode the elevator to the hospital lobby. No one spoke. Howard died a few days later.

In early October, weeks before *Beauty* was finished, the New York Film Festival invited us to screen an unfinished version of the film for an opening-night audience at Lincoln Center. If you have ever seen an unfinished clip of animation,

you know that it looks a bit like a coloring book before it has been colored in. The uncolored and colored bits bounce back and forth, and the result is really distracting and not particularly pretty. So, with sweaty palms, I boarded a jet with the directors and flew to New York for the festival. After showering, dressing, and reciting the Twenty-third Psalm a few times, we took a car from our hotel to Lincoln Center. We didn't say much on the way. We just let the flop sweat trickle down our foreheads. As the car pulled up in front of Avery Fisher Hall, we noticed a teeming crowd of people. I don't know what I expected, but people had actually showed up to see the film. Inside, we ran into some friends and were introduced to reporters. A film crew from *20/20* was there, too. They had been following us around for weeks doing a story on the making of the film. As showtime neared, we were hustled to a green room and then backstage to the wings in preparation for some opening remarks. It all felt vaguely like a scene from *Spinal Tap.*

As we walked out onstage to introduce ourselves, the packed house fell silent. We made the usual opening disclaimers and told them that what they were about to see was very rough, a work in progress. That *Beauty and the Beast* was indeed a tale as old as time—a story that had appeared around the world in countless interpretations, such as *Cyrano, Phantom of the Opera*, and *The Jim and Tammy Faye Bakker Story.*

With that, the lights dimmed and the film rolled. Each song was greeted with a hearty ovation, and each joke played like a million bucks. I was stunned by the reaction. Kirk and

Gary and I had been so close to the film—so engrossed in the process of finishing it on time—that we had lost track of the notion that someday an audience would sit down in a darkened theater and enjoy it. That someday was today.

We had taken our seats in an opera box at the side of the auditorium, where the filmmakers during past festivals always sat while the audience took in the show. When the final note sounded, the audience erupted in applause. We stood in our box like stunned mule deer and waved to the audience as they proceeded to come unglued for about ten minutes. I'll always remember that moment. Standing there in an opera box in front of a cheering crowd is about as close as I'll come to feeling like Eva Perón.

Who'd have thought it? Howard would have, and we missed him very much that night. When the film was released that November it bore this dedication:

> To our friend, Howard, who gave a mermaid
> her voice and a beast his soul.
> We will be forever grateful.

6.
Rebirth

Life isn't about finding yourself. Life is about creating yourself.

—George Bernard Shaw

Starting Over

Imagine how a newborn baby feels. One day it's in a warm, dark, comfortable womb; the next it's thrust into the cold and noisy world of pacifiers, applesauce, and *The Bachelorette*. Its senses are bombarded. Everything is new.

You were once that baby. Somewhere in the back of your brain you remember what it felt like to be a newborn, when everything was full of wonder. Every face, every storybook, every lullaby was a new experience. Babies make mental

connections with alarming speed while trying to figure out this new world they live in. At birth, a baby's brain contains roughly as many nerve cells as there are stars in the Milky Way. The first five years of life are characterized by an unimaginable capacity to learn. A child's brain makes endless connections of logical patterns and at the same time begins to eliminate connections and patterns that are never used. This growth-and-pruning process often yields a teenager whose shaved head and snappy nose ring reflect a set of emotions and thoughts that are completely unique.

Researchers at Baylor College of Medicine have found that babies who are seldom touched or who rarely play can develop brains that are between twenty and thirty percent smaller than normal. It's a kind of emotional dwarfism. Play and stimulation, especially during the early years of life, form the foundation of visual, emotional, verbal, and physical traits of the young person and, eventually, the adult.

Babies grow into adults, and as adults we find jobs, spouses, and homes and settle into predictable and pleasant routines. We break the routine by vacationing for a few weeks every year, when we figure we should stretch our senses with a visit to places like the Grand Canyon, New York City, or Orlando's Gatorland, "Home of the Famous Gator Jumparoo!" I'd like to take a moment to highly recommend the Jumparoo, since it's one of the only places on earth where you can watch an alligator stalk through the water with only its eyes and nose exposed and then leap seven or eight feet out of the water and bag an entire chicken in one gulp. As the employees

of Gatorland will tell you, "This is not a natural behavior."

But sometimes Gatorland does not completely refresh our soul (now there's a sentence that I never thought I'd use). Call it refreshment, reinvention, rebirth, whatever, we need the occasional face slap to connect with a new awareness of the universe and all the inspiration and rejuvenation that can be found there.

Awareness needs time. Not long ago, after some self-examination and a half gallon of cookie-dough ice cream, I decided that I was stuck and out of gas. Without thinking too deeply about it, I knew that I needed time and I needed to reinvent myself. I had preached reinvention to people around me for years, and this was my time to walk the walk. So I saved up some money and decided to set off on the ultimate fantasy: I took a year off from work.

I had plenty to lose in terms of money and relationships by withdrawing from film production for a year, but I had even more to lose by running myself into the ground. There's a Bible verse from my youth that I couldn't chase from my head: "What does it profit you if you gain the whole world but lose your own soul?" I felt like I had gained so much from the world, but was in danger of losing something of my soul if I didn't listen to myself. One October morning I was driving to work and all the thoughts, fears, and feelings converged in my head at once. I knew in that instant that it was time to go.

The first obstacle was to tell my family and friends what I was doing. After some shock and awe people were, without exception, incredibly supportive. Why wouldn't they be?

If it makes you happy to take a year off and you can afford it, knock yourself out. I had a very empathetic boss in Ed Catmull who understood exactly what I was trying to do. Together we set a date for my departure. I sent out an e-mail to all of my colleagues offering some sort of plausible story about taking time off to recharge. Everyone wanted to know my plans. Would I travel, or write a novel? Then everyone looked for subtext. There must be more to the story. Was I sick? Was I fired? The best that I could offer was to assure them that I was okay and then follow with a thin cover story that I was going painting in Sedona. I wasn't.

That was it. The deed was done; the news came and went fast, and in a heartbeat I was sitting alone at home. The first thing I noticed was that the e-mails dropped off. I normally received well over one hundred e-mails a day; after a few weeks, I was receiving zero. The second thing that I noticed is that nobody called. Occasionally I called someone and asked him or her to go to lunch, but no one called me. No one. I felt like a leper—only lepers get more phone calls and e-mails.

When I ran into old friends, they'd heard that I retired. It was too complicated to launch into a long explanation about how I felt. I used the word "sabbatical" as much as I could, but it still carried with it a stigma that I was a loser who had burned out and needed to get away. The stigma bothered me because in a way, it was true.

I stayed around the house for a couple of weeks, but didn't fit in very well. My wife had such an impressive flow of

people coming and going, and everyone from the pool man to the dogs was confused as to why I was there. I followed a friend's advice and got some office/studio space to use as a laboratory for the next year. I wasn't sure why I needed it or what I was going to do there, but at least it got me out of the house in the daytime to a place where there were no awkward encounters with people. I moved a desk and an easel into the space, and then I went and sat there.

On my first day, I sat and realized that all of my fantasies about taking a year off were now reality. All the saving and stressing and saying good-bye to people at work was done. All the explaining to friends and family was over. Now I just sat there and stared out the window. For about a month I sat.

My first project was to unintentionally gain weight, and I did this with tremendous fervor and rousing success. Then after a few weeks, I started to realize I was surrounded by boxes. My studio, my home, my garage, and even my car were full of boxes. I didn't even know what was in most of them. It made me worry that I might have hoarder tendencies because I could not bear to sort out the boxes and clear out the junk. I had saved everything from every chapter of my life, believing that one day it would all be in my presidential library. Without doubt I could eat up my whole year off just going through these boxes, and I was sadly convinced that it would be time well spent.

Most of my boxes contained an assortment of unrelated items that would never be seen together under normal

circumstances: a baseball glove; a Mounds bar; a battery charger for a long-lost cell phone; a map of Provo, Utah; some Slim Jims; a hand towel from the Radisson Inn; a brochure about colonoscopy; a fruitcake circa 1978; a John Tesh cassette; a shower cap; and a jar containing nails, buttons, paper clips, and dice. I thought of burying this particular box in my backyard as a time capsule. People would dig it up in a hundred years and enjoy the fruitcake as they marveled at my primitive means. My wife did an intervention and stopped me from looking through my boxes. Her rationale was that I should be looking forward and not back. Nutty, I know.

By now I was six months into my year off. Sure, I had successfully increased my body mass index number, filled a couple of diaries with self-analysis, and emptied out a few boxes, but there was no clear sense of where this was all taking me. I made a casual lunch date with a friend I hadn't seen in a long time. Mike Carroll is a photojournalist with a long resume of clients including *Rolling Stone*, *People*, and the *Boston Globe*. He was in Los Angeles for a few days shooting a book cover at Disneyland so we decided to meet there for lunch.

I really didn't know Mike that well. As we ate, we shared small talk and stories about work and our families. About forty-five minutes into our lunch, I asked him what was next.

"I'm leaving for Romania on Friday."

"Really?"

"Ya, I go about three times a year."

"Romania? Why Romania?" I asked.

For the next hour, he told me the most amazing, hair-raising story I'd ever heard at lunch at Disneyland and possibly ever. Mike had been one of the first photojournalists to enter Romania after the brutal communist regime of Nicolae Ceauşescu fell in December of 1989. Mike went to take photos, but walked into one of the most horrific scenes of the twentieth century: the pediatric AIDS crisis and tens of thousands of warehoused orphans.

His photos and the account of his discovery ran in the *Boston Globe* and brought the plight of the Romanian orphans to the Western world. But that wasn't the punch line. For twenty years since, Mike has been going back to Romania to help the kids by offering medical equipment and psychological training for child-care providers in Romania.

Mike is an average guy from Boston who couldn't find Romania on a map before his odyssey began. When I got home that night I couldn't figure it out. Why did he do this, and how could he keep doing it? He's an artist, a working photographer, but he was giving up a huge part of himself to affect change in someone's life.

There have been only a few moments of stunning clarity in my life, and this was one of them. I finally knew why I had taken a year off: I had to tell Mike's story. I had to answer for myself why this guy would do this. And if he could spend his artistic capital this way, in an outward-looking mission for people he didn't even know, then why couldn't I?

My art is that I make films, and I was going to make a film about Mike, only he didn't know it yet. I called him the next

day and told him I wanted to tell his story. He hated the idea of being the subject. He insisted that the story be about his organization or the kids or his staff of twenty in Bucharest. But it was clear to me that there was only one story to tell here: 160,000 orphans meet one guy with a camera, and they change each other's lives forever.

The film, which eventually became the documentary *Hand Held*, was my way of working on something that had no limits. I could control the budget and schedule and shape the story, too. Without even thinking about it, I left the navel-gazing behind me, and jumped headfirst into telling Mike's story and expressing how I personally felt about it.

I've already mentioned my friend and mentor Walt Stanchfield's oft-used phrase, "Impression without expression equals depression." It now rang in my head every hour of every day. I didn't know how to get it done or how I was going to pay for it, but there was strength in stepping out from the river's edge into the fast-moving current of this idea. All I knew is that there was a story here worth telling, and if I started following it with a camera, the story would reveal itself to me and maybe help renew me in the process.

I followed Mike with a camera for a year, filming in Boston, Bucharest, and Transylvania. Emotional dwarfism was no longer a footnote on a textbook page. Now it was right in front of me, staring me in the face. I could only point my camera and take it all in knowing that it would take me months to process what I had seen.

Mike turned out to be the ideal subject for a film. He

always felt like I was doing him a big favor by making this film, but it was clearly the reverse for me. By telling his story, it got me out of my head and into the real world. It led me to hospitals and foster homes in remote villages occupied by the Roma people where a year earlier they had filmed *Borat*. It led me to good people still struggling with rudimentary health care, literacy, and political inattention. It led me to some intensely creative people like Mike who were willing to give up nearly everything to solve a problem that would benefit someone else.

I felt so naive having never thought of spending creative capital like this. My year off was supposed to be about my work and my films, my career—me—but at the end of it, I was so insanely far away from where my journey started that I could hardly recognize myself. I began twelve months earlier in a search for wellness with no instruction manual, never dreaming that healing would come from a chance meeting at Disneyland, an itinerant photographer, and a bunch of kids in Transylvania.

Turns out I had to unlearn a lot of things. Most of all I had to stop the constant inner monologue long enough to shut up and listen. Mike's story was an introduction to a world where people use their best selves to make a dent in the universe. All the angst and problems of a movie producer in Hollywood didn't amount to much in comparison to the faces I saw and the people I met. I had lost all perspective, if indeed I ever had perspective, and now, one year later, I was seeing things with new eyes.

New You

Picasso said that when he was a child he could draw like the old masters, and that it took him the rest of his life to learn to draw like a child. People talk a lot about discovering the inner child—that innocent, creative toddler yearning to breathe free—but no one ever tells you what to do with the little tyke once you've discovered him within you.

When experts address the subject of finding the ideal creative spirit, the ultimate creative machine, the best that I can figure out is that they are referring to how you felt as a kid. So when you get ready to release your inner child, let's think about what you will be releasing. The average five-year-old is just learning how to read, wears underwear emblazoned with princesses or superheroes, frequently spills things on his or her clothing, and is just starting to learn the really good knock-knock jokes.

This ideal creative spirit spends four hours a day in kindergarten, which seems to be a mixture of drawing, singing, dancing, reading, studying dinosaurs, working with clay, painting, and climbing monkey bars. The remainder of the time is spent running at top speed, screaming loudly, giggling, crying, being hugged and kissed by adults, bathed by a caretaker, dressed in pajamas, and put to bed.

Now let's take a look at the average adult—the adult who is meant to acquire the attitude of the five-year-old. The average

adult works eight or nine hours a day, wears white underwear only rarely emblazoned with princesses or superheroes (and then only during the height of mating season), makes grunting sounds when rising from a chair or sofa, spends four hours a day eating or preparing food, two hours watching television, and only fifteen minutes with his or her inner five-year-old.

How on earth are these two seemingly diverse species ever going to get together? Even if you took on the characteristics of a tot, the physical exertion would land you in the hospital, and the behavior—running, screaming, giggling, crying, spilling food, losing teeth—would land you in an institution, where you would be bathed by a caretaker, dressed in pajamas, and put to bed. How, then, are we truly expected to rediscover the inner child?

To be a kid again means becoming a beginner again and making mistakes again. It's a difficult sacrifice, since we've worked our entire lives building the experience and knowledge that we've so desperately wanted. But it is far more important to rediscover that feeling of newness.

As adults we attempt to become new again in many ways. There is the corporate retreat method, where we take the humdrum schedule, pressure, and problems of our workaday world and move them to a hotel conference room equipped with some felt markers and a big pad of paper on an easel. Here we are told to observe an eight-hour schedule of meetings plus roughly four hours of eating or food preparation and two hours of watching television in our room before

calling our spouse on the phone for fifteen minutes. The adult pattern is not effectively broken.

A more interesting approach might be four hours of a mixture of drawing, singing, dancing, reading, studying dinosaurs, working with clay, painting, and climbing monkey bars followed by a period of running, screaming, giggling, crying, and spilling food. I'm exaggerating a little bit, but not much. To let the adult have a day off would let the child return and with him or her, the childlike properties of curiosity, intuition, and emotion.

The New Kid

On your quest to exhume your creative spirit, you will feel silly, you will think it won't work, you will feel dumb, you will revert to comfortable ways, you will say lots of negative things to yourself. There is going to be a constant conversation between the parent in you and the new child in you, and the knee-jerk response will be to obey the adult voice.

In American popular culture, we gravitate toward the logical part of the brain, and for mostly good reasons. Who'd want a child doing the accounting or working on the next space shuttle launch? These are jobs for logically minded grown-ups. Logic appreciates neatness and likes life to work in an orderly fashion. It enjoys dividing things into categories,

which it studies and understands in a rational, unbiased way. Our logical brain knows that the world is a much better place if it is carefully and neatly organized.

The abstract part of the brain, on the other hand, is the innovative, childlike numbskull that can look at something that it's never seen before and not try to label or categorize it. It simply takes the world at face value. Our abstract brain often thinks without words. It free-associates with patterns, colors, and previously disconnected ideas.

The abstract brain doesn't stop and count. It looks into the darkness and sees opportunities and adventures. It wants you to leap out and fly into that darkness, to experience a fresh way of thinking.

The logical brain stands and carefully considers the opportunities before it. It loves familiarity, conformity, and safety. It makes you feel comfortable when you see things you've seen before, meet people you've met before, eat food you've eaten before, and wear clothes you've worn before. When you gaze upon something new, it will send you more warning signals than the robot in *Lost in Space*.

Modern life in Western culture seems to be lived almost entirely in the logical brain, and so, in the quest for a more creative existence, we need to seek more balance and migrate more to our abstract thoughts. When your logical brain shouts, "Run, Will Robinson, run!" one way to balance yourself is with a good helping of quiet, focused thought. You can call it prayer, meditation, centering, realignment, or, as they say in the business world, "stress management," but the search

for balance between the logical and the abstract brain can help us journey from a superficial perspective to an insightful perspective, from shallow to deep, from physical to spiritual, from panic to peace.

Waking Sleeping Beauty

New discoveries are like newborn babies. They have no names and they seem a little awkward, but there is something very attractive and compelling about them. There is a kinship we have with new ideas.

A nursery is a room or place equipped for young children. It's a room where they can be raised and nurtured and where they can feel a sense of security when the lights go out and the sandman comes. And it's a place where you can crawl under the covers with a flashlight anytime you want. When was the last time you had a room that was equipped for you, just you? If you like to cook, it could be your kitchen, where you are surrounded by the security of your favorite pots and spices. Sometimes it's a spare bedroom or a garage, where you can go to have time alone to think and create. Every creative spirit needs a home, a safe haven for ideas and creative activity.

It needs to be a place where you can go and shut out the outside world and be alone with your thoughts. Some artists find that a mountain cabin or a hot tub is a great place to

create. Some do their best problem-solving in the car, others in the shower. Wherever it is that we end up, we all need a quiet, womblike place where we can create.

The same is true of a creative organization. Together, we need a safe place and culture that allows us as a group to thrive, unrestricted by hierarchy, bureaucracy, or other forces of evil.

I directed a documentary called *Waking Sleeping Beauty* about the amazing Cinderella-like transformation of Disney animation in the 1980s and 1990s and the perfect storm of people and circumstances that changed the face of the animation industry forever.

It's one of the great comeback stories in Hollywood history. For fifty years, Disney animators occupied the ani- mation building on the main lot of the Disney Studios in Burbank. The great classics of Disney animation were produced in this building. By the early 1980s, the art of animation was in transition, and the hallways at the Disney studio were full of talent coming and going. Going were veterans Milt Kahl, Frank Thomas, Ollie Johnston, Mark Davis, and Ken Anderson. Coming was a ragtag collection of artists, mostly from CalArts, who occupied the building's D Wing—what one well-known animator had dubbed the rats' nest. Fresh from school, Ron Clements, John Musker, Brad Bird, Jerry Rees, Bill Kroyer, Henry Selick, John Lasseter, and Tim Burton invaded the hallways.

Hollywood itself was under reconstruction by filmmakers like Francis Ford Coppola, Martin Scorsese, Steven Spielberg,

and George Lucas. They were visionaries who introduced the idea of the blockbuster and were reinventing the movie business. There was an opportunity for a similar renaissance in animation, but the conditions weren't right. The passion and creative risk had disappeared.

The studio was full of eager young talents chafing under the leadership of veteran artists who, as masterful as they were, had become creatively stagnant by trying to repeat well-worn formulas from the past. The studio was starved for artistic leadership and the collaboration that was once there, but both had died with Walt Disney years earlier. The culture was broken.

"I remember working at places in my career where the creative leadership was threatened by the young people coming in," John Lasseter said referring to that era. "I was told, 'Just be quiet and do what you're told.' I decided if I was ever in charge I wouldn't say to a young guy what was said to me."

Frustrations grew, and Lasseter and Bird were unceremoniously dropped from the roster. Tim Burton was spotted by live-action studio chief Tom Wilhite and given the chance to make a couple of experimental films, *Vincent* and *Frankenweenie*, that launched his career as a live-action director. Still others left the studio amid rumors that the animation department would be shuttered. In 1984 a new management team headed by Michael Eisner and Frank Wells came in, and what remained of the once-great Disney animation department was moved off the lot and into a drab Dickensian warehouse

(yes, I know that Dickens seldom wrote about the repulsive warehouse conditions in the San Fernando Valley, but you get the idea).

A couple of cars were broken into in the first months after the exodus. In the summer gnats got into the air-conditioning system, and if you sat anywhere under a duct, you were rewarded with a gentle drizzle of dead bugs all day long. In winter we froze and brought in buckets to catch the dripping water when it rained.

Despite the Cannery Row conditions there was a huge upside to all this. The building had an open floor plan so you couldn't hide. There were frequent and spontaneous meetings and rubber band fights in the hallways. Artists plastered the walls with brutally honest caricatures, and everybody knew everything. There was a positive anarchy about the place. We felt like a life raft cut loose from the mother ship. Either we would survive or drown, depending on how we all worked together.

That nadir of animation proved to be the beginning of a rebirth. With intense executives like Jeffrey Katzenberg and brilliant creative voices like lyricist Howard Ashman, the artistic leadership and collaboration was back, and the studio turned out a string of blockbusters like *The Little Mermaid, Beauty and the Beast, Aladdin,* and *The Lion King.*

The young novice animators went on to be some of the most renowned filmmakers of this generation: Ron Clements and John Musker, who made *The Little Mermaid, Aladdin,* and *Princess and the Frog;* Brad Bird, one of the

founding fathers of *The Simpsons,* who later went on to direct *The Incredibles* and *Ratatouille;* Jerry Rees, who later helped write and served as the director of *Brave Little Toaster;* Bill Kroyer, who directed *FernGully;* Henry Selick, who directed *Tim Burton's The Nightmare Before Christmas* and *Coraline;* John Lasseter, who reinvented animation with a slew of hits from Pixar; and Tim Burton, who made films like *Batman, Beetlejuice, Big Fish*, and *Alice in Wonderland.* Some made their careers at the studio, some did not, but they all lay dormant in the D Wing until a changed environment allowed them to flourish.

Building a creative organization is not just about assembling talents and placing them in a beautiful facility; it's about having a culture of open communication and the courage to listen to those talents and let them grow and flourish in their own unique ways.

Sharing the Good News

John Burroughs' quote "Leap, and the net will appear" bears repeating. Commit to an idea, and the resources to create it will become apparent. The safety net in creativity is the kinship you form with your fellow creators. So find a very close friend, leave the house, meet for coffee—or better yet, a huge meal of haggis on a bed of baby chicory—and then announce

your rebirth. You've got to share this vision someday; it might as well be with friends and haggis.

You are facing a kind of upheaval in your life, and your support network of family and friends can help you. Seek out the people who will be accepting of you, not blindly or uncritically, but with encouragement.

I really believe that people don't know how to respond to the news that you want a little more creativity in your life. When you're sick, they say, "Feel better now," and when you are sad, they say, "That's all right," but there is no socially acceptable response to the fact that you want more innovation and creative spirit in your life. I think it's because the term *creativity* is so vague and covers such vast areas of thought, from astrophysics to zoology, that most people respond with that what-does-this-have-to-do-with-me look.

Before you go around soliciting the support of friends and family, it may help to focus on the areas where creativity speaks to you. While it's not so easy to encourage the person who says, "I want more creativity in my life," it is very easy to encourage the person who wants to paint more often or wants to start a gourmet cooking class. Once we do some soul-searching and decide what we love in life, we can focus our creative spirit, and we can follow our muse.

Keeping Your Journal

Writing is a wonderful focusing mechanism for the soul. It's a way to record your observations and feelings about your conquests and failures.

Scientists keep lab notes, artists keep sketchbooks, and cooks jot down culinary successes and failures. We need a record of the findings, impressions, ideas, events, and feelings of everyday life. We may not remember that nutmeg made the sauce work, but we will remember that we wrote it down.

There is a cleansing effect in writing, too. The act of expressing ourselves in an unedited way with pen on paper gives us a chance to stop carrying our thoughts around and to put them down.

If you are more visually oriented, don't feel pressure to use words exclusively in your journal. Many people tear out or bookmark magazine pictures, cartoons, newspaper headlines, or Internet articles that inspire them. These can form a unique journal of your feelings and inspirations.

You can do a daily painting to journal your feelings (or a daily poem or song, too), but the important thing is the regular expression of those feelings. It's crucial that your journal be your private enclave for expression. Your journal is not a thing to share or analyze with others; it is a daily way to articulate your moods and feelings to yourself.

Wellness

Take care of your physical self as well as your mental self. It's hard to create on an empty stomach or with an empty soul. Our physical being is literally a sum of the food, water, and air we take in, plus the effect of the environment in which we exist. I balance my diet with grains, dairy products, vegetables, and meat, and on other days my four essential food groups consist of sugar, caffeine, chocolate, and Advil.

Physically and spiritually, we are what we eat. Our creativity reflects what we feed our intellect. This may suggest that we should feed our intellect only from a select group of basic intellectual "food groups." But if you think it's hard to eat five servings of vegetables each day, wait till you try feeding your creative spirit with a regular, balanced diet.

It's impossible and, moreover, you wouldn't want to control your input or live a life without delicious food. It's important not to jump to a moral judgment here. It's not that you shouldn't have strong moral opinions about your life. You should have them and you should express them. The temptation is to say that we should feed our spirits on a diet of only good, wholesome input, of purity and sanity and reason.

But life is more complex than that. The arena of human existence is a panoply of experience. Don't edit your input. It is crucial to your creative spirit to know as much as you can about the range of life: good and evil, black and white,

silence and cacophony, sacred and profane, order and chaos, wealth and poverty, feast and famine, day and night. That's not to say we all have to embrace every human lifestyle, but an openness to the range of human expression, every human expression, is important to feed your creative soul. Some parts of life may repel you and others may enrapture you, but your very openness to the full spectrum of life will help form your opinions and your creative voice. Creativity is no place for elitism. Pablo Picasso socialized with bullfighters, Beatrix Potter socialized with sheep ranchers (she actually *was* a sheep rancher), and Ernest Hemingway socialized with bullfighters. My point is not that two out of three artists should hang out with bullfighters or that artists need a relationship with live-stock, but that these highly creative people sought inspiration from lifestyles that were simple, honest, and atypical.

Art and creation are responses. Sometimes art responds to life with beauty, hope, and innocence, and sometimes it responds with greed, corruption, and outrage. If life is made up of an extreme range of emotions and experiences, then creativity will also reflect that extreme range.

Play

You can discover more about a person in an hour of play than in a year of conversation.

—Plato

There is one thing that we seem to know so well and so instinctively that it rivals breathing and walking upright as one of the signature traits of humanity. We know how to play.

Art is related to play. In every way, play and art are related as simple and essential and very human forms of expression. Every child knows how to play, but sometimes we inadvertently teach our children to forget how to play. We discourage kids by being overly critical of their work or by stopping them in the middle of their creative process to tell them they are doing well or not so well. We make them self-conscious about creating or even laugh when they sing off-key or dance funny or don't draw a house the right way. And then when those kids are adults, the memories of feeling self-conscious put a halt to creativity once again.

As children are judged and introduced to competition in the arts—where they are exposed to myths of talent and skill—they begin to wilt, and their playful spirits die a bit. They begin to feel ashamed of a drawing or a dance that they have done. Adults push and interfere with well-meaning but misplaced coaching, and the playful child slowly and sadly learns to stick with safer, more measured skills like math, spelling, and history. Reading, writing, and arithmetic have right and wrong answers. Play does not. Art does not.

Play is so instinctive that we don't have to teach our children how to do it. We come prewired and predisposed to play. Kids may struggle with history or math, but you can bet that they know how to play Chinese jump rope and climb the monkey bars. Playfulness is a human trait that is buried

deep in our genetic past and as such holds great power in our lives. Adults don't need to be taught how to play, either. We just need to allow ourselves to do it. Grown-ups can play just as well as kids can, only the toys are bigger, faster, and more expensive. As managers learn that play is a welcome cousin of creativity, work environments have become more tolerant of play in the workplace.

It's certainly true that in a place like an animation studio, along with the work you tend to get a lot of pie fights and funny hand sounds. The spirit inside an animation studio is hard to describe, but it might be categorized as a chaotic creative environment. Most of the nondrawing activities center around drinking coffee and shooting rubber bands at your colleagues. Every once in a while someone brings in something cool, like a paintball gun or a mummified cat. One animator celebrated his breaks by leaping up onto a desk and singing lengthy sections of Italian recitative. He didn't speak Italian, but that never stopped him from receiving a big ovation and a shower of rubber bands. Another animator kept a full-size standard poodle in his office. It was *the* place to visit if you needed a quick tongue bath.

One story person decided to save his spit in a glass jar for two weeks, which he did, proudly displaying it complete with a label—KELLY'S SPIT—on a shelf behind his desk. One day he came in early and quietly emptied the jar, washed it out, filled it with water, and put it back on the shelf before anyone got to work. At coffee-break time, he got up and announced, "Hey, what would you give me if I drank my spit?" After

wagers were placed, he drank his "spit" for a handsome profit. We all gagged for days.

Then there was Pirate Day, when the animators dressed like pirates and raided the legal and accounting staff, and there was the day that someone brought in a slingshot. It wasn't just your regular Dennis the Menace variety, but a huge one that took three people to operate. Two people would hold the ends of what looked like a massive rubber band, and a third would stand in the middle and pull the sling back into firing position. You would then insert nearly any desired object, like a pug dog—er, sorry, I meant to say, like a small plush toy dog—and with a flick of the wrist, the object would go really, really, really airborne and land somewhere near New Guinea. We started in the parking lot, firing water balloons into the street; we graduated to launching airworthy fast food—mostly Twinkies or Ding Dongs. It's nearly impossible to use mere words to describe the feeling of power you get when you lob your Twinkie two hundred feet in any direction. It is very satisfying. (As an interesting aside, The Walt Disney Company does not normally allow people to remove Ding Dongs from its premises during work hours, but using the proven adage "It's better to beg forgiveness than to ask permission," we did it anyway.)

Once the animators had mastered the outdoor event, they went inside for the more challenging pastime of Indoor Giant Slingshot (soon to be an Olympic medal sport).

The task was to shoot a doughnut or similar breakfast food across the studio—about 150 feet with a slight dogleg to the right—and try to hit some meaningful target,

such as a small Styrofoam cup full of steaming coffee.

Frosted doughnuts seemed to work better than glazed, and the day-old variety was the most desirable because of its firmness and superior aerodynamic qualities. One by one, the contestants would take turns loading up the giant slingshot with their buttermilks and jellies, and one by one, these airborne baked goods would catapult across the studio and over the heads of cowering new employees, on their way toward their dunking destination—a steaming hot cup of Folger's. Each attempt was greeted with the cheers and moans of onlookers who would then politely applaud the effort as though they were watching Lee Trevino sink a birdie at Augusta.

After each attempt, the judges carefully measured the distance from the cup of coffee to the doughnut; they disqualified only one eager contestant, who had tried to catapult his meat loaf sandwich toward the target. Everyone clearly saw this as a rules violation (as one might expect, flying meat loaf obviously belongs in the afternoon hurling event).

The winning object was an onion bagel with cream cheese that came within a breathtaking six inches of the coffee. An éclair launched by another contestant came just as close but, without the benefit of the frictional properties of cream cheese, it skidded past the target and into a hapless secretary, to the general disappointment of the gallery.

Later that year there was some loose and irresponsible talk about buying a catapult. Somebody had seen a television show about these guys in the Midwest who built one so big it could launch a Holstein, but we thought better of it.

After the Game Is Over

The brilliant afterglow of launching your creative ship will fade someday if you're not careful. Once you've opened your heart and mind to a more creative life, you will have a day when you will want to chuck it all and return to the safety of the anonymous worker-bee world. Here we take a lesson from some of the ancient books on the art of warfare. When the assault on your spirit seems insurmountable, dig in your heels and wait for it to pass. Another approach made popular in my house: buy chocolate and wait for the moment to pass. Then join the battle once more.

Our lives are very goal-oriented. Just as the sporting world rewards the team with the most points at the end of the game, business and commerce reward great achievements with money or status.

There is one small but fatal flaw, however, that is buried in the goal-oriented culture. As we focus solely on the endgame, we miss a great deal of life along the way. When the goal is so important that we miss the joy of the process, then the single-minded focus strategy is unfulfilling at best.

The process is the thing. It's the process that is full of striving and yearning; the end product is in its simplest form merely an artifact of the process. That's not to say that this artifact does not have great value. A movie is the end product of years of process, all of it creative, whether acting, directing,

writing, or cinematography. The artifact of that process is a film that expresses the experience and ideas of the filmmakers and can also be sold for money.

If the process is at the core, you might ask, does the end product need to have a value at all? If an artist paints a painting and doesn't show it to anyone, is it a waste of time, or does it have value? The answer is that it has great value and is a very important work of art, because this hypothetical artist did show it to someone . . . himself. The process of expressing our feelings on a canvas or in film or poetry is a process of emergence. Our thoughts and feelings emerge in a way that is often unexpected. At times those feelings may be absurd, or childlike, or something that you may consider to be junk, and at other times they can be inspired. We should never be forced or compelled to show our work involuntarily.

What if you really enjoyed writing poetry—if it gave you an outlet for your feelings like no other occupation? If it gave you quiet time to express some very raw inner thoughts that perhaps you might never otherwise have expressed in conversation? Your poems might be sweet and reflective on one day and full of darkness the next. The act of putting these feelings on paper is a wondrous and cathartic process—a process that need not be shared with others in order to be valid. Be content to create for yourself, and exhibit your work only when you find some sort of emotion in it that you want to share with a viewer.

Completion

If creation brings with it the pain of giving birth to an idea, then one day we should expect to feel the euphoria of success upon the completion of that idea. But instead we face a final haunting fear in our quest to create—and that is the fear of completion itself.

Completion has consequences. After the joy and celebration has faded, completion dictates that we will have to endure the criticism of our audience. Then we'll have to wake up the next day and once again return to the blank canvas. We may hesitate before we decide to create again because it was too painful the first time around. We may even have grown attached to the process of creating and fallen in love with the team of people we were working with. We feel the fear that our beloved collaborators will scatter and disappear and we'll never find a time like this again.

Implicit in the act of creation is the act of completion. We can try to deflect the feelings of loss by telling ourselves that we'll do it again. We may try to keep that great adrenaline buzz going by returning to the formulas used in prior successes. We'll even keep the creative team intact for the next project. But the components of a project and the people that put it together will never be quite the same again. The audience and the marketplace will not be the same, either.

Here is where the conflict between art and commerce is

most apparent. A gifted artist (be they an actor, cook, or poet) may create something that is highly popular and commercial. The businessperson says, "But the audience loves what you do now." And there's the rub. Do we stick to the comfort of repeating past successes and risk stagnation, or do we branch out and risk humiliation and failure?

There's no right answer. For example, take case study No. 1: *Toy Story 3* was an exciting artistic success, and it was the first animated film to make a billion dollars at the box office. Director Lee Unkrich told a strong new story with familiar characters. It made money. Everybody won.

In case study No. 2, we examine a guy who took a big diversion away from his first triumph. In 1940 Walt Disney was flush with the success of *Snow White* and wanted to break away from his cartoon roots and show the audience that animation could soar as an art form. He collaborated with conductor Leopold Stokowski to create a concert feature called *Fantasia*. It was a critical bomb and never found its audience. Walt reached out into new creative territory and failed. It bears pointing out that *Fantasia* is now one of the most successful and respected animated films of all time. It took seventy years for the audience to catch up to Walt and appreciate what he was doing, but his risk eventually paid off.

So here's the deal—after all that you've worked for to express yourself creatively as a contributor to the human project, you expect a final verdict and some closure to your work. But there is no completion. There is no closure.

Winston Churchill said, "Success is not final, failure is not fatal, and it's the courage to continue that counts."

Move on with courage. Completion is the end of one journey and the beginning of the next. Learn from failure, do a postmortem, reinvent, and then face the blank canvas once more. The creative process is what drives the human project forward and proves the genius of mankind to affect the world around us in many glorious ways. Living a life committed to the creative journey offers to us the most profound opportunity for you to say, "I am here, I am alive, I have something to show and tell, and what I have to say is important. Let me show it to you."

Epilogue

I would rather be ashes than dust!
I would rather that my spark should burn out in a
 brilliant blaze than it should be stifled by dry rot.
I would rather be a superb meteor;
 every atom of me in magnificent glow,
 than a sleepy and permanent planet.
The proper function of man is to live,
 not to exist.
I shall not waste my days in trying to prolong
 them.
I shall use my time.

—Jack London

Years have passed since the belligerent young man in the back of the auditorium voiced his concern about social injustice in Grover's Corners, and times have changed. Life goes by

so fast. My friend Toad married that female trombone player from the marching band. He became a professor of quantum physics at M.I.T. Miss Welch married some guy named Bjorn Gustafsen and moved to Orlando, where she forsook her career in dentistry and got a job on the Orlando Magic's dance squad.

And someplace right now on the planet Earth, a group of high school students are staging *Our Town* by Thornton Wilder. And when they are deep into the third act, they'll find with some sadness that Mr. Webb's daughter Emily has just died in childbirth. Before she exits, she asks the stage manager if she can revisit just one day from her past . . . her twelfth birthday. He agrees. Slowly a distant reflection of her past materializes once again into perfect focus.

There they are, her mother and father, their faces young and beautiful again. She sees her little friends all gathered for a party with their parents standing proudly behind them— friends she hasn't seen or thought about in years. She watches with bittersweet wonder the simple and precious acts of this seemingly normal day from her past and speaks softly to the stage manager:

> **EMILY:** I can't go on. It goes so fast. We don't have time to look at one another. I didn't realize. So all that was going on and we never noticed . . . clocks ticking . . . and Mama's sunflowers. And food and coffee. And new-ironed dresses and hot baths . . . and sleeping and waking up.

Do any human beings ever realize life while they
live it?—every every minute?
STAGE MANAGER: No. The saints and poets,
maybe—they do some.

Creativity in the real world seems overwhelming. In my hardware store, the nuts and bolts are clearly labeled and there's always someone there to tell me what to do. Not so in real life. The ingredients of life don't always come in a small brown paper bag with the receipt stapled on top.

Who can help me? What if I fall? When can I find the time? Where do my dreams fit in a crowded world? How can I lift my head above the awesome daily tasks of life? Why art, why storytelling, why look with new eyes? Why strive for the impossible, why be creative, why do all this? We'd willingly search everywhere for the secrets of creativity the way Voltaire's Candide did; he traveled the world over, experiencing gruesome adventures and seeking the best of all worlds, only to end up at home on a little farm, where he reminds himself with quiet regularity, "We must cultivate our own garden." In the end, there is no magic formula for creativity out there. It is all within you.

All this searching for creative achievement may seem like a lonely and at times meaningless pursuit on the fringes of society, but it is not. The creative forces at play within us are the essence of our humanity, and there is something truly heroic about it—this heroism of the seeking mind, this willingness to leap into the void, to illuminate the darkness, to

remove the blinders from our eyes and from the eyes of our fellow man. It is this heroism of the creator that drives the evolution of the human species and gives validity and meaning to our life's journey. And so all the pain, the insecurity, the buffeting, and the doubt seem justified in the knowledge that we can ultimately soar above the confines of our anxieties and experience something bigger than ourselves. We can offer up our very personal gift to the human project, and in doing so come closer to Aristotle's happiness than ever before.

Acknowledgments

Brain Storm comes to you courtesy of Wendy Lefkon, my editor, whose patience and guidance I greatly valued. I am grateful to the amazing team at Stone Circle—Connie Thompson, Maggie Gisel, and Lori Korngiebel—who make the impossible look easy, and to Scott Watts, who brainstormed the title for this book. Thank you to the Disney Editions team: Jessie Ward, Hans Teensma, Jennifer Eastwood, Gregory Lauzon, and Winnie Ho. Thanks also to photographer Mike Carroll and his band of followers at Romanian Children's Relief, whose inspiring story led me to drop everything and make a movie about life. To my family past and present, and especially Auggie and Lucy, for keeping me company when I was writing at 4 a.m. And finally, thanks to all my colleagues at The Walt Disney Company, who have inspired me along the way and whose stories fill these pages.